The Queening of America

It is our duty
and our role in
the scheme of
things to be
romantic figures.
we are rich.

The Queening of America

Gay Culture in Straight Society

David Van Leer

Routledge

NEW YORK LONDON

Published in 1995 by

Routledge
29 West 35th Street
New York, NY 10001-2299

Published in Great Britain by

Routledge
11 New Fetter Lane
London EC4P 4EE

The author gratefully acknowledges permission to reprint the following:
"In New York They Mug Monkeys" © United Press International; excerpts from *Who's Afraid of Virginia Woolf?* by Edward Albee, © 1978 (New York, Simon & Schuster, Inc.) by permission of the publisher and William Morris Agency; excerpts from *Little Me* by Dennis Patrick, photographs by Cris Alexander, © 1961 by Dennis Patrick & Cris Alexander. Used by permission of Dutton Signet, a division of Penguin Books USA Inc.; excerpts from *Breakfast at Tiffany's* by Truman Capote, © 1958 (New York, Random House Inc.); excerpts from *Answered Prayers* by Truman Capote © 1958 (New York, Random House Inc.); photograph from *Blue Velvet*, produced by Dino DeLaurentiis; excerpts from *Prick Up Your Ears* by John Lahr, © 1986 (New York, Alfred A. Knopf, Inc.) permission granted by the author and and the publisher; excerpts from *The Orton Diaries* edited by John Lahr. Introduction © 1986 by John Lahr, © 1986 by the Estate of Joe Orton (New York, Harper Collins Publishers Inc.); excerpts from *Complete Plays* by Joe Orton, © 1986 (New York, Grove?Atlantic, Inc.); excerpt from *Head to Toe* by Joe Orton, © 1990 (London, Methuen London, Ltd.); "Decision," New York City Transit Authority and Department of Health; "Whatever Lola Wants" from *Damn Yankees*, lyrics written by Richard Adler and Jerry Ross © 1955, Frank Music Corp. All Rights Reserved; "The Beast of the Closet" by David Van Leer, © 1989 by the University of Chicago. All Rights Reserved; from the Billy Rose Theatre Collection, New York Public Library for the Performing Arts, photographs by Fred Fehl and Gene Cook; frontispiece by Robert Miles Parker, © 1979.

The appearance of the models in the photo on the cover of this book in no way represents their sexual orientation.

Library of Congress Cataloging-in-Publication Data

Van Leer, David, 1949—
 The queening of America : gay culture in straight society /
David Van Leer.
 p. cm.
 Includes bibliographic references.
 ISBN 0-415-90335-1—ISBN 0-415-90336-X (pbk.)
 1. Gay men's writings, American —History and criticism—Theory, etc.
2. Homosexuality and literature—United States—History—20th century. 3. Literature and Society—United States—History—20th century. 4. American Literature—20th century—History and criticism. 5. American Literature—Men authors—History and criticism.
6. Popular culture—United States—History—20th century. 7. Motion Pictures—United States—History and criticism. 8.Subculture—United States—History—20th century.
9. Gay Men—United States—Social life and customs. 10. Homosexuality, Male—United States. 11. Homosexuality in motion pictures. I. Title
PS153.G38V36 1995
305.9'06642—dc20 94-47059
 CIP

British Library Cataloging-in-Publication Data is also available.

For Miles

because he made me

In memory of

Terry Horton
Tom Davis
George Mahan
Carleton Knight
Ed Binney
Rusty & Michael
Charles Hasbruck
Glen Palmer
Henri and Bill Banister
Michael Duddy
Brad Truax
Scott Chelius
Steve Allen
Steven & John
Robert Kinsell
John Storey
Gary Rees
Dale Craig
Scott Brown
Eugene Jardin
Peter Sturman
Fred Acheson
Tony Ascuena
Tyler Wasson
Martin Gregg
Bob Larkin
Mark Gomez
Grey Hankie
Lou Vargas
William Body
the 2 Davids
Dan Calder
Walter Raines
Michael Mehlos
Johnny Roberts

CONTENTS

ILLUSTRATIONS

ACKNOWLEDGMENTS

As most people have opinions about sex, I am indebted to virtually everyone I encountered while writing this book. Many have been extraordinarily generous with their time and insights, encouragement and corrections. I am grateful to ongoing exchanges with my teachers and colleagues Michael Colacurcio, Elaine Showalter, Emory Elliott, Sander Gilman, Sandra Gilbert, Laura Mulvey, James Kavanagh, Louis Menand, David Wyatt, Joanne Feit Diehl, Patricia Moran, Mark Seltzer, Shirley Samuels, Alan Williamson, Margit Stange, Phillip Barrish, Kenneth Myers, Sabrina Barton, Kari Lokke, Clarence Major, Anna Kuhn, Jeff Escoffier, Smadar Lavie, and Irit Rogoff. At conferences and colloquia Joseph Allen Boone, Janice Radway, Arnold Davidson, Simon Shepherd, D. A. Miller, Henry Abelove, Elizabeth Long, Linda S. Kauffman, Alan Sinfield, Eric Sundquist, Inderpal Grewal, Margery Garber, David Leverenz, Martin Duberman, Sue-Ellen Case, Martha Nell Smith, Earl Jackson, Jr., Charles Silverstein, and Jill Dolan offered stimulating responses to earlier versions of these arguments; as have my students, especially Catherine Carr Lee, Alan Silva, Lisa Giambastiani, Carolyn Waggoner, Anne Dannenberg, Margaret Garcia Davidson, Stephanie Ellis, Anne Fleischmann, Linda Trinh Moser, Terry Maloney, Mina Chatterjee, Heather Macmillan, Rhonda Handel, Kirsten Saxton, Jan Van Stavern, and Lisa Harper. I have tried to listen to them as well as they did to me.

The work was supported by grants from the National Endowment for the Humanities, the California Council on the Arts, the

University of California, and the Davis Humanities Institute. Crucial assistance was provided early by the librarians at Princeton, UC Davis, UCLA, Columbia, and especially the Billy Rose Collection at the New York Public Library, and later by the editors at Routledge. I am equally indebted to the film collections of Women Make Movies, Frameline, and Third World Newsreel, whose staff cheerfully shared their knowledge and enthusiasm. I was particularly fortunate to participate in a three-year initiative in Minority Discourse at the University of California Humanities Research Institute at Irvine. I cannot praise enough the intellectual acuity and camaraderie of its fellows—Abdul JanMohamed, Norma Alarcón, Kimberlé Crenshaw, Sterling Stuckey, May Joseph, Lillian Manzor-Coats, Vincent Cheng, Michael Sprinker—the foresight of director Mark Rose, and the tireless assistance and good cheer of Debra Massey and the UCHRI support staff.

This text, indebted to so many people, owes special thanks to three. With her keen eye and sure ear, Elizabeth Tallent brought my academic prose closer to the stylistic grace and wit I sought. I daily benefited from the intellectual encouragement and tough-mindedness of Clarence Walker. For Valerie Smith, who heard these arguments longest and liked them best, I hope I have been half as good a friend as she. Finally to the unnamed family and friends who listened, comforted, or brought me back to earth with their indifference, I can only say (again) that some debts must be remembered in other places, other ways.

INTRODUCTION

Identity and Invisibility

*C*ontemporary culture seems uniform. Palms of every hue exchange high fives, earrings hang on male lobes from Baltimore to Butte, and Arnold Schwarzenegger and Keanu Reeves stand in silent refutation of multiculturalism. In a world of white rap and karaoke *Mikado*s, one needs constant reminders of what a difference might look like and how it might work. Even among those who study minority subcultures, there is today a debate about difference. What are differences, where do they come from, and how can they be overcome? Is it possible to describe cultural specificity without reproducing the stereotypes by which communities were labelled "minor" in the first place? Does the search for commonalities among peoples forge allegiances or merely pass off as "universal" values that are specific to particular powerful subgroups?

In the debates about difference, questions of sexual preference have become increasingly prominent. After what was sometimes called the "gay decade" of the 1970s, popular support for homosexuality has decreased since the mid-1980s. The rapid spread of the AIDS virus in the gay male community revived associations of homosexuality and disease. And in the wake of the furor surrounding the photographs of Robert Mapplethorpe and the performance art of Tim Miller, John Fleck, and Holly Hughes, contemporary "culture wars" are waged over the morality of gay art. Yet even as anti-gay sentiments have become more visible in the culture at large, gay-affirmative studies have grown in the academy. This increased attention marks the liberalism

throughout academia: the desire to offer a unified front against HIV and the NEA. But the rise of gay studies also signals the conscious attempts of scholars in the field to relate the culture they study to broader theoretical concerns. Just as in the 1980s African American-ists explored the continuity between "signifyin'" and deconstruction, queer theorists have characterized homosexual discourse in terms of the disjunctive ironies and multiple subjectivities of postmodern the-ory.

Although theoretical language has afforded gay studies a greater voice within scholarly discussion, it has also widened the gap between academic scholarship and grass-roots activism. In part this division arises from the selection of texts. While scholars primarily focus on canonical literature of the late nineteenth and early twentieth cen-turies or on postmodern art, popular critics generally emphasize the explicitly gay-identified writing and film in the years after the Stonewall Rebellion of 1969. In part the dispute involves questions of vocabulary and audience. Activists accuse theorists of elitism and obscurantism; theorists find popular accounts naive and anti-intellec-tual. And in part the disagreement signals the different goals of the two groups. To legislate for the civil rights of homosexual men and women, grass-roots activists must establish the existence of sexual ori-entation as a persisting category. Yet to illustrate development within sexual communities, scholars tend to reject that very notion of persis-tence as "transhistorical."

The essays that follow inhabit a middle ground between academic and grass-roots accounts. Focusing on contemporary exchanges between different sexualities, they argue that in our century, gay and straight cultures are already informed and shaped by elements of each other, and that the creation after Stonewall of a "gay sensibility" is better understood as a foregrounding of sexuality in a sensibility that had long since been presented to (and assimilated by) the main-stream. The essays build upon comparativist theories of minority discourse and multiculturalism which join social history to self-critique. While attempting to recover the prehistory of gay cultural development, I also review theories of sexual identity, social action, and textual production to ask both what is left out of authorized dis-

course and what is sacrificed in granting minorities permission to speak.

The book falls into three sections. The long title essay examines how, in the decades before Stonewall, the unidentified sexuality of some male writing facilitated the crossing of gay motifs into straight culture. The purpose of this spacious piece is twofold: to record the variety of "closeted" gay male creativity in the period immediately preceding the Stonewall Rebellion; and to demonstrate how such sexually ambivalent rhetoric complicates any discussion of gay and straight as independent cultural entities. Drawing upon literary and film texts both high and low, I suggest that the meaning of a linguistic tradition like camp may reside as much in its movement between subcultures as in its relation to the cultures that claim it as their own.

Tempering the first chapter's celebration of cultural transformation, the three middle essays explore the intransigence of some current ways of making homosexuality visible. The second chapter, "Saint Joe," reviews the packaging of playwright Joe Orton in biography, film, and theatrical productions to discover in the conflicting explications of Orton a more general uncertainty about the ways in which a "life" is gay. The third, "The Beast of the Closet," considers the work of the influential theorist Eve Kosofsky Sedgwick to clarify the implications of conceptualizing gay invisibility as a "closet" and sexuality as something to be "known." The fourth, "AIDS in the Academy," uses certain anomalies about the simultaneous rise of gay studies and spread of HIV to examine the postmodern rhetoric of "representation." In detailing the limitations of specific analytic paradigms, these studies ask more general questions about knowledge itself as a category, especially whether "knowing" sexuality alters the conditions of its being.

The middle chapters question whether certain post-Stonewall vocabularies remain appropriate in a post-AIDS world. The (more hopeful) concluding section, "What Lola Got," returns to the popular culture of the first chapter and to the initial notion of an invisible "queening" to suggest how gay-identified readings might be made to clarify more general issues in minority discourse. Discarding the gay/straight dichotomy of the previous sections, this chapter argues that

convergences among subcultures can provide a means of talking about minorities without referring back to issues of victimization by the dominant culture. It then cautions that intersectionality is not politically neutral, and looks behind apparent convergences to question the motives of the dominant culture in sponsoring those similarities.

Although the essays stand independent of each other, not attempting a continuous argument or even a unified tone, they share certain intellectual preoccupations. Each considers the relation of sexual identity to cultural visibility. It is true that all individuals can mask somewhat the physical characteristics which dominant culture sees as the visible signs of otherness; some, like light-skinned blacks or female cross-dressers, can disguise these traits entirely. On the other hand groups like homosexuals or Jews, who generally can only be defined in terms of social activities or beliefs, still are imagined to have corroborating physical characteristics—tell-tale brows, noses, wrists, accents, lisps. Yet while the distinction between visible and invisible groups is never absolute, the routes by which less visible minorities approach power can differ from those open to the visible. White gay men willing to remain silent about their sexuality have long had access to positions of cultural authority.

In studying the relation between visibility and empowerment, one confronts the imprecision of the notion of "the visible." The concept of gay invisibility conflates metaphors of sight with those of sound, assuming that one must "look like" a homosexual to "talk as" one. It shifts the burden of visibility from those looking to those seen. Ralph Ellison locates a black man's invisibility in the refusal of white culture to look at him; gay invisibility seems an effect not only of straight culture's inability to see but also of homosexuals' unwillingness to make themselves visible through "coming out." This internalization of sight rhetoric spatializes the visible/invisible dichotomy as a distinction between public and private spheres. The relegation of an invisible sexual preference to a private "inner" realm encourages paranoia about the secret conspiracies of homosexuals. Conversely, in restricting the public to the visible, the spatialization reduces what happens *to* the public sphere to what happens *in* it.

To untangle identity and visibility, my arguments shift some

emphases of recent historiography. Gay Liberation most honored high-cultural heroes, especially those victimized for their visibility. Embarrassed by work whose marketability depended on its author's not making an issue of his sexuality, activists tended to reject successful assimilated artists as "closet queens." Uncertain that sexual reticence is necessarily a form of self-hatred, I treat "the closet" and "coming out" not as problem and solution, but more neutrally as two different strategies for dealing with the dominant culture. My account examines less the ways in which the majority silences minority voices than the ways in which minorities explore and reshape those silencings for their own purposes. Feminist theorists have argued that it is in undervalued cultural genres that such voices often make their initial artistic contributions. So my essays race past well-known figures like Oscar Wilde and the Violet Quill novelists to linger over those genres—comic fiction, commercial theater, popular music, and film—whose very lack of prestige made them less attractive to dominant culture, more open to minorities.

I reconceptualize as well traditional accounts of the growth of gay studies. Although excited by the wealth of recent work on gay materials, I do not see this explosion simply as a triumph over repression. The process by which homosexuality became a credible academic topic has a history of its own, as I indicate in the chapter on AIDS, and one must resist valorizing any single stage of the process over any other. Just as "the closet" and "coming out" seem to me best understood as different political strategies, so the various voices of gay scholarship—academic and otherwise—seem merely different ways of talking about homosexuality, each with its characteristic virtues and limitations. My own decision to focus on certain particular strategies—more readily available to white middle-class men than to women or to men of other races, ethnicities, or classes—is offered as yet another incomplete view, and in the concluding essay I consider how white male invisibility might be related to broader strategies of homosexual empowerment.

The essays share more than a thematic emphasis on white gay male invisibility. Methodologically, I move anecdotally, building from a close reading of a sentence, a paragraph, a newspaper clipping, a

movie to more general statements about the ways in which we represent and misrepresent sexuality. My choice of materials is idiosyncratic—mixing familiar figures like Sedgwick and Orton with less celebrated ones like Saki or Dennis and even with little known ones like Anthony Agnello or Venus Xtravaganza. Such examples are not representative in any larger sense, and my few attempts at linear narrative—like the history of camp in the first chapter or the prehistory of gay studies in the fourth—only sketch in some shapes without attempting an exhaustive overview. In all this, questions about invisibility resurface, not as a unifying theme but as a recurrent aspect of gay culture.

Studying the strategic dimensions of invisibility entails a number of assumptions about the character of identity itself. Minority studies sometimes flirt with a rigid version of what has been called "identity politics"—a dogmatic response to the world in terms of some simplified notion of group solidarity. Such a monolithic concept of identity denies the multiplicity of experience, the ways in which people play many different roles. Identity politics can promote exclusionary definitions of membership, insisting that only those possessing certain traits be considered fully and truly part of the group. Distinctions between the true and the false minority—the activist versus the closet queen—embrace a divisive rhetoric of "authenticity" or "experience" that quickly degenerates into a rank-pulling anti-intellectualism. As Joan W. Scott has warned, "the project of making experience visible precludes critical examination of the workings of the ideological system itself, its categories of representation (homosexual/heterosexual, man/woman, black/white as fixed immutable identities), its premises about what these categories mean and how they operate, and of its notions of subjects, origin, and cause."[1]

Gay theory originally conceptualized the limitations of identity politics in terms of the differences between essentialist and constructionist definitions of sexuality. Essentialist interpretations begin in the attempt to identify the social and cultural conditions characteristic of a specific sexual subgroup. At their most extreme, however, essentialists treat same-sex love as a timeless entity, leaving themselves open to charges of ahistoricism and even biological determinism. Constructionists,

wishing to historicize the concept, demonstrate that the definition of sexual preference as a timeless entity called "homosexuality" is itself the product of a particular historical moment late in the nineteenth century. If pressed too far, however, this corrective flirts with both linguistic nihilism and cultural determinism. As a mere word, "homosexuality" can become too easily divorced from the social reality it both denotes and misrepresents.[2]

While my arguments are generally "constructionist," I suspect that the concept of identity cannot be fully understood as a distinction between essence and invention. It is surely true, as the strict constructionists claim, that the meanings of "race," "gender," and "sexuality" are so variable that the words should always appear within quotation marks. Yet this statement is as much about language as about identity, and problems about social construction only exemplify more general uncertainty as to how any noun comes to name a diverse collection of things. Although there are no absolute traits shared by all "blacks," neither are there any common to all "chairs." Definitions of "race" do not fluctuate over time more than do those of "poetry" or "family"; and it may be injudicious to stigmatize as transhistorical our few terms for difference while leaving unchallenged the everyday vocabulary of sameness. Broad distinctions can be drawn between the scientific discourse of "homosexuality," the consciousness-raising of "gay," and the deconstructive postmodernism of "queer." Yet none of these vocabularies is fully adequate and, rather than perpetuate the search for a morally neutral and presuppositionless language of sexuality, I play fast and loose with terminology, drawing promiscuously from all three traditions.

My pluralistic vocabulary marks more than a skepticism about language. While I agree with postmodernists that theories of "experience," "the subject" (or "self"), and "identity" have been badly formulated, I do not locate the flaws within the concepts themselves. Arguments from "experience" can be misused to silence opposition: "you can't possibly understand how I feel." Yet while not endorsing this kind of argumentation, I do not feel the concept of "experience" to be wholly bankrupt. Taking my cue from Kant, I define the term as something like "sensation structured by thought": the assertion (in

anticipation of Derrida) that meaning is always already overdetermined; or (in anticipation of Foucault) that there is no such thing as presuppositionless thought. Although deploring the fact that everyone since Fichte has turned subject into a substance, I have less trouble with the Kantian (even Cartesian) definition of "self" as epistemological ownership. Experiences must be experienced; it is part of the concept of "experience" that sensations cannot float free but must be had (or "owned") by somebody. In some sense, finally, it is true that "You can't understand how I feel." That truth does not lie in the absolute superiority of my self-knowledge to your knowledge of me as other: some of the things you can know about my feeling are more interesting than my knowledge of its how-ness. Nor is the gap between knowledge and feeling merely a gap between you and me: in some ways *I* can't *know* how I feel, however undeniable my feeling. Knowledge and experience are merely different vocabularies for conceptualizing reality; and if making experiences visible precludes critical examination of experience as a category, ideological critique precludes making visible the experiences that ideologies exist to hide.

Finally I do not have the same trouble with "identity" as other theorists. We do know ourselves in different ways than we know other people. "Who am I?" and "who are you?" are not the same kind of question. Problems arise when this epistemological difference is extended to include concepts—like agency, responsibility, choice, affiliation—that are not necessarily part of identity. The confusion may lie less with the concept of "identity" than with that of "person." Our ability to wake up each morning believing ourselves the same consciousness that went to bed the night before does not tell us very much about what it feels like to be a person. In this respect "identity politics" is less of an oxymoron than is "personal identity": as concepts, "identity" and "praxis" hook up more easily than do "identity" and "persons." When people claim to base their politics on experience, they are probably doing exactly the opposite—taking up a position because it is valued by a group with which they identify. I myself experience sexual identity most strongly in my acceptance of my community's admiration for things that do not interest me as an individual—cross-dressing, lip-synching, mauve.

Counterbalancing my tolerance for identity language is my nervousness about categories in general. Many revisionist arguments seem to change the content of an analysis without altering its categories or presuppositions. The (antihomophobic) discovery that institutions like marriage or the family promote compulsory heterosexuality seems slight improvement on the (homophobic) assertion that such institutions can cure sexual deviance. Both explanations grant that marriage and family are useful tropes in analyzing cultures, disagreeing only on whether to read that centrality as liberating or oppressive. Neither explanation acknowledges that in some cultures these institutions might be irrelevant. Even the most accurate categories do not always capture the richness of everyday negotiations between groups. One can distinguish between living "on the border" and living in El Paso. Fear of discrimination does not account for all minority silences; certain conversations are just not all that interesting for minorities to have. Whatever the perks of empowerment, I doubt that anyone aspires to occupy "the center" as such, or that "the margins" are where minorities feel themselves to live—either as exiles or as cultural insurrectionists. And no critique of the inside/outside dichotomy admits the extent to which persons, indifferent to referentiality, often experience their position simply as "here."

Much recent theory has responded to such ambiguities by deconstructing the homosexual/heterosexual binarism. Rather than explore the indeterminacy of sexual identity, I critique the ways in which sexual categories, whether real or not, have been used to misrepresent and mask an identifiable cultural difference. In this aspect, my work allies itself with recent revisionist accounts in African American and feminist scholarship that, at the "risk of essentialism," discover a social reality behind the constructed categories of "female" and "race."[3] In part my emphasis marks my reading of the political situation. Even on those days when I do not think that the homosexual/heterosexual dichotomy is here to stay, I am not convinced of the practicality of dismantling it unilaterally. Deconstructing difference might problematize homosexual identity yet leave heterosexuality blissfully unaware that its universality was under attack.

My desire to retain the distinction between sexualities marks less my

confidence in the categories than my fears about categorization, and about the special place of explanation in descriptions of "homosexuality." However much minority identities are culturally constructed, there is little debate about how constructions connect with bodies. No one asks what "causes" Asians or blacks, or argues that a culturally constructed "gender" reverses tissue structure. Yet, as a minority not identifiable at birth, homosexuality has a long tradition of just such discussions of where homosexuals come from. Within legal or medical discourse, such accounts sanction pathologization, and most scientistic narratives of the development of homosexuality have been inverted to attempt its cure. Society studies how homosexuals are made in order to make fewer of them.

I risk essentialism, then, to forestall explanation; and, as should be obvious from the low pun of the title, my "queening" does not seek to establish new categories of analysis but to engage with the process of categorization itself. I do not use the category of "homosexuality" prescriptively to show what necessarily results from same-sex object-choice or what precedes it as part of some proto-homosexual cause. Nor am I concerned with granting sexual identity an historical reality, to claim that the positioning of certain figures situated within discrete sexual subcultures necessarily affected their work. My customary formulation is pragmatic or hypothetical—if something were true, how might it make a difference? What becomes visible when looking at a situation in a certain way, and what becomes impossible to conceive?

To investigate the potential of such hypotheses, the essays criss-cross, as the same or almost the same points are approached from different directions. The "Lola" chapter re-reads without reference to intentions what the "Queening" chapter casts as conscious negotiation between assimilated gay writers and the dominant culture. Most chapters consider whether the visibility afforded by stereotypes compensates for their pejorative character. And the text regularly circles back to recognition scenes between mismatched couples—Mame and Patrick, Marcher and May, Lola and Joe, even Anthony and his "girls" or Venus and her tricks. Such exchanges constitute what could be called the "gay primal scene" of desire across sexualities, the moment

when a couple (male and female and straight and gay) fashions a workable emotional relationship in defiance of cultural norms. I return to such questions not to resolve them, but to wonder how they became unintelligible—who is misunderstanding what, and to what purpose. For if knowledge is containment and identity is strategy, interpretation invites us to redraw the battlelines, to imagine the war as already won.

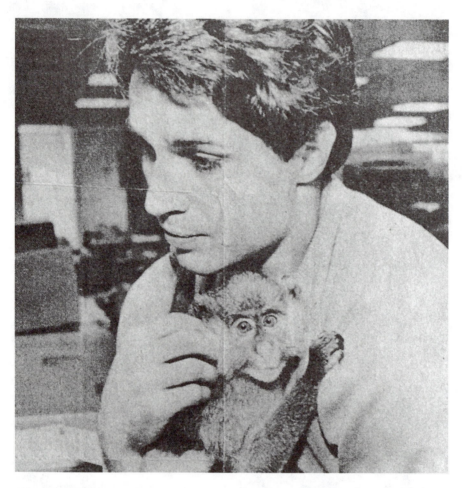

Figure 1: "Mr. Mike is consoled by his owner, Anthony Agnello, after being held up while raising funds to pay the monkey's medical bills." (photo and caption, UPI)

1

THE QUEENING OF AMERICA

Gay Writers of Straight Fiction

*T*he following news item appeared in the *Sacramento Bee* on Tuesday, September 30, 1986:

NEW YORK (UPI)—A man who mugged an ailing monkey by holding a knife to its throat and warning its owner, "Give me your money or I'll cut the monkey's head off," was the target of a police search Monday.

The monkey, known as Mr. Mike, was "shaken but uninjured" in the attack, police spokesman Peter O'Donnell said. The weapon—a 9-inch kitchen knife—was not recovered.

The monkey mugging occurred about 4 p.m. Sunday in front of a posh Fifth Avenue department store where Mr. Mike and his owner had gone begging to help pay $1,200 worth of veterinary bills for Mr. Mike's rehabilitation from a stroke, his owner said.

The pair, Mr. Mike, a 2 1/2-year-old Guenon blue-face Monkey and Anthony Agnello, 26, an out-of-work striptease artist from Southbury, Conn., have cut the vet bill down to $500 through the kindness of strangers in recent weeks, Agnello said.

But the mugger was anything but kind when he approached man and monkey and asked to hold Mr. Mike, who performed his own striptease until his paws were left paralyzed by the stroke.

Two girls had stopped to donate money and as one held the disabled simian, the man pulled out the knife, grabbed Mr. Mike's collar and held the knife to his throat, Agnello said.

The mugger threatened, "Give me your money or I'll cut the monkey's head off," Agnello told the police.

Agnello handed the mugger $100 he had collected during the day but the man grabbed Mr. Mike and ran, using the monkey as a shield until he was clear of the crowd that gathered, Agnello said.

The mugger then "slammed Mr. Mike down into the pavement" and fled, Agnello told the New York Daily News.

Police Officer Peter Sutherland, called to the scene, brought Mr. Mike and Agnello to the police station to view mug shots, but the effort was futile.

"I was hoping Mr. Mike could pick out the guy," Agnello said.

In California the report seems just another example of the horrors of Manhattan: the headline reads, "In New York, they mug monkeys." But this fleeting confrontation among differently situated individuals offers a model for the kind of cross-cultural exchanges that will be central throughout this book. Its components are simple enough. A young man from Connecticut comes to Manhattan to beg on Fifth Avenue for his recuperating pet. Two women stop to hold the animal and give the owner some money. A mugger holds a knife to the monkey's throat and, after receiving money, runs away. At some indeterminate time after his flight, two policemen appear, one to process the complaint and another to present it to the *Daily News*.

The newspaper version of the incident is structured around contrasts—between city and suburb, man and monkey, beggar and robber, officer and victim. Yet these pairs are not truly parallel, and the journalist's relation to them varies. Most obviously, the article's attitude towards the mugger is ambiguous. The comic tone of the account only barely contains its celebration of violence. It is after all the mugger, with his long knife and aggressive actions, who affords the incident its narrative momentum. The journalist relishes (and quotes twice) the

man's graphic threat to "cut the monkey's head off."

The mugger's power is implicitly acknowledged in the article's respect for his narrative counterparts—Officers O'Donnell and Sutherland. Although neither is essential to understanding the incident, both policemen are named in full and treated as models of authority. Despite their inability to change the shape of the event—to do anything more than take down and pass on other people's accounts—they are presented as if they are actively engaged in pursuit and retribution. The initial paragraph casts the incident as a struggle for revenge between two morally opposed but equally powerful forces—the searching police and the "targeted" mugger. Only later does the journalist double back to introduce those initially victimized.

This tension between the narrative's initial revenge plot and its subsequent shift to the motif of victimization determines the piece's odd characterization of the docile owner—Anthony Agnello. If at first the mugger seems the villain of the piece, by its end the victimized Agnello bears the brunt of the journalist's scorn. Whatever our sympathies for Mr. Mike, they do not extend to his owner. Agnello is not even named until halfway through the account, and then only in a subordinate clause. The policemen's profession and rank are dignified with capital letters; Agnello's is doubly ridiculed. His livelihood is denigrated through the use of the antiquated term "striptease artist," rather than the more neutral "dancer" or "model." He is even (somewhat inconsistently) criticized for his failure to succeed in a career already deemed unworthy.

More important, Agnello has no individuality in the piece. Although the ultimate source for most of the information in the article, Agnello is rarely allowed to speak for himself. Presumably the text paraphrases rather closely Agnello's account to the police. Yet he is not quoted directly until the article's last lines. Even then he offers not his words but those of the mugger, repeating the threat of decapitation with which the article opened. Only in the article's final sentence does he uninterruptedly speak his own words. His statement—that he was hoping Mr. Mike could identify a mug shot—in its admission of Agnello's inability even to recognize his assailant stands as the journalist's parting sneer: clearly the monkey is the

brains of this particular couple.

Agnello's weakness is not simply attacked by the journalist. His sentimental fecklessness is coded as homosexual effeminacy, and contrasted to the more admirable masculinity of both mugger and police. The most obvious clue is visual: the accompanying photograph shows a face of delicate features (and perhaps mascara) cradling a traumatized monkey, who nevertheless stares boldly into the camera, while the owner himself turns demurely away [Figure 1]. Yet the prose also carries sexual implications. The unnecessary reference to Agnello's occupation as stripper is probably intended as a clue to his deviance. Whatever the sexual interests of their audiences, a disproportionate number of male nude dancers are gay. Even the monkey's name of "Mr. Mike" would be hint enough for many readers. The hypermasculine combination of the butch monosyllable with the unnecessary "mister" illustrates the kind of stylish excess associated with gay slang; "Mr. Mike" is a name for hair dressers and fashion designers. If comic overstatement was not Agnello's intention in naming the monkey, it is the journalist's in ridiculing the name. The narrative's constant repetition of "Mr. Mike" emphasizes its comic character. Although Agnello is rarely mentioned outside the tag "Agnello said," Mr. Mike is named ten times in the twelve sentences.

The sexual implications of Agnello's fragility are reinforced by his relation to the two anonymous women of the narrative. It is easy to miss the presence of the kindly "girls," for the journalist obscures and trivializes their role. Yet they are centrally involved in the incident. It is their expression of generosity towards Agnello that first exposes the monkey to the assault. Although the narrative is vague on this point, the mugger seems to have placed his knife against Mike's throat while one girl was still holding him. In her arms Mr. Mike is cut off from even Agnello's slight protection. The indirect attack on Agnello through his monkey more immediately attacks the kindly woman, whose hand (not to say body) is also endangered by the knife drawn against Mike. And the phallic "nine inches" of blade that threaten Agnello with symbolic violation represent an even more powerful menace of rape for the woman actually holding the animal. For the journalist, however, victimization only marks weakness, and no con-

cern is afforded the threatened "girl," who is never again mentioned or (evidently) questioned.

The journalist's reshaping of this (admittedly factual) incident then can be read as a form of sexual allegory, built around two very different relations to the monkey. On the one hand there are the figures of masculine authority—the mugger and the two policemen. They are the characters fighting to ensure Mike's civil liberties. On the other hand are the helpless figures of the two women and of Agnello himself. These passive characters stand at the piece's emotional center. Yet the journalist does not really credit the importance of their emotion. As a "human interest" story, the article depends on the readers' automatic sympathy for the cute animal. Yet despite the sentimentality of our response to the monkey, we are asked to identify as weak those within the narrative who respond similarly. The women evaporate entirely from the account. And Agnello's affection for and attention to his monkey are discounted, leaving him with only his unemployment and victimization.

My point, however, is not the emotional inconsistencies of a throwaway news item. Perhaps in their pursuit of a minimalist "masculine" style, all journalists are tempted to stigmatize as "feminine" the difference between political "news" and personal "anecdote." And given the audience for most such articles, the knee-jerk misogyny and homophobia of the human interest page go pretty much without saying. What is interesting is not the predictable ways in which the piece reproduces the insensitivities of its culture. The key moment instead is one the article's author does not control, the one exchange when Agnello may override the journalist's insensitivities. In the sentence where he is first named, Agnello is said to have "cut the vet bill down to $500 through the kindness of strangers in recent weeks." The reporter, in a toughness borrowed from Theodore Dreiser by way of Jack Webb's *Dragnet*, responds, "But the mugger was anything but kind."

The reporter's condescension toward Agnello's fragility is consistent with his tone throughout the article. But this particular put-down misses the mark; for it fails to see that Agnello is himself quoting from a different literary source, countering the reporter's Sergeant

Friday with his own Blanche DuBois. At the end of Tennessee Williams's play *A Streetcar Named Desire*, the protagonist Blanche is committed to an insane asylum. She falsely believes that the doctor and nurse who arrive to institutionalize her are taking her to cruise the Caribbean with a former beau. Upon first discovering her error, Blanche runs away in terror. When she realizes, however, that there is no longer space for her in the hostile environment of her sister's household, she acquiesces, and apologizes for her reaction with her final words in the play (and one of contemporary drama's most resonant lines): "Whoever you are—I have always depended on the kindness of strangers."[1]

This phrase has subsequently become—at least among gay males—a clichéd expression of homosexual alienation, and Agnello's quotation of the line is probably a mindless parroting, part of the same sensibility that named his monkey. Yet in voicing this cliché, Agnello unconsciously assumes the authority of a gay cultural tradition strong enough to undermine the hard-boiled street smarts of the reporter. Previously silenced in the account, Agnello, through quotation, speaks his own words. Although the journalist presents them as paraphrase, Agnello undoubtedly said the words "the kindness of strangers." He thus forces his voice into the account a full seven paragraphs before the writer intentionally permits him to speak. Moreover, once Agnello speaks, the journalist has trouble reestablishing his authority. The phrase implicitly locates the journalist's sneers about Agnello's pet (and employment) within a larger context of sexual ostracism and scapegoating, substituting for the article's dismissal of gay incompetence the celebration via Williams's phrase of gays as martyrs of refinement and breeding. In dismissing Agnello with his response that "the stranger was anything but kind," the journalist is himself forced to take up the gay cliché—speaking not his own words but those of Agnello and of Williams before him.

The intricacies of this ephemeral anecdote epitomize the complex ways in which gays and straights actually interact, both in their everyday conversations and in their literary representations. Too often sexuality is represented as a battle between opposing armies, both fully cognizant of their own goals and of the character of the enemy.

This militaristic model focuses on a history of incrimination and distrust, in which empowered homophobes oppress timorous closeted men and the women who admire them. Such a model is uni-directional—concerned with the oppressors' perception of the oppressed but not with minorities' manipulation of (or indifference to) those perceptions. Although there is no reason to deny the pervasiveness of homophobia, it is important to see, as the anecdote about Agnello suggests, that confrontation is only one of many avenues to power. Most social intercourse involves not coherent conversations, but densely coded improvisations between groups barely conscious of their own identities or of the differences between them. And often minorities speak most volubly between the lines, ironically reshaping dialogues the oppressor thinks he controls or even finding new topics and modes of speaking to which the oppressor himself lacks access.

This chapter explores some of these less overt skirmishes in the battles over sexuality, and especially how homosexuals more celebrated than Agnello have exploited invisibility in their writing. In fiction, evidence of homosexuality is usually sought in characters, plots, and settings that explicitly represent sexual difference. My analysis, however, focuses on the language itself, turning from the visible to the verbal, from homosexual narratives to homosexual dictions, rhythms, rhetorics. The sexual character of language is rarely direct, and post-Stonewall criticism has occasionally stigmatized such writing as "closeted." But just as invisibility does not impede all forms of speech, so the refusal to identify one's personal interests can facilitate other kinds of gay statements.[2] The verbal jockeying for position that characterizes the brief exchanges among Agnello, the police, the mugger, and the girls will reappear throughout this study of popular discourse among gays and straights. Like Agnello, gay writers found in certain linguistic strategies a voice of their own long before sexuality was spoken of openly. And like the UPI reporter, straight readers responding to this voice can unintentionally find themselves speaking someone else's language. Only by charting linguistic sallies across such indistinct cultural borders can we understand the complementary processes by which homosexuals and heterosexuals together create meaning, and distinguish what is truly hidden from what is simply unseen, that

which is never spoken from that which is seldom heard.

Camp Crossing

Camp is the best-known gay linguistic style, occupying within male homosexual culture roughly the same position as "playing the dozens" or "signifyin'" within African American culture. A complex of loosely defined theatricalisms, camp imitates the hyperbole of musicals and popular movies as well as other visual extravagances like overstated decor and fashion, and especially cross-dressing. In its verbal forms, it favors quotation, mimicry, lip-synching, gender inversion, trenchant put-downs, and bad puns. Between World War II and Stonewall, such theatricalisms were epitomized by the stylized performances of gay drag queens. The most influential definition of the phenomenon was offered by Susan Sontag in her 1964 essay "Notes on Camp." Here Sontag identified camp as a variety of pure aestheticism, which uses artifice and stylization to empty the world of content. Seeing "everything in quotation marks," camp thrives on exaggeration, theatricality, travesty, and the glorification of character. Though serious in rejecting traditional aesthetic judgment, it is a "sensibility of failed seriousness, of the theatricalization of experience."[3]

Sontag's reading has been criticized for overstating the aesthetic dimension of camp. To clarify the phenomenon's relation to other postmodern styles she thought resistant to interpretation—Barthesian semiology, Artaudian Theater of Cruelty—Sontag understated its relation to the gay community. Although quotations from Oscar Wilde introduce each new section of the essay, homosexuality, whether Wilde's or anyone else's, is not mentioned until the final pages of the piece. In de-homosexualizing camp, Sontag also de-politicized it. Separating camp from the cultural conditions that fostered it, she obscured the specific problems of ostracization and invisibility the style was created to address.[4]

Sontag's account is surely incomplete. Yet critics have found it difficult to say exactly what is wrong with her argument. In delineating a definitively homosexual history of camp, gay theorists can seem to engage in turf war. It is impossible to prove who "owns" camp. One's answers always depend on how the phenomenon is defined: those

who include in camp Bellini's *Norma* or London's Carnaby Street offer very different genealogies from those who see camp only in explicitly gay activities. The very language of "ownership" is dangerous. What begins in acceptance, acknowledging participation in a style, ends in aggression, claiming camp as a possession. Demonstrations of how a particular ironic style functioned in a certain way for the gay community tend to internalize camp as something more fundamental—a "natural" part of the gay sensibility. One is left with paradoxical questions about what happens to camp when it travels outside its gay origins—what camp is when it's not at home—without ever clarifying what it might mean to call a word, a gesture, or a punchline "gay."

Although correctly identifying the limitations of Sontag's formulations, her critics may misrepresent both her project and their own. To understand more neutrally what is at stake in these ownership debates, I wish to turn to a roughly contemporary use of camp—in *Who's Afraid of Virginia Woolf?* From the profanity of its opening line "Jesus H. Christ," Edward Albee's 1962 play assaults audiences with a hyperbolic account of sexual tensions in a quiet academic community. Yet one aspect of this assault is as striking for its form as for its intensity. Having established only the characters' names and the late hour, Albee begins the first of many fights that occupy most of the play's dialogue. Looking around the room, Martha "imitates Bette Davis" with the line "What a dump."[5] She then browbeats her weary professor husband for not remembering the name of the film in which the line appears.

> MARTHA: Nobody's asking you to remember every single goddamn Warner Brothers epic . . . just one! One single little epic! Bette Davis gets peritonitis in the end . . . she's got this big black fright wig she wears all through the picture and she gets peritonitis, and she's married to Joseph Cotton or something [. . . .] and she wants to go to Chicago all the time, 'cause she's in love with that actor with the scar [. . . .] She sits down in front of her dressing table . . . and she's got this peritonitis . . . and she tries to put her lipstick on, but she can't . . . and she gets it all over her face . . . but she decides

> to go to Chicago anyway, and. . . .
> GEORGE: Chicago! It's called *Chicago* [. . .]
> MARTHA: Good grief! Don't you know *anything*? *Chicago*
> was a 'thirties musical, starring little Miss Alice *Faye*. Don't
> you know *anything*? (pp. 3-5)

The squabble introduces the tensions in George and Martha's marriage, and some subtexts of the exchange—about knowledge, age, illness, the lure of the city—resurface throughout the play. Yet on a more literal level the fight is surprising. We are asked to believe that Martha prides herself on her knowledge of movie trivia, although the references—to Bette Davis, Alice Faye, Joseph Cotton, *Chicago*, and an unnamed actor (David Brian) and movie (*Beyond the Forest*)—are not those traditionally associated with academia in the early 1960s. Nor is such an interest in keeping with Martha's own character. *Beyond the Forest* is just another B movie, neither a celebrated Davis performance, nor one of the films subsequently recuperated by auteur theory. Defensive of her intelligence as she later shows herself to be, Martha would be more likely to advertise her familiarity with the prestigious art films of the French New Wave or of Ingmar Bergman than with a "goddamn Warner Brothers epic."

The exchange works less to characterize Martha and her knowledge than to prepare the audience for the bantering wit that will dominate the evening's exchanges. That banter displays an inordinate fondness for popular culture, especially for female icons like Bette Davis and Alice Faye, and prizes commercialism over art, Warner Brothers over Metro Goldwin Mayer, and both over Bergman. This kind of low quotation was not in 1962 a well-known comic style. And the drawn-out nature of the exchange does more than externalize George's exhaustion and frustration with Martha's gamesmanship. It stands as a slowed-down version of this particular language game, a crash course in camp for those in the audience unfamiliar with the verbal style.

A more interesting version of camp quotation occurs later in the evening, when the audience is more familiar with the range of games these characters play. In the third act, called "The Exorcism," George

acts out a long ritual with Martha that ends in his exploding their shared fantasy of an imaginary son. Upon entering, to start this ritual, he carries a bouquet of snapdragons snatched from a neighboring flower bed.

> GEORGE: (*Appearing in the doorway, the snapdragons covering his face; he speaks in a hideously cracked falsetto*) Flores; flores para los muertos. Flores.
> MARTHA: Ha, ha, ha, HA!
> GEORGE: (*Affecting embarrassment*) I . . . I brungya dese flowers, Mart'a, 'cause I . . . wull, 'cause you'se . . . awwwwww hell. Gee.
> MARTHA: Pansies! Rosemary! Violence! My wedding bouquet. (pp. 194-95)

Again the emotional situation is straightforward. The couple uses humor to forestall or temper the brutal honesty that will leave them sadder but wiser at the final curtain. Yet the lines expressing those emotions do so only indirectly through parodic allusion. George quotes the street calls of the Mexican Woman from late in *A Streetcar Named Desire*, and his inarticulate accent in his next lines is probably meant to recall Marlon Brando's famous portrayal of Stanley Kowalski. The quotation is certainly ironic, a sneering reference to one of those forced symbolic moments that haunt most of Williams's plays (and are often cut by fastidious directors). Yet, though ironic, George speaks the truth: he is bringing flowers for the dead, or at least for the fantasy son whose imaginary death he will shortly announce to Martha.

Martha's response is more complex. Basically she lowers the stakes, countering his references to overheated Williams and Brando with an even less elevated allusion to Cole Porter and Patricia Morison. Her inappropriate comment about the bridal bouquet parodies the lead-in to a song from *Kiss Me, Kate*, Porter's musical reworking of *The Taming of the Shrew*. Mistakenly sent flowers by her former husband, Porter's heroine Lilli Vanessi exclaims, "Snowdrops, and pansies, and rosemary. My wedding bouquet. Oh, he didn't forget." She then confesses her lingering affection in "So in Love," one of those masochistic torch songs common in Porter ("So taunt me and hurt me, / Deceive

me, desert me, / I'm yours 'til I die, / So in love with you, my love, am
I"). Martha's reference to Lilli's undying love underscores her own
ambivalence toward George. Moreover, by changing the names of the
flowers to include the pun on violets and violence, Martha superim-
poses on Porter one of Freud's famous dream readings. Her goal is not
to reveal unimagined depths in Porter but to reduce Freudian sym-
bolism to Broadway sentimentality. This shrew, Martha warns, is not
to be won with pansies and psychoanalysis.

As in the play's opening, the oddity of this exchange of quotations
lies less in its emotions than in the theatricalized context within
which those emotions are expressed. But in this passage the audience
stands in a different relation to that theatricalization. Earlier the
spectators were outside the games, trying to learn the rules. Now the
audience plays along with the characters, understanding or at least
admiring the stylization. By this point, we take for granted the
improbable premise that academia is a world replete with references
to musical comedy and bad imitations of Davis and Brando, where
intelligence is measured not by the ability to understand Freud but by
the need to burlesque him. The self-consciousness of the couple's per-
formance does not mark their maladjustment. Unlike the Bette Davis
parody, which called attention to itself, this later set of quotations
passes virtually unnoticed as part of the characters' natural way of
speaking. We lose patience with the play's other two characters pre-
cisely because of their inability to keep up with the verbal vaudeville.

Throughout the performance Albee has trained his audience to
accept highly artificial camp exchanges as a "natural" mark of intelli-
gence and emotional depth. But what, other than easy laughs, does
such camping accomplish? The dialogue's camp elements were initial-
ly read against the play by critics. Albee's own sexual identity had long
been an open secret. It was claimed that his negative picture of mar-
riage reflected the gay man's traditional hatred of women, and that the
characters in the play were better understood as gay men than as het-
erosexual couples. A milder version of this charge argued that gay
men's relations to straight society are entirely confrontational and that
their vengeance takes the form of elevating style over content, using
poetry and wit to mask a destructive negativity.[6] The attacks primar-

ily marked critics' homophobic fear that there were too many gay playwrights on Broadway. Yet the play slanders marriage and Martha only for those who themselves idealize marriage and fear strong women. The objection does not make sense even on its own terms: not only do Martha and George play no more convincingly gay than straight, but a homosexual reading can make little of the masculine infidelities and false pregnancies of Nick and Honey, the play's other couple.

It is imprecise to attribute the humor to either script or characters. Albee's story is not camp. However excessive its length or language, *Who's Afraid of Virginia Woolf?* is essentially a well-made family drama in the high moral tradition of Henrik Ibsen, Eugene O'Neill, and Arthur Miller. It could be more justly criticized for having too much content than for having too little. Nor do the characters camp. Although Martha may on occasion sound like a drag queen, her quotations are not camp irony but realistically convey a true emotion. Even her initial "what a dump" describes her actual dissatisfaction with her environment, not a theatricalized relation to Davis as icon. Similarly, George's quotations may deflate straight masculine assumptions. But they do so entirely from within heterosexual behavior patterns, without reference to the supermasculine or effeminate models of the camp tradition.

Camp quotation in the play is itself camped, performed "within quotation marks" as a formal device, but emptied of its customary meanings and used for purposes not common in the gay tradition from which it derives. Yet it is unclear what new social functions Albee substitutes for camp's traditional ones. Martha's fixation on *Beyond the Forest* seems unmotivated. How many women actually do Bette Davis imitations? Martha is not even imitating Bette Davis herself. In *Beyond the Forest* Davis just says offhandedly, "What a dump." It is only later drag performers who overemphasize the words' final consonants to turn the line into an all-purpose Davis imitation ("Whah tuh dum-puh"), and Martha's delivery owes more to Charles Pierce than to Davis herself.

Although focused on different elements, George's performance also stands in ambiguous relation to gay camp. *Streetcar* is of course more

highly valued than *Beyond the Forest* or *Kiss Me, Kate*, and his allusions might appear purely academic, roughly comparable to quotations from Shakespeare or Wordsworth. Yet like most camp quotation, George's use of *Streetcar* emphasizes its inapplicability rather than its relevance. His only precise quotation, of the Spanish lines of the Mexican Woman, crosses gender lines and is delivered in the "hideous" falsetto sometimes employed in drag comedy. The references to Brando are less explicitly camp. Unlike Davis, Brando is not a figure of drag parody and, though famous for his Stanley, his mythic stature is associated more with lines from later works—"I coulda been a contender" from *On the Waterfront*, "I'll make him an offer he can't refuse" from *The Godfather*, even "Pass the butter" from *Last Tango in Paris*. Yet if imitations of Brando are not inherently camp, George does offer his as such, emphasizing less the performer's worth than his excesses.

At this point one must concede that the homophobic critics are half-right to attend to the gay dimensions of the play. While *Virginia Woolf* is not a play in drag, drag styles do serve as touchstones against which to measure the more idiosyncratic games of George and Martha, and the audience must know a great deal about gay culture to make those comparisons. Martha's imitation of Bette Davis is funny only if viewers remember that other (gay) imitators have preceded her. When Martha camps as a straight woman, the audience should recognize the act as more commonly gay, think about gay camping as a social response to cultural disempowerment, and wonder whether Martha's low quotations involve a similarly oppositional stance towards power. So George's more sedate imitations ask viewers to think about the ways in which his timidity overlaps with gay behavior—whether parodies of Brando's brutishness protect him from fears of his own weakness and effeminacy, as some gay camp will stigmatize conventional masculinity as "butch."

While nothing in the plot, characters, or setting of *Virginia Woolf* is gay, its linguistic games are in dialogue with gay camp humor. A similar dialogue between gay and straight cultures underwrites what Sontag does with camp two years later in her "Notes." Both Albee and Sontag decontextualize camp, removing it from its customary home in

the gay drag review and allowing it to "crossover" into straight culture. That these two different translations are subsequently charged with complementary forms of malfeasance—Albee with homosexual proselytizing, Sontag with homosexual erasure—suggests the real problem is not sexuality but cultural transportability. The transformations are not intellectually compatible. Albee's crossover seems largely a comic effect, implying the interchangeability of gay and straight cultures. Indifferent to sexuality, Sontag wishes to annex camp to a larger theoretical project, dignifying camp through semiology and shoring up semiology with camp. Both uses are plausible, and neither necessarily denigrates sexuality. Yet to understand the implications of such shifts and shorings we need a more general sense of the history of boundary-crossing within gay humor—a transgressive tradition in which Sontag and Albee's transformations are comparatively late events.

Camp as Class: Crossing in England

The prehistory of camp has been traced back at least to the seventeenth and eighteenth centuries. Where precisely camp originates depends on how the phenomenon is defined. Those who see its irony as an assault on mainstream culture locate proto-camp gestures in the transvestitism and the mock birthing rituals of the (subcultural) molly houses. Those who do not see it as an oppositional standpoint find its antecedents scattered throughout culture—from *bel canto* Druids to the domesticated foliage of the landscape garden.[7] By the late nineteenth century, however, a particular version of this humor was associated with the "homosexual" subculture beginning to arise at that time. The most powerful literary voice in this subculture was of course Oscar Wilde, and his epigrams are the distant model for what in the twentieth century would become the camp irony of the drag review. Yet an explicit identification of homosexuality and camp was politically impossible for Wilde. And it was only later generations that would make the style a code for homosexuality itself.

The most celebrated equation of homosexuality and stylization was associated with Ronald Firbank. In novels like *The Flower Beneath the Foot* (1923) and *Concerning the Eccentricities of Cardinal Pirelli* (1926), Firbank joined aristocratic characters, exotic settings, and thinly plotted

comedies of manners to showcase an artificial, highly stylized prose. The works are mainly gay by association. In *Inclinations* (1916), to be sure, Miss Geraldine O'Brookomore inclines primarily to Miss Mabel Collins, and one of Pirelli's "eccentricities" is his nude pursuit of the choirboy "Chicklet" throughout the cathedral on the night of his death. But other plots imitate traditional heterosexual stories, like Laura Lita Carmen Étoile de Nazianzi's flight from his Weariness Prince Yousef into the Convent of the Flaming-Hood in *Flower*. And some, like Sally Sinquier's aspirations to the stage in *Caprice* (1917), have no sexual component whatever. Moreover, Firbank's situations are so sketchy and his characterizations so hyperbolic that one gets little sense of specific social dynamics. If mentioned at all, sexual identity is not perceived realistically, but offered as merely one more example of a generalized exoticism. Homosexuals become just another incarnation of extravagance, identical to princes, prelates, or actresses.

Although Firbank's plots and characters are not essentially gay, they have come to be read as such, in a way that even Wilde's work has not. Despite his coded references to implicitly gay topics—excavations of the ancient city of Sodom or displays of statues of the *Lesbia of Lysippus*—Firbank's supposed gayness is located more regularly in his use of language. While Firbank's fondness for descriptive names has antecedents in morality plays, Restoration comedy, and even Charles Dickens, the languor of his choices—"her Gaudiness the Mistress of Robes"—and their mock Catholicism—"Pope Tertius II"—has been read as effete and effeminate. Similarly, Firbank's humor looks back through Wilde to the best of comedies of manners in Shakespeare, Sheridan, or Austen. But the jokes do not often aspire even to the epigrammatic high polish of Wilde. Some engage in a mild form of gender inversion. His assertion that "alone unchanging are women's ambitions and men's desires" reverses the traditional association of men with ambition and women with emotion. More common, however, is the self-consciously facetious observation: "Oh, the charm, the flavour of the religious world! Where match it for interest or variety!" Nor is Firbank above the pedestrian pun: one character is reminded "of the time when Anna Held—let go."[8]

There is no reason to suspect that stylized sophomoric humor is inherently gay. But one can imagine how such a flagrant parody of heterosexual mores might function within the gay subculture—reinforcing the self-esteem of those who thought their nontraditional sexuality a rebellion against the conventionalism of late Victorianism. Even if gay self-affirmation was not among Firbank's original intentions, it became one of his meanings for subsequent generations of readers. Whatever the gay coding of the actual works, Firbank himself was so coded to become, like an earlier generation's green carnations, a watchword of the gay community. An appreciation of him became the litmus test both of one's sexuality and of one's allegiance to the dandyism of post-Wildean homosexuality. When gay poet W. H. Auden announced that "a person who dislikes Ronald Firbank may, for all I know, possess some admirable quality, but I do not wish ever to see him again," his statement was not an aesthetic judgment. It was a declaration of community solidarity, itself couched in a blasé diction more customary to Firbank than to Auden himself.[9]

Even more revealing is a complementary rejection of Firbank by Ernest Jones (the literary critic, not the psychoanalyst). "Sex, for Firbank, was always a matter for comedy; but just as in life his infantilism betrayed him into preposterous affectation, in his novels the comedy of sex is too frequently marred by an almost obsessional bravado and schoolboy snickering. The world of his fiction, with its international elite and its splendid palaces, is a Nirvana in which homosexuals are the ultimate chic, and in which, as in *Le Temps Retrouvé*, almost everyone turns out to be at least bisexual."[10] The passage bristles with its own defensiveness. It desires simultaneously to take Firbank seriously and to trivialize him, to dignify him as pathological (obsessional and infantile) and to reject him as insignificant (schoolboy and preposterous). But more important, Jones characterizes as particularly homosexual many conditions—internationalism, elitism, aristocracy, orientalism—not exclusively associated with sex in either Firbank's novels or modern culture. The parting irrelevant comparison of this wafer-thin stylist to the monumental Proust only reaffirms how fully Firbank stands for Jones as epitome and synecdoche for anything gay. By this reading Prince Yousef's

weariness is as homosexual as Cardinal Pirelli's pederasty.

Firbank's direct influence was limited by his decision to write for a select, though not sexually defined, audience. In the works of English authors like Evelyn Waugh, Christopher Isherwood, E. M. Forster, and perhaps even Henry James, camp style percolated into mainstream fiction disguised as an aristocratic mannerism. In Waugh the influences surface in characterization and comic dialogue borrowed from Firbank; in Isherwood, in a more general preoccupation with flamboyant characters, especially women. Forster's debt to camp is deeper and more complicated. His masterpieces *Howard's End* (1910) or *A Passage to India* (1927) subordinate comedy to high moral seriousness. But the earlier novels, like *A Room With A View* (1907), employ, to a limited extent, the same camp exaggeration of names and melodrama that Firbank would later push over the edge. It is at least difficult to tell the difference between Forster's romance novelist Miss Lavish in *Room* and her even more fatuous incarnation as Miss Chilleywater in *Flower*.[11]

On stage the parodic style of camp permeated the commercial work of Noël Coward and to a lesser extent Terence Rattigan. Here again artificial dialogue and overwrought emotions were offered as an adoring evocation of upper-class culture. Yet the humor owed as much to sexuality as to class. As a joke, Coward's notorious putdown "Very flat, Norfolk" was more akin to Firbank's "Anna Held—let go" than to anything Coward heard dining with the aristocracy. Although *Private Lives* is not enriched by overreading the camp rhythms in Coward's dialogue, gay audiences were surely amused by the duplicity of Coward's theatrical language. At least they openly jeered if Coward's persona turned too univocally heterosexual. When he appropriated Forster's phrase to sing of domestic bliss, Coward's wish for paternity in his "Room With A View"—the last verse's hope that "Maybe the Stork will bring / This, that, and t'other thing / to / Our room with a view"—drew snickers from knowing audience members.[12]

H. H. Munro attempted a more complicated assimilation—using the association between class and camp to attack both the social and sexual hypocrisy of the English upper classes. Munro is best known for macabre stories with bone-dry narration and deadpan endings,

tales in which ravenous beasts and murderous infants stalk the English countryside. Usually marginalized as a children's author, an upscale O'Henry or a sane Poe, he is actually more of an inverted Kipling, using adolescents to expose the rot in Edwardian imperialism. His earliest works simply transcribe camp patter as prose narration. Subordinating plot to voice, Munro revisited the literary landscape of Henry James in the company of a dandified narrator, who makes the garden party an occasion for epigrams on everything from marriage and death to cravats and chocolate-creams. With a pseudonym drawn from Edward Fitzgerald's homoerotic translation of *The Ruba'iyat of Omar Khayyam*, Munro as "Saki" embraced the sexual stigma attached to such allegedly effete topics as attire, appearance, age, and appetite, and in collections like *Reginald* (1904) and *The Chronicles of Clovis* (1911), constructed stories out of camp "dish." Though presumably Reginald and Clovis Sangrail are both in their mid-twenties, neither narrator admits to being out of his teens, for, as Reginald insists, "To have reached thirty . . . is to have failed in life."[13] Reginald's cosmetics are such that "his right eyebrow was not guaranteed to survive a sea-mist" and when told that boys used to be "nice and innocent," he confesses, "Now we are only nice. One must specialize in these days" (p. 14). Although less explicitly sexual, Clovis displays a skepticism about marriage and fidelity filched from Wilde, as in his epigram that "brevity is the soul of widowhood" (p. 107). His dietary declaration—"You needn't tell me that a man who doesn't love oysters and asparagus and good wines has got a soul, or a stomach either," (p. 106) not only flirts dangerously with sexual allegory; it does so in the same blasé cadences with which Auden will later endorse Firbank.

The Reginald and Clovis stories are merely strings of one-liners and bad Firbankian puns—like the "What did the Caspian Sea?" with which Reginald trivializes the Crimean War (p. 14). Saki pushes sexualized camp further in his gothic tales. In the werewolf story "Gabriel-Ernest" (1910) a young man discovers a younger one lying nude in the forest.

On a shelf of smooth stone overhanging a deep pool in the

> hollow of an oak coppice a boy of about sixteen lay asprawl, drying his wet brown limbs luxuriously in the sun. His wet hair, parted by a recent dive, lay close to his head, and his light-brown eyes, so light that there was an almost tigerish gleam in them, were turned towards Van Cheele with a certain lazy watchfulness. (p. 64)

The prose is shockingly sensual for the customarily flippant Saki, and much of the tale's irony grows from Van Cheele's obsession with the boy's animalism, epitomized on the one hand by his continual nudity and on the other by his cannibalistic taste for "child-flesh." The middle of the tale is bad boulevard comedy, as Van Cheele introduces "Gabriel-Ernest" to his aunt in the morning room while trying to explain away the boy's nudity. The story ends ghoulishly with the town's honoring Gabriel-Ernest as heroic martyr; they think the werewolf drowned trying to save a Sunday-schooler it has in fact eaten. Camp understatement reasserts itself in the story's final admission: "Van Cheele gave way to his aunt in most things, but he flatly refused to subscribe to the Gabriel-Ernest memorial" (p. 69).

As always in Saki, the story is a trick in both tone and plot. But here the trick—that the werewolf is the hero—disguises more interesting ambiguities about desire. At the climax, Van Cheele wonders how to avoid the impending slaughter of his aunt's Sunday school. "He dismissed the idea of a telegram. 'Gabriel-Ernest is a werewolf' was a hopelessly inadequate effort at conveying the situation, and his aunt would think it was a code message to which he had omitted to give her the key" (p. 68). Yet, as Saki invites us to realize, the statement *is* a code message. Van Cheele's fascination with the nude sixteen-year-old, like the werewolf's love of tender infants, stands in for homosexual desire. Far from rejecting that fascination, the story insists that readers share it. The narrative fixates on the genitals that Gabriel-Ernest barely hides behind the *Morning Post* when meeting the aunt. Little sympathy is wasted on the innocent town, aunt, or devoured infants, all of whom are stock figures recycled, like the werewolf's name, from Wilde's *Importance of Being Earnest*. And Van Cheele's final refusal to participate in the town's canonization of Gabriel-

Ernest marks not only his moral horror but also perhaps his hope that the werewolf still lives.

"Gabriel-Ernest" is one of Saki's more emotional tales—an implicit reworking of pederasty as pastorale. Equally ambiguous, though less emotional, are the anthology pieces for which Saki is most famous— "Sredni Vashtar" and "The Open Window." Though universally admired as ironic miniatures, the stories are difficult to categorize— unscary ghost stories or anti-psychoanalytic accounts of child psychology. The understatement of these narratives works against what they apparently set out to achieve. The result is a species of children's camp, where inexperience rather than aestheticism accounts for the disjunction between tone and content and where the tension between heterosexual conventionality and nontraditional sexual urges marks the failure of Edwardian society. "Sredni Vashtar" (1911) is the more explicitly rebellious. Ten-year-old Conradin hates his cousin-guardian Mrs. De Ropp and idolizes his hidden pet, a ferret he worships as "Sredni Vashtar." Inevitably the idol and the enemy meet offstage in a battle of which the only marks are long stretches of silence and the "dark wet stains around the fur of jaws and throat" as the victorious ferret slips into the bushes (p. 140).

The story might be read as a straightforward oedipal allegory of sexual awakening in which a youth fights an oppressive adult to escape from social conventions into healthy sexuality. Yet the sexual symbolism is intentionally skewed. The location of villainy in the female rather than the male is unusual. The misogyny of the story is not perhaps greater than that of most fairy tales—say "Hansel and Gretel" or "Cinderella." Yet Conradin's hostility is explicitly associated with a sexual fastidiousness uncommon in folk tales. The cousin is not only ostracized as "The Woman" but stigmatized as "unclean" (p. 137 et passim). The only male figure of note, a doctor who supports the guardian's tyranny, is rejected as effeminate, "silky and effete" (p. 136). Even the ferret is an odd emblem for Conradin's awakening sexuality, simultaneously penile and furry.

The story's refusal of its own symbolism is matched by its equally odd unwillingness to take seriously its psychology. Saki's children succeed in their mean-spiritedness, their refusal to display either

Victorian innocence or the bully-boy enthusiasm which Kipling offered as corrective. The psychological truth of "Sredni Vashtar" lies in the child's obsession with his animal. Yet in Saki obsession is not attended by passion. Unlike more sympathetic accounts of idolatrous children—say, Henry James's "The Turn of the Screw" (1898) or D. H. Lawrence's "The Rocking-Horse Winner" (1926) —Saki's narration distances the reader from Conradin's fevered thoughts by describing them in the deadpan rhythms of camp. While Conradin anxiously awaits the outcome of the final battle, the narrator quibbles, ". . . the minutes were slipping by. They were long minutes, but they slipped by nevertheless" (p. 139). Earlier in comparing the ferret to a chicken with which Sredni shares his shed, the narrator explains, "The Houdan hen was never drawn into the cult of Sredni Vashtar. Conradin had long ago settled that she was an Anabaptist" (p. 138). As the narrator admits in the next sentence, a ten-year-old boy cannot really understand a joke about Anabaptists. But the narrative does, and under the guise of exploring a boy's mind the narrator offers camp put-down.

The tonal ambivalences are clearest in the tale's final scene: Conradin's eating toast while the servants work up the courage to tell him of the bloody death of his guardian. The moment reverses the traditional resolution of the sexual awakening motif. Once liberated, rather than lighting out for the territories, Conradin leaves the countryside to Sredni, while he stays indoors and takes tea. The scene also overturns another truth of popular psychology—that a strong mother-fixation results in effeminacy. Conradin's escape from female oppression liberates him not from homosexuality but into it. For all the sexual murkiness, by the end of the story the improbably named Conradin has grown not into a Laurentian free-spirit but into a self-possessed young aesthete—buttering his toast with the same sexual defiance with which Wilde's Algernon consumed cucumber sandwiches.

An even more painful examination of adolescent sexuality lies at the center of Saki's most popular work—"The Open Window" (1914). Unlike much Saki, this ghost story is not campy in its references, tone, or diction. The nervous young Framton Nuttal pays a first visit

to his country neighbors. Here the fifteen-year-old Vera warns Framton about the horrible deaths of her uncle Mr. Sappington and two other men in "a treacherous piece of bog," and about her aunt's delusion that the men will some day return through the French window that she always leaves open (p. 260). Framton is panic-stricken when Mrs. Sappington does speak as if her husband's return were imminent, but even more terrified when the three men enter through the window. The story ends with Vera, whose "specialty" was "romance at short notice," concocting an improbable explanation for Framton's rapid departure (p. 262).

The story's ironies are obvious and mechanical. Vera's self-possession and Framton's nervousness are so carefully established that only the slowest readers credit Vera's overstated account. There is no horror to her gothic inventions about "treacherous" bogs, and the real surprise would be if the three men failed to reappear. The tale's characterization is as perfunctory as its plotting. Vera is simply a precocious brat, taking advantage of her guest's social inexperience and psychological instability. And the potentially sympathetic Framton is repeatedly mocked by a narrator who sneers, for example, that the young man "laboured under the tolerably wide-spread delusion that total strangers and chance acquaintances are hungry for the least detail of one's ailments and infirmities, their cause and cure" (p. 261). At best, the narrative's smugness dramatizes the complacency of the genteel society it satirizes; at worst it merely internalizes it.

What saves the story from simple mean-spiritedness is the tension between its studied cleverness and the social situation it depicts. Beneath the cheap jokes about bored hostesses, unwelcome guests, and muddy hunting dogs lurks a sardonic revision of the coming-of-age ritual of courtship. In the traditional courting narrative, a spirited young couple overcomes the objections of her skeptical parents. Modern variations sometimes differentiate between the bride's confidence and the groom's nervousness, between her father's reluctance and her mother's eagerness. In feminist revisions—most famously Sarah Orne Jewett's "A White Heron" (1886)—it is the girl who feels the suitor's attentions as a sexual threat, symbolized in Jewett's story by the suitor's phallic rifle and his desire to trap the girl's beloved heron.

Despite its structural similarities to this tradition, Saki's story is about courtship only to the extent that no courting occurs. Framton's visit lacks the sexual threat that such a call might normally occasion. The adults blithely leave the teenage Vera alone to "amuse" the strange young man, though social convention would require a chaperon. This very absence of threat activates the sexual clues elsewhere in the narrative. Framton's nervousness and his social gracelessness operate as emasculating motifs that suggest not simply his unsuitability as a suitor but his ineffectuality as a heterosexual. Most obvious is his connection with the rest cure, associated in the late nineteenth century almost exclusively with women. Yet though his presumed homosexuality renders him harmless, he is vilified by the other characters far more than his mild character warrants. Not only is Vera's lie about the window cruel. Her final story imagines for him a particularly violent end, hunted "on the banks of the Ganges by a pack of pariah dogs" and spending the night "in a newly dug grave with the creatures snarling and grinning and foaming just above him" (p. 262).

"The Open Window" moves in the opposite direction from most of Saki's stories. Usually in the tales, horrors are real and represent the seamy underside of Edwardian gentility. Within this violent world, sensitivity, intelligence, and extravagance of language often suggest homosexuality to be a viable cultural alternative. In "Window," however, horrors are fake, imagination adolescent, and sensitivity ostracized as sexually aberrant. Yet these differences may mark the story's particular power. The complacency with which the story reinscribes conventionality and banishes the homosexual represents in fact the tale's true terror. For readers attuned to the class and gender implications of Edwardian heterosexuality, the return of the hunting men at the end of the story can be horrifying—not because they were presumed dead, but because of their phallic power and privilege. Unlike Jewett's heroine, Vera aligns herself with her uncle's hunting guns against the sexually maladroit suitor. This choice suggests less her childish good spirits than a despairing acknowledgment of patriarchal oppression; her recognition that society makes women into open windows as well as blank pages. Her fury against the homosexual Framton signals her recognition that in some senses he has already won. Though not so free as Conradin, Framton is not so completely trapped

as Vera. And her playing at chasing away a harmless non-suitor only fore-shadows her eventual fall to heterosexual masculinity.

Camp without Class: American Crossings

Turn-of-the-century camp humor functioned initially as a private strategy to build gay self-esteem by mocking the traditional manners against which homosexuals rebelled. As it became more public, camp camouflaged its sexual connotations by aligning itself with more mainstream verbal traditions. In England, aesthetes and others pre-sented camp humor as a form of upper-class affectation. For some authors, like Coward or Forster, "aristocratic" camp reinforced class values. For others like Saki, it undermined them, embedding in a wry critique of class a denial of the moral superiority of the heterosexual mainstream into which it was crossing. In the United States, camp entered dominant culture by different routes. Knowing Americans' announced hostility to the elite, writers could not pass off gay hyper-bole as aristocratic hauteur. Instead they sought various other ways to accommodate the exoticism of the style.

One attempt, blending sexuality with race, offered gay camp as a black speech pattern. Carl Van Vechten was perhaps the key white male sponsor of the Harlem Renaissance. Starting as a journalist, he promoted the writings of such (then) unpopular authors as Herman Melville, Elinor Wylie, and Gertrude Stein, and was Ronald Firbank's chief American champion in the 1920s. Van Vechten's early fiction, including the Firbankian-titled *The Tattooed Countess* (1924), awk-wardly combined the stylish prose of his English mentor with social commentary drawn from American models, notably Sinclair Lewis and Theodore Dreiser. Only in his fifth novel, *Nigger Heaven* (1926), did style and social conscience coalesce into an aesthetically com-pelling (and commercially successful) work. To modern eyes Van Vechten's account seems inoffensive enough, a well-meaning though exoticizing introduction to Harlem culture, like rent parties or club life, and to the moral dilemmas, like passing, faced by the New Negro. Contemporaries, however, were suspicious of this intruder who, though a relative latecomer to a cultural "renaissance" that had been in full force since at least 1920, had managed to beat many more

knowledgeable black authors into print.

The novel's greatest insensitivity to the specifics of African American culture lies in its language. The title's "nigger" is only the most obvious of Van Vechten's verbal miscalculations. More often he fails not through appropriating black slang but through imposing Eurocentric literary effects on Harlem. The novel opens with a sensationalist depiction of a savage underworld that Van Vechten generally avoids in the narrative.

> Anatole Longfellow, alias the Scarlet Creeper, strutted aimfully down the east side of Seventh Avenue. He wore a tight-fitting suit of shepherd's plaid which thoroughly revealed his lithe, sinewy figure to all who gazed upon him, and all gazed. A great diamond, or some less valuable stone which aped a diamond, glistened in his fuchsia cravat. The uppers of his highly polished tan boots were dove-colored suede and the buttons were pale blue. His black hair was sleek under his straw hat, set at a jaunty angle. When he saluted a friend— and his acquaintanceship seemed to be wide—two rows of pearly teeth gleamed from his seal-brown countenance.[14]

This very Firbankian description is troubling from a number of angles. By beginning the book here, of course, Van Vechten foregrounds the very criminality downplayed elsewhere in his depiction of middle-class Harlem. His characterization of Longfellow as "lithe" and "sinewy" sexualizes the black body, a bestialization compounded by the inopportune use of the verb "aped." Yet most interesting is how this catalogue of dress carries different implications in Harlem than it does in the Firbank fairylands from which it derives. A color consciousness—of tans, doves, seal-browns, and especially fuchsias— which in Firbank is purely aesthetic in Harlem seems to mark the Creeper's skin color and his class. The same clothes that make Prince Yousef striking show the Creeper as vulgar.

Similar transformations affect Van Vechten's use of minimalist dialogue. In Firbank, elliptical dialogue is merely stylish, rarely individualizing the characters and never evoking more than the gen-

eral enervation of society. In Van Vechten, however, the same absence of individuating traits suggests the characters' hollowness. Especially in the novel's more lurid moments, minimalism seems to uncover the essential carnality of the black soul.

> I'd like to cut your heart out!
> Cut it out, Lasca, my own! It belongs to you!
> I'd like to bruise you!
> Lasca, adorable!
> I'd like to gash you with a knife!
> Lasca! Lasca!
> Beat you with a whip!
> Lasca! (pp. 252-53)

Van Vechten illustrates the difficulty American writers had making a space for gay material in the high literary traditions of the first half of the twentieth century. In adopting the high style of Firbankian camp, Van Vechten created a striking voice for his Harlem characters and a narrative more engaged than his previous, merely "charming" works. But the otherworldliness of that voice, when reapplied to a culturally specific situation, made that culture seem inconsequential. His transposition of gay verbal styles to ghetto settings reinforced racial stereotypes, further exoticizing and sexualizing African American culture. In popular genres, where the standards of excellence were not so high, however, the inconsistences that undermined more serious writing could work to an author's advantage. Exploiting mistranslation and inappropriate juxtapositions for their comic potential, artists less self-conscious than Van Vechten were sometimes able to incorporate camp motifs more extensively (and more innocently).

Popular song, for example, allowed elements of the camp sensibility to surface virtually unmasked. Not expecting songs to mean much of anything, no one seems to have thought seriously about their sentiments or situations. Noël Coward and Cole Porter wrote torch songs like "Mad About the Boy" or "Love for Sale" without anyone examining too closely the sexual dynamics of the ballads. More surprisingly, Lorenz Hart's "Johnny One Note" from *Babes in Arms* (1937) was so

enlivened by Richard Rodgers's uptempo musical setting and Hart's low rhymes that listeners ignored the lyric's meaning. An unsophisticated tenor for whom "holding one note was his ace" is a decidedly odd hero for a popular song. The lyric's contempt for its putative hero—who "Brought forth wind that made critics rave, / While Verdi turned round in his grave!"—targets the very tension in opera between dramatic integrity and exhibitionism that makes the form so amenable to camp appropriation. Hart's satire implicates the audience as fully as the inept singer. In criticizing the tenor's lack of subtlety, the lyric assumes the superiority of mimetic performance to entertainment, of artistry to audibility, of opera to other song forms. Such protestations to integrity were hypocritical from a Broadway show which had no interest in integrating plot and songs—least of all in the free-floating "Johnny One Note," which has no relation to the slight plot of *Babes in Arms*. And under the guise of an all-American celebration of the triumph of will over ability, Hart pandered to and exposed the prejudices of his profession and his patrons.

"Johnny One Note," though anticipating Terence McNally's more extended meditation on opera camp in *The Lisbon Traviata*, is an admittedly minor crossover. More important, because more widespread and influential, are those works that linked gay sensibility with female psychology. Questions of judgment and taste arise whenever authors create characters across gender. Not all readers feel that Hawthorne understood Hester's femaleness, or Flaubert, Emma's. Charges of overidentification as misidentification are even more pronounced against those gay male authors who favored strong female protagonists. The stylistic restraint of Marcel Proust, Henry James, and Christopher Isherwood is usually accepted as proof of these authors' objectivity. But authors writing more extravagantly—Tennessee Williams, William Inge or, of course, Edward Albee—are often accused of creating women who are only gay men in disguise. Not only did gay playwright John Van Druten, in *I Remember Mama* and *I am a Camera* triumph commercially with plays about marginalized women. In *Bell, Book, and Candle*, his 1950 fantasy about a secret New York community of witches, the coven's psychology so closely parallels that of the gay urban closet that "witchcraft" in the play

seems merely a euphemism for homosexuality.

A more interesting alliance between gender and sexuality was accomplished by Edward Everett Tanner III, who published under the pseudonym of "Patrick Dennis." Apparently writing the kind of 1950s sex comedies most closely associated with Max Shulman's *Rally Round the Flag, Boys* or *The Many Loves of Dobie Gillis,* Dennis revised traditional crossgender coding by locating the gayness of his novels not in the characters' psychology and social situations but in their verbal style and even physical appearance. The technique is most obvious in his 1961 travesty of the Hollywood star autobiography, *Little Me.* Here Belle Poitrine trumpets her dubious achievements as wife, mother, actress, and producer; the woman turned *The Scarlet Letter* into a campus musical. The text is filled with the customary coded references to homosexual culture. Poitrine's daughter attends a boarding school called "Radclyffe Hall," and Belle is accompanied in her rise to fame by two gay men, who, proclaiming her "empress" of Hollywood "queens," mischievously support her worst projects, like auditioning for *Alice in Wonderland.*

> . . . reliable old Dudley du Pont and Carstairs Bagley even telephoned to encourage me to take a screen test as Alice. "Belle, darling, it would be *the* camp of the year," Dudley said. "*You* be Alice and *we'll* be the queens. Do it with us, for laughs." Those darling boys were so gay, how could I refuse?

Although in 1961 none of this terminology was new, the homosexual slang terms "camp," "queen," and especially "empress" (queen of the transvestite "court") were unusual in commercial fiction. And Dennis's reference to homosexual men as "gay" may be one of the first explicit uses of this term to denote sexuality in heterosexually identified literature.[15]

The text is remarkable not only for its vocabulary. The very genre of mock autobiography internalizes camp's ambivalence about meaning— what is being satirized and for whom. The joke is superficially against Belle Poitrine herself, a self-proclaimed star who in fact never achieved celebrity. Yet finally the satire targets the pretensions less of its putative

author (or her real-life antecedents) than of its actual readers. The book offers itself as a piece of intellectual slumming, a star autobiography for those who would never read a star autobiography. By identifying the possibility of reading these autobiographies ironically, Dennis introduced to a general readership the possibility of camp reading that had accounted for the genre's popularity from the first. Belle Poitrine forces readers not so much to view stars with comic irony as to acknowledge that ironic distance has always been built into star idolatry.

The duplicity of the book's humor, and its origin in camp exaggeration, is most obvious in the more than 150 photographs by Cris Alexander that accompany (and virtually overshadow) the text. At their simplest the images are mere burlesques: actress Jeri Archer poses lewdly in dresses from the "Archer Archives of Outlandish Costumes" that recall their origins in the hyperbole of vaudeville and drag comedy. The cover photo burdens Belle with dripping jewels, an oversize champagne glass, and breasts barely contained by her bodice. The more sophisticated are second-rate matte jobs, half-heartedly trying to cut-and-paste Belle into Hollywood settings, just as her narrative ineptly weaves her non-achievements into the thread of pop history. The extravagant failure of the illustrations calls into question the very category of lifelikeness, and at its best anticipates the deconstructive self-reflexivity of postmodern photography. A luncheon photo with "Roz" Russell or a formal library portrait, with its flat (probably false) backdrop of books, suggests the staginess of all representations of friendship or domesticity. Just as Cindy Sherman's self-portraits place her in dialogue with contemporary icons of femaleness, so Belle's "snapshots" explode the clichés out of which we construct celebrity or indeed any narrative of self.

Yet Alexander's most complex images undo their own irony. In many of the male pictures, especially those of Belle's fourth husband, Letch Feeley, parody circles back to become straightforward representation. Under the pretense of satirizing the aging Belle's lust for young men, the text presents explicitly homoerotic images, familiar from physical culture magazines but previously absent in the mainstream press. The most famous of these—a production still from Belle's *Paradise Lost*—offers a nude, ecstatic Adam, all the more phallocentric for the out-

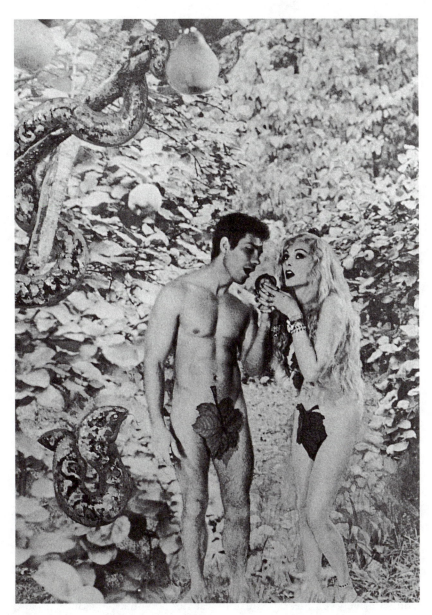

Figure 2: Lance and Belle as Adam and Eve (Cris Alexander, photographer).

landish fig leaf covering his crotch. [Figure 2] Far from distancing readers, these parodies are sexually arousing, and invite an inner circle of gay readers without fear of exposure to gawk at the bulging crotches and nude male rears. For this select audience, the whole narrative functions like the false dust jacket traditionally used to disguise the socially unacceptable "dirty" book.

Family Camp

Dennis's *Little Me* effected a triple crossover. In the 1950s and early 1960s, when star idolatry was common only in gay culture, the book argued that fame was worthy of more general (if comic) attention. Moreover, to valorize that celebrity, Dennis used a hyperbolic deadpan narrative until then restricted to drag reviews. And Alexander's images imported into the mainstream press photographic traditions previously considered pornographic. For its theatrical topic, its camp tone, and especially its racy photographs, the book found a place of honor in the libraries of many gay men, and continues to remain a cult favorite. Yet the effectiveness of the book's crossover was limited by its confrontational attitude toward traditional values. Too much an insider's joke, the book sold well in urban markets, but never captured a more general audience.

Dennis accomplished a more complete fusion of camp with mainstream fiction in the earlier *Auntie Mame* (1955), his perennially successful mock biography of Mame Dennis and her adventures educating her orphaned nephew Patrick out of his midwestern Presbyterianism into a recognition of the riches of life. Unlike *Little Me*, *Auntie Mame* does not question normative sexuality at the level of the narrative. While Belle Poitrine disarms moral judgment through her unnaturalness and artificiality, Auntie Mame ultimately speaks for tradition and decorum. At the core of the novel lies a gooey vision of familial support. Learning to love Mame, Patrick remembers, was comparatively "painless." Not only was her personality "seductive" and her "helter-skelter" charm "notorious." She was also the "first real Family" the "insignificant" ten-year-old had ever known. Her detractors saw Mame's enthusiasm for Patrick as just another opportunity to "meddle"; and Patrick himself condescends to what he suspects to

have been her "loneliness." But whatever the psychological sources of her affection, her "staunch, undependable dependability" made for a unique experience each was willing to call "love."[16] Although the adult Patrick distances himself from his youthful sentimentalism, his pronouncements about Family, love, and dependability are probably not disingenuous. Such moralizing does, however, appear too early (and flatfootedly) to have much effect on a text whose main focus lies elsewhere.

The sexual conventionality of plot and theme are most obviously undercut by the language and tone. Like *Little Me*, the novel is filled with coded references to homosexuality. Bohemianism and intellectualism in the book are defined by references to gay culture, and the list of Mame's heroes reads like a who's who of the homosexual elite: Ramon Novarro, Willa Cather, André Gide, Virginia Woolf, Marcel Proust, Cole Porter, Cecil Beaton, Christian Bérard, Gertrude Stein, and Virgil Thomson. In the most extended of these coded jokes, Auntie Mame's secretary Agnes Gooch is repeatedly introduced as her "Alice B. Toklas," as if such an attribution established the pure professionalism of the relationship. As Patrick reminds his aunt, Stein's interest in Alice extended beyond her secretarial skills: he repeatedly wonders what Mame needs a Toklas *for*. (p. 95). Sexual coding is occasionally couched in camp vulgarity. When only fifteen, Patrick dismisses the sexual voraciousness of one of Mame's admirers with a shopworn gay one-liner: "He's laid everything but the Atlantic Cable" (p. 118). It is even possible that the "auntie" ironically appended to Mame's name owes less to generational affection than to gay slang, where the term customarily identifies an older, timorous spokesman for community traditions.

Dennis often attributes the tension between straight text and gay subtext to the limitations of his narrator—his own alter-ego the adolescent "Patrick." Orphaned at an early age, Patrick needs to retell the story of his unsettled youth as a family narrative. He not only obsessively attaches the cloying familial adjective "auntie" to all references to his most unfamiliar of relatives, but compares each episode from Mame's escapades to "*Digest*" stories of an orphan raised by a sweet little New England spinster (p. 4). Although claiming to celebrate

Mame as a "madcap," by such comparisons Patrick actually tries desperately to write Mame back into a narrative of moral education. He would expand readers' sense of what can count as traditional without challenging the assumption that tradition counts. By Patrick's account, liberation comes to mean simply "true love": marriage to a likeminded liberal and the production of another generation of repressed children for (now Great) Auntie Mame to liberate.

Dennis does not in any simple sense support Patrick's utopian view of the family. What is regularly called "bohemianism" in the work stands as a covert attack on the nuclear family as the linchpin of heterosexism. If Belle Poitrine is blithely indifferent to the demands of marriage and motherhood, *Auntie Mame* is more openly critical. Mame's calling, after all, is to overcome the disastrous training of children's biological parents, while herself remaining conspicuously without offspring. The ominous claim that Mame is all the "real Family" that Patrick knows acknowledges not only the literal indifference of Patrick's father. It underscores the more symbolic absence of his mother, whose death in childbirth occupies one of the least emotional dependent clauses since Virginia Woolf executed Mrs. Ramsay in a parenthesis (p. 7). Mame's honorific "auntie" both affirms and denies her relation to family, while the ubiquitous comparisons to the New England "spinster" allude obliquely to the purported sterility (and probable lesbianism) of that figure.

Yet the irregularities of the text cannot be wholly attributed to the literary distinction between a savvy author and his priggish narrator. Both Patrick and Dennis use the concept of "eccentricity" to minimize the threat of Mame's anti-traditionalism. For Patrick, Mame's eccentricity means that despite her actions society's values will finally be reestablished. She merely stands as the temporary aberration against which we measure the norm. Even his sentimental account of her "helter-skelter" bohemianism ends in a reaffirmation of her underlying "dependability." Her "meddlesome" liberty and imagination camouflage more fundamental personal failures—like loneliness—and Patrick completes her life more fully than she liberates his.

If Patrick uses the concept of eccentricity to mute those aspects of Mame's morality that he finds troublesome, Dennis uses it no less

self-protectively to obscure her psychology and motivation. "Eccentricity" serves as the hollow explanation for why Mame does any of the things she does, and the woman herself becomes a cipher without past or future. In some senses the clearly reprehensible Belle Poitrine is the more likeable character; her greed and selfishness make for a coherent personality in a way that Mame's warm-heartedness does not. Not interestingly sexual even during Patrick's youth, the character of Mame becomes less human, more mythic in each successive episode, until at the end of the novel she transcends both gender and social situation. Her final appearance wrapped in a Indian sari heightens her androgyny and dissociates her from the American popular culture in which the novel began. In light of this transcendence, the novel's final claim that she is the (male) "Pied Piper" seems not only true but ominous.

Dennis's use of the concept of eccentricity to obscure the cultural origins of such behavior is a common technique in assimilationist minority literature. By convincing the dominant culture to read ethnicity as a species of eccentricity, minority authors have taught mainstream readers to accept as merely quaint or picturesque materials that might otherwise seem threateningly foreign. Such a noncombative approach seems today to reinforce ethnic stereotypes, and the works which attempted it—Leonard Q. Ross's *The Education of H*Y*M*A*N* K*A*P*L*A*N* (1937), Kathryn Forbes's *Mama's Bank Account* (1943), Betty Smith's *A Tree Grows in Brooklyn* (1943), Chin Yang Lee's *The Flower Drum Song* (1957)—are not generally admired by ethnic scholars.[17] Yet some special problems attend Dennis's refusal to identify the gay origins of his bohemia. Most obvious is the novel's duplicitous relation to class. In its celebration of tastelessness, camp humor presupposes the importance of taste; there is no joke in substituting low art for high unless everyone understands which is which. Although Auntie Mame regularly sneers at Patrick's trustee, her alternative to his "babbittism" is a connoisseurship as grounded in consumption as is his embrace of "class." The snobbery underlying Mame's liberalism is most evident in one of the most famous (and campiest) sequences in the novel—Mame's "puncturing" of Patrick's romance with Park Avenue debutante Gloria Upson. Mame's plan

depends on Patrick's recognition of the inadequacies of the Upsons' aspirations to style. Their Park Avenue address compares unfavorably to Mame's house on Washington Square; and all fashionable people are appalled by the Connecticut country retreat, where, as Mrs. Upson crows, downstairs is Sloane's and upstairs is Altman's (p. 191). Even the honey-laden Upson daiquiris that pursue Mame relentlessly through the engagement parties depend on class distinctions between acceptable drinks like martinis and Scotch and parvenus like the daiquiri.

The sequence tries to disguise the elitism of Mame's campaign against her prospective in-laws by equating the Upson's tastelessness with bigotry. Patrick rejects his fiancée not for her insipidity, or even her greed, but for her hostility to Jews. This shift of topics is revealing. There is of course no reason to equate shopping at Sloane's and B. Altman's with anti-Semitism; given the ethnic origin of the owners of those stores, one could even make a case that true anti-Semites shop elsewhere. When Claude Upson attacks the whole "lousy stinking race," Mame, with an odd literalism, objects that he can't really be so naive as to believe that the Jews are a "race." Such a defense concedes too much, allowing that racial stereotyping might be valid were the Jews properly a race. At least Upson's dismissal of Mame's "high-toned anthropology" recognizes the classist "toniness" of Mame's defense (p. 296). Similarly suspect distinctions inform the famous daiquiri joke. Claude learned the recipe from "this bartender, Wan"; later Mame offers to teach Patrick how to make a daiquiri "as Juan does" (pp. 193, 200). The distinction between Claude's ignorant "Wan" and Mame's "Juan" is an authorial sophistry. Claude's misspelling would not exist in spoken language, for "wan" and "Juan" are virtually homonyms. And under the guise of exposing Claude's racism, the author exposes as well his own class contempt for uncultured pronunciation.

Even more distressing than the novel's murky class politics is its ambivalence about the gay men whose humor it borrows. Mame's tolerance of homosexuals, like her championing of Jews, is meant to signal her liberalism. Again, the Upson sequence is most representative here. At her dinner party for the Upsons, Mame employs as

footmen two talented young actors—as "a camp" (p. 186). Later, to visit the Upsons in the country Mame cancels her weekend at Fire Island with some of "the most amusing boys" (p. 188). The sexual innuendos soon become explicit: when Patrick warns that the Upsons need not hear about her "queer" friends, Mame snaps back that she cannot be held responsible for the sexual preferences of her associates (p. 189). Her retort is surprising on at least three counts. The author's clear intent is to distinguish Mame's openmindedness from Patrick's priggishness. But in fact Mame is here at least as homophobic as Patrick. It is she who crudely reads a literal sexual preference back into an adjective by which Patrick means only "odd." Moreover, in denying her own responsibility she implicitly grants that homosexuality is the kind of thing for which someone must be held responsible. But most important, the whole exchange obscures the fact that, despite the text's frequent allusions to gay culture and here to Mame's gay "associates," we never actually see any gay people in the book. Dennis insists that Auntie Mame is the kind of liberal who would have gay friends. Yet he does not depict those men for fear that we might then think too much about the psychosexual tensions between gay men and the women who seek their company.

By removing his discourse from the specific sexual culture in which it has most meaning, Dennis presents characters who are not only sexually undermotivated but virtually incoherent. Such sexual incoherence is most evident in two unsuccessful sequences not retained in any of the novel's subsequent incarnations. In "Auntie Mame in the Ivy League," the episode just before the Upson engagement, Mame has an affair with one of Patrick's Princeton classmates, more than twenty years her junior, while Patrick is entangled with a vulgar waitress called Bubbles. The episode is unusual because it is the only time Mame (or Patrick) is depicted as engaging in sex. The denouement, in which Mame escapes detection because she is deemed too old to be an object of sexual desire, is simply mean. Old Casey, a night watchman of unnumbered years, recognizes "Miss" Dennis and begins to reminisce about the days when she came down to dances as a "girl." When Casey innocently assumes Mame now has daughters of her own coming to the dances, Patrick cruelly compounds the error.

In his telling, the fictive daughters of the chidless Mame, already themselves too old to dance, have settled complacently in Akron, Ohio, and made Auntie Mame into a grandmother (pp.175-76). The watchman's odd attribution of daughters to "Miss" Dennis may call attention to Mame's own anxieties about aging and reproduction; Patrick's humiliation of Mame clearly reveals the book's underlying prudery, its need to punish both Mame and Patrick not only for choosing inappropriate partners, but for having sex at all.

Even more sexually confused is the original version of the pregnancy of Agnes Gooch, Mame's secretary. In the sanitized theatrical versions, Gooch marries the unappealing father of her child. In "Auntie Mame on a Mission of Mercy," however, Mame takes the pregnant Gooch to Patrick's prep school, to seek Patrick's assistance in the delivery. Caught off campus by his corridor master Mr. Pugh, Patrick enlists the help of the sympathetic teacher, who finally marries Gooch himself. What is striking about this version is not its sentimental ending but the implications of the comic misunderstandings that forestall that resolution. First, there is the character of the teacher. "He was a long, lanky, old-maidish man of about forty with an Adam's apple as big as a duck egg and a passion for poetry and music and art and nature and children. Well, I guess I haven't made him sound very attractive, but he was a hell of a nice guy in a prim sort of way" (p. 131). The effeminacy of this characterization is reinforced by the scene in which Patrick discovers Pugh off campus after curfew, hiding in a ditch. Although the teacher claims to be watching for night birds, the inadequacy of his excuse invites the more customary explanation of sexual misdoing—the prep school teacher's traditional diddling with his male students.

Pugh's ambiguous sexuality is compounded by his unconvincing relation to the pregnant Agnes. Although here as everywhere in the novel the plot offers a traditional heterosexual reading, narrative irregularities invite us to read his interest otherwise—as a passion for Patrick displaced onto the more socially acceptable object of an unwed mother. His initial "cold" response to Gooch reinforces earlier hints of his sexual disinterest in women. He only begins to revise his opinion of Agnes when she identifies herself with Patrick, falsely

claiming to be "Mrs. Patrick Dennis" (p. 135). As Pugh warms, he tries to cheer Agnes about the future of her illegitimate child by mentioning famous bastards in history; his list is striking in that most of the illegitimates—like Leonardo da Vinci and Alexander Hamilton—are also famous homosexuals. The resolution—in which Pugh is "said to be" happy in his marriage—is complicated by his naming of Agnes's girl child with Patrick's name—Mame Patrick Dennis Burnside Pugh (p. 150). The irregularities of the Ivy League sequence suggest that, in pursuing his classmate, Mame may be indirectly fulfilling her desire for Patrick. The greater improbabilities of the prep school sequence place Patrick at the center of a passion not only incestuous but pederastic as well.

Other People's Voices

In the years between Ronald Firbank and *Auntie Mame,* straight culture was exposed to a considerable range of gay humor. By the time Susan Sontag and Edward Albee called attention to camp in the mid-1960s, they were not so much introducing the style into the mainstream as isolating and naming what had already been assimilated. Yet if in some respects the crossing of camp recalls traditional models of assimilation, in others it inverts them. Beginning, unlike race or ethnicity, as an invisible difference, camp is not absorbed by mass culture but becomes more identifiable after assimilation. The very notion of "camp" continues to group together as a distinct style characteristics scattered throughout culture. Many scholars suggest that attitudes adopted by both gays and straights are still profitably called "gay." By labeling that crossover a "queening," I even imply that assimilation transforms the (straight) culture more than it does the (gay) style.

These assumptions are not justifiable in any empirical sense: we do not know what would count as evidence in determining the cultural constitution of a style. Even could we agree on camp's initial gayness, the problems remain of whether such an identity persists after the style travels outside the community and of why it might do so. Despite a general suspicion that translation is always mistranslation, there is no consensus on what happens in transcultural exchange

when we take up other people's language. We may simply change others' words into our own. We may transform ourselves into those other people. Or somewhere between those two extremes, we may end up saying things other than we intend. The transformed statement may mean nothing, because the cultural conditions in which the statement made sense no longer pertain. Or it may mean multiple things, both what we intend and what they did.

That camp rhetoric does retain links with homosexuality is suggested by the vehemence with which mainstream uses of the rhetoric deny the connection. Attempts to incorporate camp motifs into a straight context are often accompanied by an overdefensive renunciation of homosexuality itself, and the subtle homophobia by which *Auntie Mame* disguises its gay allegiances mars most crossover literature. Truman Capote's *Breakfast at Tiffany's* (1958), for example, is sophisticated in both language and characterization. But in its desire to repress its debt to camp, it reproduces the insensitivity and sexual dishonesty of Dennis's more commercial work. Capote's heroine Holly Golightly, a teenage call girl, stands in a long line of strong women— Hester Prynne, Becky Sharp, Isabel Archer, Sally Bowles—who haunt the male literary imagination both gay and straight. But it is her language that most clearly links her to gay male culture. Like Mame (but unlike Sally Bowles) Holly speaks in the epigrammatic style of domesticated camp. Her outrageousness lies less in her actions than in her chatter, and what we remember from the story is her one-liners— about Maria Ouspenskaya, the "means reds," and breakfasting at Tiffany's.[18]

It is as an anxious denial of this narrative debt to gay camp that one must understand the story's gratuitous homophobia. The narrative itself avoids any direct consideration of homosexuality. The narrator is silent about his preferences and the nature of his attraction to Holly. Holly refuses to acknowledge that she earns much of her pocket money serving as "beard" for the gay playboy Rusty Trawler. When the subject of homosexuality is raised indirectly, both narrator and heroine turn defensive. Early in the novel the narrator reads a story about a female schoolteacher, who when her housemate gets engaged spreads an anonymous note attacking her. Given the plot's similarity

to Lillian Hellman's famous play *The Children's Hour* it is not surprising that Holly reads in the story a lesbian subtext; and the narrator's denial of this reading sounds disingenuous.

More striking than these denials of lesbianism are Holly's generalizations after the story.

> "Of course I like dykes themselves. They don't scare me a bit. But stories about dykes bore the bejesus out of me. I just can't put myself in their shoes. . . . Incidentally, . . . do you happen to know any nice lesbians? I'm looking for a roommate. Well, don't laugh. I'm so disorganized, I simply can't afford a maid; and really, dykes are wonderful home-makers, they love to do all the work, you never have to bother about brooms and defrosting and sending out the laundry. I had a roommate in Hollywood, she played in Westerns, they called her the Lone Ranger; but I'll say this for her, she was better than a man around the house."[19]

By post-war standards Holly's insensitive vocabulary and cultural stereotypes, like Mame's, seem innocent enough. What is surprising is the mere existence of the passage. Obviously Holly is denying some imputation against her own sexuality. Yet since no reader has ever actually accused the character of incipient lesbianism, the denial can only refer to the gay sources of her language.

Capote himself seemed to admit his subterfuge near the end of his career. His final unfinished work *Answered Prayers* (1987) is notorious for its tactless representations of Capote's society friends. But for those ignorant of (or uninterested in) his wealthy models, the real shock of the novel is Capote's honesty about the gay sources of the comedic voice that charmed the literary establishment in his early work. By offering society scandal in the jaded voice of homosexual hustler P. B. Jones, Capote drops any pretense to universality or cosmopolitanism and explicitly admits his debt to camp comedy. Camp governs the dialogue of "La Côte Basque," the tale of lunchtime gossip whose publication late in 1975 was considered a betrayal of his friends. Consider, for example, "Mrs. Walter Matthau's" account of a woman flirting with her husband.

"Lovely face. Divine photographed from the bazooms up. But the legs are strictly redwood forest. Absolute tree trunks. Anyway, we met her at the Widmarks' and she was moving her eyes around and making all these little noises for Walter's benefit, and I stood it as long as I could, but when I heard Walter say 'How old are you, Karen?' I said 'For God's sake, Walter, why don't you chop off her legs and read the rings?'"[20]

It is only a short leap from Holly's sprightly patter to the camp dish of *Prayers*—from the Lone Ranger to the redwood rings. And one suspects that society was outraged as much by Capote's homosexualization of the matrons' gossip as by his publication of their secrets.

It is not only closeted gay authors who feel compelled to suppress the homosexual elements of camp speech. Much self-identified "straight" camp similarly finesses the sexual implications of its representations. P. G. Wodehouse's dry dialogue exploits the apparent similarities between class and camp to obscure the implications of both. Comic effect in the Jeeves series depends on readers' repressing the novels' elitism and the homoeroticism of the Drones or of Bertie Wooster's subservience to Jeeves. Evelyn Waugh's attempt in *Brideshead Revisited* to be explicit about the sexual character of his comedies of manners not only dilutes his satire. It results in the offensive (even heretical) representation of the protagonist's love for a brother as the "forerunner" to his more mature love for the sister, with Sebastian playing a profane John the Baptist to Julia's Christ. And, while recasting Albee's bickering couple as homosexual professors, Simon Gray's *Butley* obscures their social-sexual relation, jumbling together quotations from T. S. Eliot and Mazo de la Roche to collapse the differences between gay camp and academic erudition.

Even more suggestive is the homophobia of some straight female camp. Fran Lebowitz's *Metropolitan Life* (1979) explicitly attempts to recast the gay wisecrack in a female (if not exactly feminist) voice. The self-consciousness with which Lebowitz examines the relation between women and gay men saves her from the subterfuges of Dennis and Capote. More troubling is Nora Ephron's *Heartburn* (1983), a comic reworking of Ephron's real-life breakup with her philandering

husband, Watergate journalist Carl Bernstein. Writing like Lebowitz in an epigrammatic, hyperbolic style associated with gay camp, Ephron wittily appropriates a male comic voice as a source of female power. Perhaps the high point of this appropriation comes when the heroine and her husband sing to each other songs about marriage. It is hard to believe that the sexist husband would be willing to engage in anything so unmasculine as singing Broadway tunes; and as with Martha and George, the traded quotations of pop culture seem more gay than straight.[21] Ephron's appropriation of camp rhetoric is accompanied by a surprising hostility to homosexuality. Rejecting lesbianism as an option, she quips, "Lesbianism has always seemed to me an extremely inventive response to the shortage of men, but otherwise not worth the trouble" (p. 63). The comment reproduces heterosexist assumptions that homosexuality results from the failure of heterosexuality and that lesbians lack the full range of sexual equipment while, in the dry understatement of the adjective "inventive," drawing from the very culture it demeans.

More graphic is the novel's rejection of male homosexuality. Midway through the book, Ephron's heroine doubts her sanity when she hears a blood-curdling scream in the middle of a quiet weekday afternoon. She recovers her sense of equilibrium after she finds the scream to be real, the death cry of a meek homosexual being brutally murdered by, in Ephron's knowing phrase, "rough trade" (p. 82). Somewhat envious of a man "so sexually driven that he might actually skip lunch—and after an auction!" nevertheless the heroine blames his death on gay sexual voraciousness—"this relentless priapism [that] is characteristic of the obsessive, casual sex that lasts so much later in the lives of homosexuals than in heterosexuals" (p. 83). Like the quip about lesbianism, this passage is an anomaly. The scene is disproportionately long, and its callous violence stands out in a novel whose climax involves nothing more forceful than a pie in the face. As always, it is hard not to read as strategic the tension between the use of gay humor (even vocabulary) and the indifference to gay death: the brutalization of gay culture permits the appropriation of its language without guilt.

Repressing their anxiety about the origins of camp, authors invite

that anxiety to resurface in the text in more homophobic ways. Although some decontextualization attends all cultural absorption, the process is particularly destructive to invisible subcultures, like homosexuals, for whom language is one of their few distinguishing marks. Transculturation not only fails to provide a new context by which to give gay words a straight meaning; in making contextlessness seem the meaning of camp, it implicitly denies the rhetoric's original oppositional function as a burlesque of heterosexual excesses and complacencies. To this extent, anxiety about the possibility of a gay language marks a greater unwillingness to accept the existence of homosexuality as culturally distinct.

Such doubts about the integrity of homosexuality as a minority culture are particularly evident within mainstream representations of social mobility. After World War II fantasies about transcultural movement were epitomized in "reverse-passing" narratives, like Laura Z. Hobson's *Gentleman's Agreement* (1947) or John Howard Griffin's *Black Like Me* (1960), in which a member of the dominant culture assumed a minority identity. There were no homosexual novels of reverse sexual passing—no "Gay Like Me"s—perhaps because the invisibility of homosexuality makes reverse passing too easy. Homosexuality played a crucial role, however, in a variation of reverse passing popular in the early 1990s, where mobility was represented in terms of the witness relocation programs of the federal government. In a comedy like *My Blue Heaven* (1990), the idea of changed identity just becomes an occasion for Steve Martin to demonstrate his mastery of comic accents. But more serious versions, like John Badham's comedy-thriller *Bird on a Wire* (1990), use the adventure narrative of the traditional road picture to reinvent an assimilationist myth of America as a land of opportunity for all.

Starring Mel Gibson as Rick Jarmin, an American forced to go underground as a result of countercultural activities in the 1960s, *Bird* follows Jarmin's retracing his former identities to discover clues about his betrayal by the FBI. This flawed narrative is a casebook study of cultural dislocation. Not only is its fraudulent nostalgia for the 1960s represented bizarrely by the Australian Gibson's affection for Bob Dylan's Guthriesque "Blowin' in the Wind" and Galt MacDermot's

Broadway "Aquarius." The very precisely identified locations—Manhattan, Detroit, St. Louis, Racine—are largely studio sets, with exteriors all shot in Vancouver, British Columbia. As the skewed chronology and settings imply, social mobility as relocation is a fantasy, requiring the geographic mobility and alternative career opportunities in fact available only to WASP middle-class male heterosexuals. Whenever Gibson returns to former jobs, he finds his minoritized co-workers—blacks, women, the aged—still stuck where he left them twenty years earlier.

The political lie of Gibson's mobility is faced directly only when the film treats minoritized homosexuals. In the sequence supposedly set in Wisconsin, where Gibson had worked as Matty Carlson, a hair stylist at "Raun's of Racine," Gibson is accosted by the remaining hair dressers—all of whom are gay males except for a lone black woman. When his co-star Goldie Hawn turns to him in disbelief and says euphemistically "You were a *hairdresser?*" Gibson replies, "Well, you don't get a lot of choice in the relocation game." The exchange is dishonest on two counts. First, choice is exactly what Gibson as white male does have, and what his minority friends lack. When rejecting his former gay lover's pathetic request to escape with him, Gibson snidely responds "No, this town needs you, Raun," and unintentionally acknowledges the necessary relation between ethnic minorities and the spaces they are permitted to occupy.

More interesting, however, is Hawn's surprise that Gibson was a hairdresser, given the even greater improbability of Gibson's other jobs—especially as a jivin' garage mechanic in the middle of a Detroit 'hood. She disbelieves that the virile Gibson could have passed as a homosexual, much less performed as one (the film refuses to distinguish). Yet in purely physical terms, homosexuality is Gibson's most plausible disguise and convincing performance: gay is one minority a middle-class WASP male might actually be. It is this plausibility that the sequence both visually exploits and intellectually represses. The virulent homophobia of the sequence exposes the lie at the heart of the fantasy of mobility: the empowered male hates the only thing he could be, because his desire for minority status is predicated on his assurance that he will never really have to be one.

Witness relocation movies are an admittedly minor variation on

American fantasies of social mobility. But just as *Bird on a Wire* uses gay characters to disguise its hero's privilege, so the invisibility of homosexuality can be exploited more subtly to validate white advancement. Garry Marshall's *Pretty Woman* (1990), for example, is a class-conscious retelling of the Cinderella tale in which Julia Roberts as "Vivian" leaves prostitution to marry corporate trader Richard Gere. The film argues that the power denied women because of their gender can be returned to them through wealth; as the picture's opening line states, "It's all about money." Yet such a fantasy must finesse the ticklish issue of the step-sisters, against whose failure Cinderella's own success is measured. If someone is to move ahead, someone else must be left behind. For the myth to satisfy, such inequities must seem reasonable and not discriminatory.

Acknowledging the social differences it will ultimately overcome, the film uses "other" minorities to measure its heroine's triumph over gender and class. Through Laura San Giacomo's "Kit," a "minoritized" hooker of indeterminable ethnicity (probably only Italian), the filmmakers concede that only a WASP prostitute could "clean up" sufficiently to be a plausible partner for tycoon Richard Gere. Yet that concession seems potentially racist, and in its final moments the script offers a career in cosmetics as an escape for Kit. A less problematic foil for Vivian is the finicky hotel manager Barnard Thompson, played by Hector Elizondo. At first contemptuous of her, Elizondo is soon enlisted to provide "Miss Vivian" with the lessons in clothing and etiquette she needs to accompany Gere. To explain why an apparent figure of authority expresses sympathy for Roberts's underdog, the movie hints at the manager's own sense of cultural exclusion, in terms not of the actor's visible Latino ethnicity, but of an implied though never stated homosexuality. Accomplished without any traditional Hollywood stereotyping, Thompson's sexuality is inferred entirely from his table manners, his passionless sympathy for female outcasts, and the mere fact that he occupies a social space in the real world frequently occupied by gay men. By never explicitly mentioning sexuality, the producers avoid suggesting that gays are, like ethnics, sociologically trapped. When in their final exchange Vivian bonds with the manager—"you and I live in the real world"—cultural "dif-

ference" gets further rewritten as simple psychological realism. Thompson remains a hotel manager simply because his kind of person is happy in that space; and Vivian can guiltlessly marry millions while Thompson remains stuck in his servile employment.

A Dialogue of Their Own

Delineations of a gay language counteract the tendency of works like *Pretty Woman* to exploit homosexuality while making it disappear. Yet studies of cultural specificity do more than police the political errors of commercial works not too scrupulous about how they attract audiences. Kobena Mercer has defined as "the burden of representation" the dilemmas minority figures face when asked to represent themselves as spokespeople for their group.[22] The inability of any individual to "speak for" the diverse opinions of a group sometimes comes to feel for minorities like their more general inability to speak—the absence of any form of minority discourse or even of subcultural identity. The study of gay language, then, serves most importantly to alert the community to ways in which it may itself have underrated its own ability to speak.

An overly narrow sense of what might constitute gay conversation is evident in the phrase traditionally used to define homosexuality—Lord Alfred Douglas's poetic line about the "love that dares not speak its name," immortalized in Oscar Wilde's *De Profundis*. Though probably as accurate as any epigram, the phrase misrepresents gay speech in at least three ways. By coupling "its" with "name," the phrase engages in a fantasy of self-naming, and obscures the extent to which minorities do not choose a "name" but have one imposed on them by dominant culture. "Dares" perpetuates this fantasy by characterizing all speech as courageous, any silence as cowardly. But most simply, the phrase accepts that the sole topic of homosexual speech should be self-identification. Not only is homosexuality more vocal than the phrase suggests, but there may be many things gay love might speak about other than "its" name.

During gay liberation Douglas's self-pity was rewritten as the claim that the love that once dared not speak its name now never shuts up. Yet the exuberant joke still perpetuated the limited focus on self-iden-

tification as the chief mode of gay self-expression. Preaching the importance of openness and self-respect, gay activists tended to undervalue those more covert strategies of cultural negotiation that depended on indirection. For "coming out" to become the *sine qua non* of self-respect, all non-confrontive activity must seem to take place "in the closet." If "I am gay" represents empowerment, then any other statement feels not quite gay. At the height of liberation in the late 1970s, flamboyant humor embarrassed those trying to project a more masculine image. The parodic tradition of camp was anathema to those advocating plain speaking, and to clarify for others what they were not (or were no longer), activists created in the image of the "queen"—the effeminate gay man—a self-hating stereotype as destructive as any imposed on them.

The complexities of homosexual discourse are not well served by such loaded dichotomies as dishonest/truthful, or closeted/open. A similar oversimplification informs most popular discussions of camp, including my own. Generalizations about verbal structures, rhetorics, and syntaxes characteristic of gay language tend to treat as identical all statements about the kindness of strangers or not being in Kansas anymore. Yet even within a clearly gay tradition of camp quotation, what is striking is the variety of uses to which camp is put. Although all such quotations depend on an ironic interplay between the line and its reappropriation, the exact character of that irony depends considerably on the author's tone, degree of self-consciousness, and relation to the original context of the line. Some quotations satirize the author, some the character, some the sentiment; some side with all three in a more general disdain for social norms. And some are merely phatic—gay versions of "Have a nice day" or "Gimme a break."

Perhaps it would be better to speak not of "camp" but of "camping"—not of a single style but of specific situations in which particular quotations can function in very distinct ways. To understand more fully the varying conditions under which such language games are played, then, I would like to conclude with three examples of camp-in-action. Most basic is camping as self-announcement, as exemplified in the television persona of actor Paul Lynde. *Hollywood Squares* was a tongue-in-cheek quiz show in which two audience con-

testants judged the accuracy of answers given by celebrities sitting in a tic-tac-toe board, with correct answers awarded the "X" or "O" for the appropriate square. One of the mainstays among the celebrity panelists—usually occupying the crucial central square on the board—was Paul Lynde. When asked why motorcyclists wear leather, he responded, "Because chiffon wrinkles so easily."

His answer suggests the complex dynamics of gay camp within a straight context. First consider Paul Lynde's place as one of the show's key players. His answers were almost always correct, and clever contestants agreed with him even when his responses seemed improbable. Yet to enhance the entertainment value of the show, Lynde almost always responded first with a wisecrack. His humor depended on a very carefully constructed persona. After years of night clubs and "New Faces" revues, Lynde rose to prominence in the 1960 Broadway musical *Bye Bye Birdie*, where he played the beleaguered father of a teenage girl. His embattled delivery of the pop hit "Kids"—with its anguished refrain of "What's the matter with kids today?"—epitomized the early tensions of the generation gap, before the confrontation turned violent in the late 1960s. His quiz-show persona expanded on this heterosexual exasperation, but compounded it with a cynicism and quick repartée associated with "bitch wit." Although there was no mention of sexuality on the show, camp was Lynde's preferred language, acknowledged both in his delivery and in his relation to the apparent heterosexuality of the moderator.

This homosexual context informs the exchange on *Hollywood Squares*. The question itself is not serious, nor did Lynde have any doubt about the real answer: motorcyclists wear leather to protect against injury. The humor arises from the moderator's directing this kind of question at Lynde in the first place. In his role as cynic and aesthete, Lynde was deemed an unlikely source for information about motorcycles. Encoded within the moderator's question is both the recognition of Lynde's gay persona and the homophobic assumption that gay people know nothing about bikes. Homosexuality is itself characterized as a lack of knowledge. This coding is acted out in the verbal play between the knowing straight moderator and the supposedly inexperienced Lynde.

Lynde's response inverts this sexual stereotyping in two ways. First his literal response that motorcyclists actually prefer chiffon denies the question's heterosexism. Instead of knowing nothing about motorcycles, gay people stand at the center of bike culture. Either the bikers are gay, with leather just another form of drag, or the machismo of heterosexual male bikers merely masks their latent homosexuality. In this bald form, the joke reinforces the heterosexism of the question. By answering, Lynde merely aligns himself with the discriminatory assumptions of the moderator. His knowledge about bikers proves him straight, and his knowledge of their sexuality distances himself from that sexuality in the classically sexist formulation—the eye-rolling "We all know what that means."

If the content of Lynde's answer is homophobic, however, the style of his quip counters that homophobia with a statement of gay affirmation. Lynde does not associate himself with the gay bikers, who remain resolutely "them" in his account. But the epigrammatic form of the response, the overstatement of its reduction of the world of fabric to leather and chiffon, and the hyperbolic delivery all associate him with another representative of gay culture—the world-weary sophisticate. The point of this style is to reappropriate for the gay person the possibility of knowledge. Lynde knows the joke answer not because he is straight, but because he is not. Straight society becomes the keeper of dull facts—that clothes guard against injury. Gay culture knows the higher, forbidden truths—of the fetishistic powers of fabric. Thus his slight dig at the hypermasculinity of gay bikers is more generally an affirmative of a specifically gay knowledge. And if his content answers "*They're* not straight," his style responds "*I* am gay."

One must read skeptically the distinction between the moderator's naiveté and Lynde's wisdom. Questions on *Hollywood Squares* were constructed to make the panelists look good, and the moderator merely cooperated with Lynde's inversions, as would any comic sidekick. Yet, however contrived, the exchange does suggest that camp irony can be a way of mapping out a territory of uniquely gay knowledge and power. My second example of camping is more complex: non-gay-identified director David Lynch's allusions to the difference

between straight and gay voices in *Blue Velvet* (1986). Lynch's film explores the hidden sexuality of conventional small-town American life. Returning from a visit to his sick father, Jeffrey Beaumont (Kyle MacLachlan) discovers a human ear in an abandoned lot. In search of the story behind the ear he meets not only a police detective's innocent daughter Sandy (Laura Dern), but a crew of sadistic drug dealers, especially Frank (Dennis Hopper) and Ben (Dean Stockwell), and Dorothy Vallens (Isabella Rossellini), an exotic torch singer drawn into a masochistic relation with Frank to protect her kidnapped son and husband. As Jeffrey becomes more obsessed with "seeing something that was always hidden," he sinks deeper into Frank's world: he initiates his own sadomasochistic relation with Dorothy; is himself kidnapped for a nightmarish "joyride" with Frank; and finally kills Frank to renounce his own potential for perversion.

Although the movie focuses on heterosexual desire, homosexuality is represented as an explicit alternative in the scene at Ben's apartment that begins Jeffrey's "night journey." With his foppish manner, flashy clothing, heavy makeup, and arch dialogue, "suave" Ben is clearly coded as gay. His difference from the others is epitomized at the end of the scene when, using only a floodlight to light his face, Ben lip-synchs Roy Orbison's 1963 country-western song "In Dreams." Lip-synching is, of course, one of the few forms of gay camp that has not been widely taken up by straight culture. Except in film, where pre-recording is necessary, dubbing is considered a form of fraud, and the credibility of mainstream performers as different as Liza Minelli and Milli Vanilli suffered when they were accused of it. Yet Lynch uses Ben's lip-synching as a sign of his intellectual superiority to Frank. Miming to the distorting glare from a phallic floodlight, which he holds as a mock microphone, the hip homosexual Ben distances himself from the lyrics he performs. Silently repeating the same words out of synch, the psychotic heterosexual Frank believes the sentiments of the song. [Figure 3]

Lynch's distinction between the gay and straight performances of "In Dreams" is reinforced by his implicit comparison of Orbison's country-and-western ballad with Bobby Vinton's rock-and-roll per-

Figure 3: In *Blue Velvet*, Dennis Hopper repeats seriously the lyrics parodied by Dean Stockwell (DeLaurentiis Entertainment Group).

formance of "Blue Velvet." Unlike "In Dreams," whose references to "dreams," "drugs," and "the sandman," foreshadow the uncanny aspects of the joyride, Vinton's "Blue Velvet" is comic, representing the insipidity of small-town normalcy. Lynch's use of "Blue Velvet" itself builds upon an earlier camp appropriation of Vinton's performance—in Kenneth Anger's classic of underground gay cinema *Scorpio Rising* (1964). A quasi-narrative series of brief silent scenes, each accompanied by (then) contemporary popular songs, *Scorpio* touches on most of Lynch's central subjects: homosexuality, leather fetishism, bike culture, drugs, sadomasochism, gang mentality, and totalitarianism. In the film's most famous sequence, young bikers dress up in leather and its paraphernalia while the soundtrack plays Vinton's "Blue Velvet." Anger's point of view—a mix of horror and fascination, moral approbation and homoerotic titillation—resists any single reading. Yet the comic shock underlying his juxtaposition of velvet and leather is not far removed from Paul Lynde's comments

on motorcycles and chiffon.

Lynch uses Anger's camping to make "Blue Velvet" seem eerie even when returned to its original heterosexual context. The song's prom-night sensibility is in fact appropriate to Lynch's small-town setting and to the hyper-normal images of the opening sequence in which it is first heard. Yet Anger's strategic misapplication of the song stands between Vinton's performance and the picket-fence America of Lynch's opening scene. It is as if Lynch were claiming that, after Anger, any attempt to get "Blue Velvet" back together with its own middle-class complacency is not simply naive but downright malevolent. Gays do not camp normalcy; the normal is already hyperbolic. Lynch's appropriation of Anger's camped biker-outlaws to camp the good citizen may not open up conversation on the varieties of desire. *Blue Velvet* introduces Anger and lip-synching only to absorb them into a resolutely heterosexual vision of sexual diversity. Yet by implying Ben's influence over Frank, and that of Anger's film on his own, Lynch at least acknowledges that homosexuality shapes heterosexuality as fully as it is shaped by it.

The social and sexual implications of Lynch's use of camp in *Blue Velvet* are ambiguous. Yet Lynch's layering of sexual contexts—his use of contrasts in voice and performance to represent sexual difference—recalls my suggestions about the cultural specificity of style and language. And the final "camping" I would consider is my own delineation of a "queening of America." Throughout this analysis I have been intentionally vague about what "queening" means—what it was, when and why (or if) it happened, how (or whether) it was intended. At the simplest level "queening" refers to a group of processes by which rhetorics and situations specific to homosexual culture are presented to a general readership as if culturally neutral. The crossover affords power and perhaps sly revenge, as straight culture takes for its own a humor it only incompletely understands. But the success of the trick depends on a degree of secrecy that may undermine the self-respect of authors unforthcoming about their sexual preferences.

Depending as it does on the invisibility of the minority, this strategy is probably more common among gay men than among lesbians,

who, however invisible their sexuality, are already perceived as minorities because of their gender. Recently, however, what might be called "lesbian camp" has become a strong element in the work of independent filmmakers and of such alternative theater performers as Holly Hughes, the WOW Cafe, and the Split Britches Company. Jane Cottis's videos—especially *Dry Kisses Only* (1990, with Kaucyila Brooke) and *War on Lesbians* (1992)—mix the established forms of drag camp, like parodic cross-dressing and extravagantly bad performance, with post-modern video techniques, especially dissociative crosscutting. Celebrated moments of *Kisses* alternate real sequences from *All About Eve* and *Johnny Guitar* with camp restagings that activate (or insert) a lesbian subtext into the films. And the video ends with what can only be called female-female drag—Cottis extravagantly dressed as "Lady Manilla Lively," tattling on the sexual activities of Dolly, Doris, Julie, and Jody.

In her meditations on cinematic and cultural "viewpoints," Asian-Canadian filmmaker Midi Onodera exploits lesbian invisibility more subtly to question who "owns" spectatorship. In Onodera's *Ten Cents A Dance (Parallax)* (1985) two women face each other across a table at a Japanese restaurant discussing whether or not they will become lovers. The stationary camera reinforces the stasis of the conversation, which runs through as many of the clichés of lesbian courtship as it can in ten minutes. To straight audiences the result is austere, beautiful, and moving. To lesbian audiences, who recognize the overstatement of the dialogue and mise-en-scène, the scene is also very funny—camp deadpan masquerading as social realism. Similarly, Onodera's *The Displaced View* (1988) uses the filmmaker's relation to her grandmother to explore the internment of Japanese-Canadians during World War II. Yet passing references to the grandmother's difficulties understanding the director's lesbianism, and repeated images of a solitary Onodera studying videos of the internment while relatives play with their children, challenge the singularity of the title, and of subject position in general. If the film has only one "view," the displacement may be less one of race or of generation than of lesbian sexuality.[23]

"Queening," then, suggests the ways in which gay men and to some

extent women shape dominant cultural forms by silently importing into heterosexual plots rhetorics and motifs more common to their own homosexual subcommunity. At its simplest, it overturns notions of camp as merely a humorous exaggeration of straight culture. Consider, for example, the camp moment with which we began— Agnello's reference to Blanche's dependency on "the kindness of strangers." Gays have been drawn to this moment not only because it is the creation of an openly gay playwright, but because the line and the extrafamilial move it represents make more sense in a gay context than in the literal context of the play itself. Rejected by their parents, gay children frequently go off to construct alternative family units; whatever she claims, however, Blanche primarily depends not on strangers but on her sister. In quoting Blanche's line to the police, Agnello is not satirizing straight values, but laying claim to something that was always more his than theirs.

"Queening" then calls attention to the extent that much camp humor is not appropriation but re-appropriation—a recapturing of something that was already part of gay cultural heritage. In so doing, it associates itself with recent discoveries of agency among the apparently disempowered. Theories of minority discourse once assumed that marginalized cultures were passive, reacting to (even "damaged by") dominant structures, and that "codes" of meaning were initiated by dominant culture, while minorities, in Gilles Deleuze's phrase, "live in a language not their own." Later, more hopeful critics have emphasized the deconstructive potential of minority discourses. In double-voiced processes like "mimicry" and "hybridization," post-colonial theorist Homi Bhabha identifies an "ambivalence" and even "menace" accompanying colonial accommodation and imitation. The ambiguity of the native's "sly civility" converts authoritarian narcissism into the paranoia of power, the colonizer's conviction that "he hates me." Similarly, sociologist Paul Willis has studied the "symbolic creativity" of youths' interactions with popular film, television, and music. Rejecting traditional readings of consciousness and meaning-making as "internally coded," Willis focuses instead on the originality with which youths (mis)read mass culture to produce "*new* [however small the shift] meanings intrinsically attached to feeling,

to energy, to excitement and psychic movement."[24] Like Bhabha's "ambivalence" or Willis's "symbolic creativity," my "queening" seeks out minority agency in a disempowered group's manipulation of language. Against those who claim that minorities contribute nothing to society, queening imagines minorities actively exploiting their invisibility to cross the boundaries between cultures: leaving enough congenial motifs in alien territory to facilitate future visits there; while maintaining enough cultural autonomy to keep the borderline distinct and the homeland protected.

The history of linguistic crossings can never be exact. It is impossible to trace a developmental line from Williams's "kindness of strangers" to the Beatles' "Little Help from My Friends," and not especially worthwhile to wonder if John Lennon undergoes homosexualization in transit. Yet however we describe works like *Auntie Mame*, it is clear that they have a special place in gay folklore. There is such a thing as "gay cultural literacy"—the things one has to know to communicate successfully with (or within) the community. Part of this literacy involves artifacts that have taken on significance for contemporary gay men. Without having actually to admire these artifacts, one accepts at least that they hold a special importance for much of the community. And while gays need not camp—need not "do" Judy Garland or adore Noël Coward—they cannot disdain their cultural landscape without seeming antisocial and elitist.

Finally it makes little difference if "the queening of America" happened over the last fifty years or over the last fifty pages. If the camp colonization of straight culture is simply my invention, that too would be fully consistent with the process of reappropriation I have described. After my interpretation, it is difficult to read the UPI bulletin on Agnello's monkey as anything but camp, though surely no newspaper article consciously adopts such a tone. If my analysis of Saki or *Auntie Mame* is equally idiosyncratic, it is of a piece with gay appropriations of *The Wizard of Oz* or *All About Eve*. I have enacted a queening of America as much as delineated one. But whether as enactment or delineation, history or performance, the argument about sexual identity remains unchanged. Sexuality can be associated

not only with uncloseted characters and storylines, but also with a range of less overt linguistic effects. And the cultural specificity of rhetorics permits us to chart how in their cross-cultural dialogues groups maintain and dissolve the borders between them.

2

SAINT JOE

Orton as Homosexual Rebel

*L*et's begin with a simple test. Name the English playwright whose career was tragically cut short when his male lover bashed in his head with a hammer. How many plays did he write? Name them. Name any actors or directors associated with the production of these plays. Now, the scoring. No points for knowing the name Joe Orton. Ten points if you guessed he wrote more than three plays. Five points for naming one play, ten for each additional play, fifty bonus points for getting all seven. Twenty points for every performer named (some obvious choices are Ralph Richardson, Beryl Reid, Richard Attenborough, Lee Remick, Malcolm McDowell, Albert Finney, Lindsay Anderson; and—in America—Alan Schneider, John Tillinger, Joseph Maher, Carole Shelley, Kevin Bacon, and Alec Baldwin). Give yourself five points for remembering Alfred Molina; subtract ten for Gary Oldman or Wallace Shawn. If at any point you mentioned Stephen Frears, John Lahr, or Christopher Marlowe, stop reading.

Joe Orton is probably the most visibly gay writer of the post-war period. Although many self-identified homosexual authors, like Tennessee Williams or Truman Capote, are as admired as Orton, until recently critics rarely considered sexuality's bearing on their work. Other writers, like Robert Patrick, Doric Wilson, or Ethan Mordden, address issues of gay life and culture more explicitly and intently than Orton. But at present they are not so famous as he. Orton stands in the twentieth century—like Oscar Wilde in the nineteenth—as the

mainstream English-language author whose sexual preference has always been acknowledged in evaluations of his work. Unlike most writers, for whom homosexuality and celebrity are inversely related, Orton's sexuality is the most famous thing about him.

Yet (as test scores suggest) sexual visibility does not ensure aesthetic appreciation. Familiarity with the personal facts of Orton's life has not served the traditional function of literary biography—to bring readers to, or closer to, the writings. American fascination with Orton's history rarely leads to textual reexamination, let alone theatrical revivals. It is as if there were two Ortons—the homosexual and the playwright—in competition for an audience. Reviewing representations of the two Ortons may not reveal the "truth" of either. But it can uncover some of the conventions used to describe homosexual achievement and raise more general questions about the intersection of biography, sexuality, and literature—what it means for a life or a work to be "gay."

Life as Death

Since his violent death, understanding Orton has always begun with his biography. But biographies do not just happen. They are constructed by the selection and ordering of life experiences, as imperfectly recorded in documents or incompletely recalled by participants. The construction of Orton's biography began with his own adolescent invention of an identity. It continued in both his self-mythifications and the media's celebrations (and excoriations) of his achievements. The interpretations proliferated with Orton's death; their shape, however, became more uniform as a standard account began to be formulated. In 1978 these various versions of Orton were consolidated with the publication of the first (and still the reigning) book-length biography, John Lahr's *Prick Up Your Ears*.

Lahr divides Orton's life into a rising professional career and a falling personal one. As a playwright Orton pulled himself up from the "nowhere" of an oppressive working-class family situation. After a relatively slow start as an actor, including two undistinguished years at the Royal Academy of Dramatic Arts (RADA), Orton spent the next decade polishing his particular style of comic anarchy. In 1962 these years of apprenticeship culminated in the parodic defacing of

book covers that earned him six months in jail. Orton's remaining four years were more public. After the radio performance of *The Ruffian on the Stair* and the promising theatrical debut of *Entertaining Mr Sloane*, both in 1964, Orton's ascent seemed meteoric. In the final ten months of his life—from the London debut of *Loot* in October 1966 through his murder the following August—*Loot* won the *Evening Standard* Award for best play, and productions were mounted of *The Good and Faithful Servant* (1964) on television and of *The Erpingham Camp* (1965) and the revised *Ruffian* on stage (as the double-bill *Crimes of Passion*). During this fertile period Orton also finished the teleplay *Funeral Games*, the screenplay *Up Against It* (commissioned by the Beatles), and his final stage work, *What the Butler Saw*.

In Lahr's retelling the professional successes of these final months were counterbalanced by personal failure—the disintegration of Orton's sixteen-year "friendship" with his lover Kenneth Halliwell. According to Lahr, Orton and Halliwell "shared everything except success."[1] Early in the relationship, Halliwell had been in control, educating Orton and collaborating with him on the early novels. When, after prison, Orton became more independent and involved in a theatrical career with agents, directors, and actors, Halliwell seemed increasingly a professional, social, and finally emotional encumbrance. Orton's colleagues were uninterested in this "middle-aged nonentity," especially as Halliwell became more possessive of Orton and more vocal about his own contributions to the plays. Orton himself sought sexual relief elsewhere in anonymous encounters in bathrooms (called "cottages" in British gay slang, "tearooms" in American). Halliwell's inability to deal with both Orton's success and his promiscuity, Lahr concludes, led to the murder that stopped both.

While it is impossible not to admire the elegance of Lahr's interpretation, with the Aristotelian symmetry of its rising and falling plots, such a structuring of Orton's biography raises problems of its own. Rather than emphasizing the continuity between Orton's life and his art, Lahr depicts them as opposed to each other. The professional plot is all theater and success; the personal plot all homosexuality and failure, especially as epitomized by Halliwell's hysteria and Orton's promiscuity. The murder ending both plots seems a

weak foundation for biographical interpretation. Death is not denouement but only the inevitable end of any real-life narrative. In Orton's case this limitation is compounded by the ambiguity of Halliwell's motives. "Evidence" concerning the murder is highly speculative, largely others' recollections after the fact of trivial incidents which might be said to "foreshadow" Halliwell's act.[2]

These two plots not only prevent an integrated view of Orton. Neither is entirely accurate on its own terms. The professional plot imagines Orton's final months to be uniformly successful. Yet, as his diaries record, Orton saw his own rise undercut by the even greater triumphs of others. He found himself taking a back seat not only to the admittedly admirable work of Laurence Olivier, Tom Stoppard, and Peter Nichols, but also to the crowd-pleasing mediocrity of Frank Marcus's *The Killing of Sister George* and Charles Dyer's *Staircase*. Not merely a function of his insecurity, Orton's sense of failure was grounded in reality. Despite his notoriety in the press, critical and commercial response to his work was erratic. Orton's first play, *Entertaining Mr Sloane*, received mixed notices and small houses. His final months, too, were less triumphant than Lahr suggests. The Beatles rejected his screenplay without comment. After much debate, ITV cancelled planned productions of *Sloane* and *Funeral Games*. The double-bill *Crimes of Passion* opened to disappointing reviews. And even the West End *Loot*, the most successful production of his life, had empty seats and people walking out at every performance.

Just as Lahr's professional plot emphasizes the triumphs, so his personal plot overstates the failures. There were of course tensions in the final months of the relationship, as Halliwell (and probably Orton) became increasingly dependent on tranquilizers and antidepressants. Yet there were also moments of untroubled intimacy. After his intimidating (and humiliating) interview with Paul McCartney, Orton retreated to the quiet security of his apartment, where Halliwell made tea and listened to complaints late into the night. The two-month vacation in Tangier offered a calming sexual release to Halliwell as fully as it did to the more famously promiscuous Orton. The last extended passage in the *Diaries* depicts neither a squabble with Halliwell nor a cruising of tearooms but the couple's weekend visit to the

Brighton house of Orton's straight producer. Whatever the pressures of the murderous week that followed, the diary ends with Orton and Halliwell sneering together at the boring coziness of suburban family life.

Finally, the two plots may not be fully consistent on their own terms. It is probably unfair to banish Halliwell so completely from the success plot, in which he plays for Lahr the curtain walk-on of an avenging Fury. The defacing of the library books—the early act in which Lahr most clearly recognizes anticipations of the "Ortonesque"—was literally (and legally) attributed as fully to Halliwell as to Orton. Moreover, the murder plays a different role in the plots it supposedly unites. In the professional story, Orton's death is fortuitous, the unexpected reversal by which the character is suddenly toppled from the heights. In the personal story, however, violence is entirely predictable. Halliwell's rampage is simply the culmination of long-standing tensions in the relationship, tensions that only someone as self-involved as Orton could have overlooked.

These inconsistencies suggest a more fundamental problem in Lahr's attempt to synchronize sexuality and success. To characterize the growing jealousy between the two, Lahr equates Halliwell's sense of failure with his grief over Orton's promiscuity; and assumes that, as he became more successful, Orton found Halliwell uninteresting as a sexual partner and turned to anonymous encounters for sexual release. Although such an interpretation is psychologically possible, there is in fact no evidence either that Halliwell resented Orton's cruising or that Orton's cruising increased as he became more famous. Buried in Lahr's formulation are assumptions—about the impropriety of promiscuity in a long-term gay relationship, and even about the more general relation between professional success and sexual appetite—that misrepresent the realities of gay (and probably straight) sexuality.

Life as Gossip

The limitations of Lahr's account reflect the deficiencies of his documents. Apart from Orton's notoriously unreliable statements to the media, there is relatively little first-hand material. Two of Orton's diaries remain—some inconsequential notes written when he was a

teenager and his more substantial account of the final eight months. Of the formative thirteen years between acting classes and *Sloane*, however, little survives, except some dim recollections by RADA classmates and unenlightening trial and newspaper reports on the book-defacing incident. This lack of material has made it difficult to characterize the pre-public Orton: his literary development before *Sloane* and especially his early relationship with Halliwell.

To supplement these meager resources, Lahr conducted a wide-ranging series of interviews. These interviews are both tantalizing and problematic. The participants—largely family members, who knew him best in the early years, and theatrical colleagues, who knew him only in the final four—are most knowledgeable about those years for which there was already considerable documentation. More important, they provide not first-hand accounts of his relation to Halliwell but only outside interpretations of it. Yet the very inconclusiveness of the interviews makes them interesting barometers of cultural clichés in the late 1960s in England. In jumping from what they know to what they conclude, the interviewees tend to rely on the unchallenged assumptions of the generation. And by delineating the leaps in their logic, we can to some extent outline the shape of those invisible beliefs.

Take, for example, the claim that before the murder Orton was on the verge of leaving Halliwell. Although no documentary evidence confirms that Orton seriously considered severing the relationship, the rumor is a common thread running throughout the interviews. Representative is the comment about the couple's search for a country house by Kenneth Williams, an actor friend of Orton's:

> When Joe said to me, "I'll never leave Kenneth," he meant, "I'll never forsake him." He said, "I'd have the [London] flat to do what I like. I'd go down to Brighton on weekends." They'd still be together, but in London he'd be free. You see he had no place to bring these pick-ups.[3]

Whatever the accuracy of the conclusions, there is a striking difference between Orton's actual words and Williams's interpretation.

Redefining "leave" as "forsake" and conflating London with promiscuity, Williams assumes the freedom of "doing what I like" to be purely sexual. Such a reading inverts the literal meaning of the words, implying that, despite his explicit claims of fidelity, Orton was in the process of breaking with Halliwell.

More revealing, perhaps, is the testimony of Sir Terence Rattigan, author of the well-made melodramas *The Winslow Boy* (1946), *The Browning Version* (1948), *Separate Tables* (1954), and *Ross* (1960) and at the time one of England's leading establishment playwrights. Discussing an evening spent with Halliwell, Orton, Laurence Olivier, and his wife Joan Plowright, Rattigan recalls:

> Larry and Joan came over. You saw the royal pants being bored off Larry. Halliwell lectured him. It was a very depressing evening. Joe didn't seem to mind. He was quite sensitive enough to know what kind of appalling impression Halliwell was making. And also the appalling impression he was giving of Joe. Obviously Joe was going to have to leave this man. He couldn't have lived with him much longer and kept his sanity.[4]

The analysis reveals more about Rattigan's own theatrical allegiances and class biases than it does about Orton's difficulties with Halliwell. Rattigan's concern for social proprieties and solicitousness towards Olivier's "royal" pants mark his own upper-class background, which probably helped make his own homosexuality acceptable to an earlier, more closeted generation of theatre folk.[5] Yet this very discretion impedes his ability to read the motives and social behavior of the militantly working-class Orton. Although Rattigan supposes that anyone would desert a lover so socially maladroit, he unintentionally confesses that Orton was both fully aware of what was going on and undismayed by Halliwell's boorishness.

As a self-styled rebel in a more liberated generation, Orton shared none of the older man's reticence. Although grateful for Rattigan's support early in his career, Orton was otherwise disrespectful of both the man and his work. He was no more admiring of "Sir Larry." Having lost a preferred performer to an Olivier production, Orton recalled,

"'Olivier collects young actors like butterflies' someone once said. He doesn't give them parts, though. He has them playing the set." Later, of Olivier's prostate trouble, Orton quipped, "All this taking up fucking at such an advanced age, I expect." The contempt—and the skepticism about Olivier's protestations to heterosexuality—suggests that, far from being embarrassed by Halliwell's hostility to Olivier, Orton took covert pleasure in (and possibly conspired with) his lover's behavior.[6]

Lahr's interviewees may interpret the situation correctly; perhaps Orton did plan to leave Halliwell. Yet their interpretations are not merely factual, but influenced by assumptions about how one deals with the successful, and with success. Halliwell did not know how to behave with England's most treasured performer and powerful producer; therefore, the interviewees conclude, Orton would eventually leave him. Or, whatever his relation to Olivier, Orton would leave behind his working-class lover and Islington bed-sitting room because that is the sort of thing a rising playwright does, even in the generation of kitchen-sink realists. We may, however, want to challenge their implicit conflation of success with upward mobility. One could even argue that, had Orton been considering leaving Halliwell, his motivation might have been a heartless desire for advancement as fully as it was any particular irritant from Halliwell himself.

The elitism of these readings is missing in Orton's own statements, and is in fact at odds with the working-class sensibility of the plays. Yet the prejudice permeates the interviews. One of its chief voices (and one of Lahr's major sources) is Peter Willes, then television producer and strong advocate for Orton's work. "I was the only gent Joe ever met. I introduced him to a different kind of life and attitude. Like I did Pinter." The statement is doubly inaccurate: it falsely assumes that Willes was the best-bred person Orton knew, and that Orton cared for such distinctions. In Orton's own diaries, Willes is primarily a comic figure, regularly ridiculed both for his social climbing and his mediocrity as a producer. Halliwell called him "dotty" for his purchase of nutcrackers in the shape of diplomat Sir Austen Chamberlain, an unctuous gift for Chamberlain's daughter. Orton echoed the sentiment when Willes overreacted to being stood up by

aging musical star Dorothy Dickson: "I went off to lunch thinking what a nutcase P. Willes was."[7]

It is in the context of their own elitism that one must read the interviewees' disapproval of Halliwell. Often in such attacks Halliwell merely stands in as a scapegoat for Orton's own lack of class consciousness. Consider, for example, the dismissal of Halliwell as a "middle-aged nonentity," frequently cited by Lahr. At one of Peter Willes's dinners, Halliwell appeared in an Old Etonian tie. To such a send-up of Eton, Willes replied:

> You're making people angry. . . . People dislike you enough already. Why make them more angry? I mean—it's permissible, although silly, as a foible of youth, but you—a middle-aged nonentity—it's sad and pathetic.

Willes's logic is suspect, for both its sentimentalization of youth and the very un-Ortonesque argument that it is injudicious to anger people. Whatever Orton's initial position on Halliwell's tie, he clearly rejected Willes's response. Not only did he dismiss the outburst as "a sort of eldritch shriek," but he explicitly denied Willes's characterization of Halliwell: "Kenneth has more talent, although it's hidden, than P. Willes can flash if he had the reflector from Mount Palomar to do it with."[8]

The attacks on Halliwell's improprieties were at least in part an attempt to render acceptable Orton's own boorishness. This attribution to Orton of "refinement by nature" marked not merely his colleagues' class prejudice but also their assumptions about the structure of homosexual relations.[9] The problem was not simply homophobia. Long before the 1960s, the straight theatrical world had made a kind of peace with its gay subculture, and among Lahr's major sources, Rattigan, Willes, and Williams (at least) were openly gay. At the same time such truces were carefully negotiated. To be tolerated, homosexuality had to conform to certain social patterns. Although Orton's homosexuality was in the abstract unobjectionable, Halliwell was not an acceptable lover. The most traditional model for a gay relationship involved a privileged older man training a lower-class lover.

In their earliest days Halliwell and Orton approximated this model, with the older and richer Halliwell supporting and educating the less well-bred Orton. Yet when Orton surpassed Halliwell in his professional life, their situation no longer conformed to the cultural cliché. So strong was this stereotype, however, that some friends simply rewrote the power dynamics of the relationship altogether. Until the murders, for example, Willes assumed that Halliwell had always lived off Orton's income.

A similarly sexist cliché underwrites the differentiation between Orton as acceptably masculine and Halliwell as embarrassingly effeminate. Rattigan sneered at Halliwell's use of makeup, and Willes rejected him as "wildly dated," behaving "very much like a camp young man of the thirties."[10] Both arguments undermine themselves. Those eager to stereotype others are often running from what they fear as unmasculine behavior in themselves. Rattigan's snide reference to Halliwell's "slap" (rouge) is itself an example of the camp "dish" that he dismissed as effeminate. And while distinguishing Orton's demeanor from Halliwell's, Willes admitted that often he could not tell the difference between their voices. The very willingness of Rattigan, Willes, and Williams to characterize gay men as either masculine or effeminate suggests a commitment to the sort of sexual categorization that Orton explicitly denied in his theatrical depictions of homosexuality.

The effect of such stereotypic descriptions is finally to reduce Halliwell to his physical characteristics. The most obvious form of this reduction is the preoccupation with Halliwell's lack of hair. Here again the first-hand evidence about the importance of baldness to Halliwell or Orton is limited. There are few references to Halliwell's scalp in the diary; those that do appear are neutral. The criticism comes not from Halliwell or Orton, but from Lahr's interviewees. Margaret (Peggy) Ramsay, Orton's literary agent, is particularly explicit in her conflation of Halliwell's personality and his hairline:

> Joe's extraordinary charm captured everyone, whereas Kenneth's rather brittle, sharp manner didn't. Certainly Kenneth improved when he began wearing a wig. He was

quite bald, and was very ashamed of his baldness, and kept his hat on everywhere, including the theatre. The first money Joe earned was spent on a couple of wigs for Kenneth, and he chose a style with a rather endearing forelock. I think that by looking at himself in the mirror and seeing someone rather charming and sincere, it actually altered his personality, and he became rather charming and sincere, so that indeed I quite forgot my first alarmed reaction to his personality.[11]

Without challenging the accuracy of Ramsay's observation, one would want to question the specific assumptions that determine it. Orton's "[very] first money" does not seem to have been spent on wigs. Nor is the difference between Orton's "charm" and Halliwell's "brittleness" solely attributable to their foreheads. Photographs suggest that Orton's hairline was receding as early as 1965, a fact he disguised by combing his hair forward in bangs. Like his lover, Orton frequently wore a cap, occasionally keeping it on in the theater. But most striking is the narcissistic image with which Ramsey ends her analysis. Introduced by a speculative "I think that . . . ," the moment is presumably pure invention; it is unlikely that Ramsay actually saw Halliwell looking in the mirror, altering his personality with his hairstyle. Moreover, the final shift of pronouns—from Halliwell's point of view to her own—suggests the true meaning of "Kenneth's" transformation. Seeing the wig's forelock as "rather endearing," Ramsey implies that she personally finds baldness and middle age sexually unattractive. Whatever Halliwell's own preferences, Ramsay relates better to men with hair.

Life as Style

It is easy to blame the limitations of the standard account on Orton's friends. The interviewees are not in general neutral observers. Social, psychological, and even economic considerations inform many of their judgments. Lahr is not the ideal interpreter of these materials. As a heterosexual American, standing doubly outside the gay English world in which Orton lived, he seems unaware of the class and sexual prejudices of both his sources and his subjects. After Lahr a whole

generation of academic readers—Shepherd, Dollimore, Sinfield, Clum, and Nakayama (among others)—has sought to situate Orton in his historical, national, class, and sexual contexts.[12] Yet an inability to correlate sexuality and achievement persists in Stephen Frears's rethinking of the material in his 1987 movie *Prick Up Your Ears*. The problem is not one of candor or understanding, visibility or sympathy. The well-written, beautifully acted movie is in every way intellectually superior to its source in Lahr. Yet the film's conceptualization of rebellion as an intellectual style not only continues Lahr's de-contextualization of Orton but unintentionally forces an even greater gap between Orton's life and his sexuality.

Based on the biography, the movie shares some of the weaknesses of Lahr's account. Although the script works hard to show the positive dimensions of Orton's private life, his professional failures are once again minimized. Moreover, though psychologically more appealing than he is in Lahr, Halliwell is still reduced to his physical appearance. An expanded version of the wig anecdote explicitly connects physical appearance with sexual potency. The problem is compounded by casting opposite the Orton of Gary Oldman the actor Alfred Molina, a compelling and sympathetic performer, but one presented as less attractive (and more woebegone) than was Halliwell himself. And as in Lahr the movie foregrounds the murder. It not only underscores Halliwell's early acts of violence and his mental instability; like the book, the movie opens and closes with the murder, treating Orton's life as an explanation for his death.

The problems inherited from Lahr, however, are less ruinous than the metaphors the filmmakers introduce to represent and clarify Orton's behavior. Feeling that Orton mistreated Halliwell, screenwriter Alan Bennett recasts the story as "an account of a marriage, or at any rate a first marriage."[13] Bennett's revision, though sympathetic, is misconceived. It is not only prejudicial to present gay relationships as variations on the standard model of heterosexual marriage. To do so offers an implicitly demeaning view of straight marriage. There have surely been wives who supported their mates through the lean years (in graduate schools, for example, or early stages of their careers) only to be dumped unceremoniously when the husbands succeeded.

Yet in representing such an exploitative situation as commonplace, even habitual, the trope obscures social inequity by naturalizing it. The limitations of the metaphor of the "first wife" are particularly evident in the characterization of "Anthea" Lahr, intended as a foil for Halliwell. Early in the film, Anthea makes a stronger impression than her husband, and after a few scenes in which she threatens to upstage John (and rob him of audience sympathy), she disappears. Anthea is exploited and abandoned less by John than by the filmmakers, who ignore her after she has served her thematic function in the movie.

The inadequacies of the "first marriage" motif are compounded by the film's major revision of the biography—its sympathetic depiction of Orton's promiscuity. Lahr disapproves of Orton's fondness for anonymous sex, reading it, at best, as a sign of the disintegration of his relationship and, at worst, as a death wish. Bennett and especially Frears see the cruising, instead, as a form of social rebellion comparable to Orton's book defacing and his theater pieces. Although this depiction of Orton is obviously more generous than Lahr's characterization of him as sociopath, the paradigm of "sexual rebel" is still problematic. Most obviously, it implicitly pathologizes Halliwell's relative disinterest in promiscuity. Orton's rebelliousness is repeatedly read against Halliwell's traditionalism, although in fact Halliwell was neither so monogamous nor so outraged by cruising as the film suggests.

More interesting, however, are the cultural implications of the sexual rebellion trope. In the film promiscuity is attractive because it is dangerous and obsessive. Gay pleasure resides less in bodies than in social transgression; and Frears's Orton does not like men so much as he likes to break the law. Such a reading seems anachronistic in 1987 when, to retard viral transmissions, the gay community was consciously striving to construct a new sexual identity, one that did not equate personal freedom with (temporarily) unsafe activities. The film's disinterest in these contemporary gay problems suggests a more fundamental indifference to the social function of cruising in the 1950s and 1960s.[14] Orton's sexual rebellion, if rebellion it was, must be understood in terms of the more general illegality of his sexual preference. While covert sex may be exciting, there are also more pedestrian reasons for secrecy: public expressions of homosexual

affection were criminal throughout Orton's life.[15] By portraying anonymous sex apart from the process of institutionalized discrimination and prosecution which fostered it, Frears does more than mythologize cottaging. He de-homosexualizes it, making Oldman's Orton indistinguishable from his portrayals of other "rebel youths" from Sid Vicious to Dracula.

The film's characterization of promiscuity as rebellion is doubly decontextualized—addressing neither the specific cultural situation of Orton's pre-liberation 1960s nor that of the audience's post-AIDS 1980s. This dislocation suggests more general ways in which the filmmakers fail to situate their story within any particularized culture, gay or straight. The homosexuality of Orton and Halliwell exists in a social vacuum. Although Lahr's biography indicates the couple's half-hearted friendship with other gay artists, the film does not even acknowledge the existence of that community. And, apart from passing references to the Beatles, there is no attempt to examine the period's general rebelliousness. Such historical dislocation leads to unintentional misrepresentation. By inventing a scene in which Orton insensitively does not invite Halliwell to an awards ceremony, for example, Bennett unwittingly isolates the personal tensions in the relationship from the antiestablishment feelings that actually led Halliwell to refuse Orton's invitation.

The most troubling form of this cultural indifference in the film is the depiction of the Tangier vacation the couple takes shortly before the murder. Like Lahr, the film considers the trip to Africa in terms of Orton's personal relations, without examining the notion of the sexual vacation itself or the questionable morality by which the comparatively wealthy gay vacationers profit from the poverty of the Arab boys. Interpreting Halliwell's interest in hustlers' feelings as simply another example of his conventionality, the movie presents Orton's reprehensible exploitation of interchangeable youths as one more heroic rebellion. This acceptance of imperialism and prostitution is particularly surprising from a director whose previous film, *My Beautiful Laundrette* (1986), critiqued a version of the same kind of colonialism in London. And, again, the lack of nervousness about

such vacations seems outdated in 1987, when scholars around the globe argue the effects of transcontinental promiscuity on viral transmission.[16]

The failure to place personal problems within a social or political context undermines the film's most striking revision of the standard account—its self-reflexive critique of the desire to know Orton. Unlike Lahr's unapologetic and occasionally melodramatic account, the movie recognizes that the search for knowledge can degenerate into voyeurism. The filmmakers regularly question the accuracy and morality of their representations. By introducing outside characters—primarily John, Anthea, Anthea's mother—and making the diary one of the film's chief props, Bennett frames Orton's story by the process of observing and retelling it. There is no objective Orton apart from the things people say about him. Moreover, the one undeniable fact of his life explains nothing. Frears's theatrical staging of the murder parodies the tabloid mentality that gives it undue prominence: with overstated horror-film sound effects and red splatters; Halliwell's blood-stained monologues to the camera; and especially the representation of the murder's discovery by the close-up of an eye peering through a mail slot.

Yet the film's laudable concern with the politics of knowledge is incomplete. While the filmmakers revel in the epistemological ambiguities of Orton in particular and of life in general, they are more straightforward in their treatment of the middle ground of homosexuality. A movie that refuses to draw conclusions about Orton or his world is graphic and unambiguous in its portrayals of gay sexual activity. The murder scenes focus not on the corpses but on the intruding eye; in the sex scenes the camera gazes unimpeded and unobserved. Such objectivity does not encourage identification with the experience. The murky lighting and grainy photography of the "homosexual saturnalia" sequence at Holloway Road have clear affinities with gay pornography. Yet the tone is anthropological—more concerned with informing outsiders about the ritual behavior of exoticized creatures than with titillating initiates.

The flatfootedness of the film's characterization of gay desire is probably meant sympathetically; ambiguity about sexual issues might

have been read as prudery or even disapproval. Yet the effect of such cinematic candor is to reintroduce into the film the very kind of voyeurism it otherwise critiques. The problem is most evident in the film's use of "John" Lahr and "Peggy" Ramsay to frame Orton's story. Although clearly intended both to unify and to problematize the narrative, the characters also function as heterosexual tour guides, supplying needed facts (and a properly liberal tone) for an audience even less informed about English gay culture than John himself. The source and significance of the characters' knowledge, however, are never explored. The usually obtuse John is surprisingly versed in homosexual customs, announcing, for example, that in America gay bathrooms are called "tearooms" (a term not commonly known by heterosexuals). And while John's motives for wanting to know Orton's story at least are clear, we are never certain why Peggy is willing to serve as John's guide (and by implication our own). Questions about Peggy's specific attitude towards Orton and homosexuality are simply overshadowed by in the intelligence and intensity of Vanessa Redgrave's performance, whose integrity would make any position look morally unassailable.

Life as Narrative

Frears's *Prick Up Yours Ears* offers a familiar postmodern revision of Lahr's more conventional mode of literary biography—converting the lack of evidence into a statement about the impossibility of ever knowing anything with certainty. In the process, however, Orton's homosexuality is bifurcated and finally displaced. In its candor about his promiscuity, the film sexualizes Orton, so much so that his plays are scarcely mentioned and never represented. In its treatment of his life as an epistemological paradox, however, the film desexualizes Orton, making him, in Frears's hands, a symbol of rebellion or, in Peggy's and John's, a curious object of study. Such a de-homosexualization may be part of the filmmakers' point about the impossibility of certainty. Yet the film's inability to deal with the cultural specificity of Orton's life raises questions about the appropriateness of some of the models biography uses to unify separate events into a continuous narrative.

Most obviously, Orton's life does not conform to traditional assumptions about talent and the individuality of the artist. Success is customarily viewed as the result of something special in the writer. Biography as a genre reinforces this assumption by studying in detail the lives of individuals to isolate those unique qualities that account for (and even predict) their creative achievements. Yet Orton's story undermines these assumptions in a number of ways. No seeds of talent are evident among the few surviving details of his early life. Talk of a developing mastery misrepresents Orton's largely hit-or-miss approach to writing. No metaphor of maturation can be used to describe seven plays that were written in rapid succession in barely three years. In the late work Orton recycled with little revision themes, plot devices, and even dialogue from the early unpublished prose. And although becoming more attuned to how scenes would play in the theater, he never confronted directly his structural problems, especially the episodic nature of his narration.

Such irregularities do not suggest Orton's lack of craft so much as inadequacies in the ways we traditionally define individual talent. The highly collaborative character of theatrical performance works against the idea of a single authorial creator. The importance of collaboration is especially clear in Orton's work. The plays do not always read well. Unlike Oscar Wilde's epigrams, with which they are often compared, Orton's pseudo-epigrams are not themselves especially witty: "Promiscuity always leads to unwanted children"; or "The police are for the protection of ordinary people."[17] The joke emerges only when they are spoken aloud in the voice of public authority that they parody. Furthermore, though some individual lines may be foolproof, the plays in general require (at least) actors and directors trained in farce timing to overcome the scripts' erratic pacing. Few accounts of any playwright, of course, spend much time acknowledging the importance of performers' contributions. Yet in the case of Orton criticism, this refusal to acknowledge others frequently takes the form of vilifying them. In most accounts Orton is at war as much with his collaborators as with his critics.

Problems evaluating the collaborative aspects of performance are compounded by the rebellion motif usually associated with Orton. By

relocating the writer's power not in his work but in his politics, the notion of the rebel outcast reinforces the image of the individual as the sole moving force behind the plays. And the motif's emphasis on rebellion over dramaturgy encourages the substitution of life for plays that always plagues accounts of Orton. The very concept of a rebel outcast, however, has recently come under scrutiny. It is unclear what it means to rebel against society as a whole—what would constitute victory, or even what societal space one occupies while rebelling. A kind of implicit defeatism inflects any account of Orton's rebellion, and not simply because of his premature death. Lahr shows little sympathy towards the "psychopathic" decade for which Orton speaks. Even the movie's retrospective focus and elegiac tone make clear that, whatever changes Orton wished to effect, contemporary England retains no sign of his influence. In such a context, rebellion begins to seem a liberal affectation, and Orton himself less a rebel than a martyr.

Questions about talent, collaboration, and rebellion might arise in any biography. Yet in Orton's case these problems are complicated by his homosexuality. The difficulties of imagining a gay life for Orton are not exactly those that customarily haunt biographers. There is, for example, no debate whether Orton was and thought of himself as homosexual.[18] Nor do critics attempt to account psychoanalytically for the origins of his homosexuality. By Orton's own telling, his early gay experiences antedate most other specific facts about his childhood. At the same time, few accounts of his life see sexual preference as an integral part of his character. Sexuality is segregated from (and subordinated to) other personal traits, like ambition or a vaguely defined sense of specialness. As a result Orton's homosexuality cannot be viewed as a cause, only as an effect. Although his sexual identity is in fact the only unusual aspect of his early life, for example, it is rarely seen to contribute to his talent, which develops independent of (even in spite of) his sexuality.

The difficulty with which readers integrate Orton's sexual practices and his other characteristics is especially evident in the uneasiness about his dependence on others. In understating the collaborative dimension of Orton's work, critics are less concerned with denying his

debt to his actors and directors than with skirting the thornier issue of his debt to his lover. Everyone accepts the magnitude of the debt. In their initial years together, Halliwell was Orton's teacher as well as his breadgiver. The early writings were co-authored with Halliwell, and in the first Firbankian novels Halliwell's contributions were probably more substantial than Orton's own. Even the works signed by Orton alone probably incorporate Halliwell's prose. The unpublished novel "The Vision of Gombold Proval" (1961) shows some signs of Halliwell's style, and Orton himself referred to *Entertaining Mr Sloane* as "our" play. For the final works, as Orton acknowledged, Halliwell supplied the titles and certain symbolic dimensions. Yet, in general, criticism only admits this contribution negatively. Halliwell is traditionally blamed for the works' weaknesses, especially their mythic pretensions.

The failure to treat more seriously Halliwell's co-authorship marks an understandable lack of charity towards the man who is Orton's murderer as well as his life-partner. Yet difficulties in assessing Halliwell's contributions also involve misperceptions of the intersection between homosexuality and talent. The traditional division of Orton's life into the professional and the personal permits discussion of Orton's writing apart from his sexuality. But that division locates Halliwell entirely in the personal story. For all his supposed sexual timidity, Halliwell is customarily represented as more essentially gay than Orton himself: if Orton as playwright is not necessarily sexualized, Halliwell as lover is. This very sexualization makes it difficult to evaluate Halliwell's talent. To claim for the lover an influence on Orton's art is to introduce by the back door the very questions about the effect of homosexuality on Orton's style and themes which all accounts scrupulously avoid facing directly.

Sexuality complicates discussions of Orton most clearly, however, in considerations of his rebelliousness. In such discussions homosexuality would seem to be central, one of the most obvious marks of Orton's rebellion. Here too, however, sexuality is displaced. The focus regularly shifts, from homosexuality as a subject to homosexuality as a metaphor for revolt. Orton's rebellion is not seen as the activity of a gay man, nor do accounts consider the socio-political reasons for gay

anger. Instead homosexuality itself becomes an expression of an anti-establishment sentiment whose origin lies elsewhere. Translating the language of sexual difference into the language of rebellion may in some senses domesticate it. For the predominantly straight audiences of Lahr and Frears, rebellion is probably more familiar (and less frightening) than homosexuality. The translation implicitly reintroduces (and answers) the prejudicial question about the origin of Orton's sexual preference. By transforming homosexual rebelliousness into homosexuality as rebellion, critics present sexual preference as an effect, if not of personal psychology then of politics and sociology. Moreover, given the hints of martyrdom, homosexuality can seem to betray the rebellion it foments. Though not perhaps the cause of Orton's destruction, sexuality is at least the occasion for it.

The desexualizing tendency of the rebellion motif is clearest in the term "Ortonesque," coined to label Orton's unique style of rebellion. In his plays, Orton relied primarily on two comic techniques. First, he parodied the public language of morality, exposing the cruelty and sexual appetite it disguised. Traditional prudery was transformed into voyeurism, for example, by recasting morality as the desire to spy on the good.

> . . . love-making should be kept for one's marriage partner alone. Outside marriage the act may seem the same, but I have my doubts as to whether anyone derives any real and lasting satisfaction from it. There is no finer sight than two married people making love. (p. 182)

Second, in a related inversion, Orton regularly undermined gender conventions by treating heterosexuality as aberrant:

> FAY: It'd be better if I was present [at Truscott's interrogation of Hal]. He's more relaxed in the company of women.
> TRUSCOTT: He'll have to come to terms with his psychological peculiarity. (p. 243)

Yet the term invented to describe these comic techniques actually

obscures them. Neither the contempt for authority nor the inverted sexuality is addressed in traditional definitions of "Ortonesque" as "macabre outrageousness."[19] Moreover, the very invention of a neologism tends to isolate Orton's rebellion, much as Sontag's notes did to camp. As a category, the Ortonesque stands self-sufficient; as a "style" of rebellion, it has no content. It is both dissociated from Orton's customary objects of attack and isolated from the conditions that generated it. The concept of the "Ortonesque" has no necessary connection to sexuality or social background. Anyone can Ortonize, and in most biographical retellings all characters of whatever gender, class, and preference speak Ortonese.

Life as Visibility

All accounts of Orton acknowledge his sexuality, some to the exclusion of acknowledging anything else. Yet knowing Orton's homosexuality does not entail knowing him as homosexual. While his sexual practices are endlessly paraded before the reader with quasi-pornographic relish, these activities rarely impinge upon his literary achievements. This discontinuity in part suggests our difficulty in explaining the relation between sexuality and achievement in any form. We do not at present possess a sophisticated critical language for characterizing collaborative effort—whether the contributions of wives, lovers, or teachers—and even those gender critics who acknowledge sexuality as an element in creativity hesitate to declare it a cause.[20] Yet whatever the limitations of our analytic methods, Orton may himself have contributed to the process by which sexuality so regularly disappears from his writing. To present his sexuality to mainstream audiences, he had to make it both interesting and acceptable to them. Self-explanation inevitably transformed that self; and, in making sexuality visible, Orton made it visible as something else.

His own first biographer, Orton began the mythologizing of his achievements. Like many public figures, he regularly lied about his age. To heighten the mystique of his rapid rise, he rarely acknowledged the contributions of others. He was dismissive of his actors and directors, both in the early failures and in the much applauded *Loot*. Intolerant of attacks on his sexuality, he was less protective of his relationship to

Halliwell. His early press releases alluded vaguely to a wife, now estranged. He seems seldom to have defended Halliwell publicly against the homophobic condescension of his colleagues. The crew of *Sloane* called Halliwell "Mrs. Orton," evidently without rebuke. And by not answering the attacks of Willes and others, Orton publicly condoned them, however much he regretted them privately in the diaries.

Orton's ambition and self-protectiveness are understandable in a neophyte playwright trying to establish himself in a homophobic culture. More troubling is the symbiotic relation between his depictions of sexuality and traditional stereotypes. His public persona as sexual rebel overturned old clichés about homosexuality by substituting the new one of leather macho. His preoccupation with his physique and fear of effeminacy (not to say baldness) suggest tacit acceptance of his generation's gender definitions. Although challenging society's false notion of gay men as limp and lisping, Orton left unexamined the categories of the "masculine" and the sexually "natural" that underwrite such misconceptions.

His fictional inversions of sexual stereotypes are equally ambiguous. In his unpublished novel "The Vision of Gombold Proval" (1961, published in 1971 as *Head to Toe*), Orton critiqued cultural definitions through role-reversals and cross-dressing. Yet the text alternates between essentialist and constructionist definitions of sexual difference. In an early passage, Gombold finds himself in a matriarchal society, where he is forced to adopt traditional female dress and chores. Rebelling, he dresses in male attire and recovers his aggressiveness. One measure of this new mastery is his ability to distinguish between his three rebel accomplices—a man, a woman, and a youth—whom most of his feminized society perceive as identical. When subdued by his wife-master and again placed in female clothes, Gombold loses the ability to tell the three apart. With his final return to his "proper" attire, he regains the ability to distinguish.

Obviously concerned with the problem of sexual stereotyping, Orton's parable cannot decide exactly what is wrong with it. Although the ability to discover sexual identity seems a prerogative of power, Gombold sees that identity itself as absolute: "When I thought I was

a woman I imagined you [three] were indistinguishable; now that I am a man I see you are quite recognizable apart." The accomplices, however, respond that differences of gender and age are purely a matter of social conditioning: "Perhaps with suitable study you could learn to face the truth. We are indistinguishable."[21] Although Orton himself seems to agree with the three, his position is not self-consistent. The variations in Gombold's knowledge when he cross-dresses suggest the differences are not merely constructed. Were men and women "truly" equivalent, Gombold's own gender identification would not affect his vision. It is ironic that Gombold reaches the "correct" conclusion about indistinguishability when "misidentifying" himself as a female; but in terms of Orton's gender categories, it is incoherent as well. Indistinguishability requires that there be no way to identify a correct gender identification or a false one.

Although not fully resolved, the gender implications of this early parable are tantalizing. The sexual characterizations in Orton's plays are more reductive. Orton's female characters are simply disagreeable stereotypes, and his gay men, though more individualized, reinforce the very formulae they mean to overturn. *Entertaining Mr Sloane*, which treats the battle between the licentious Kath and her equally eager brother Ed for the sexual attentions of the passive hoodlum Sloane, broke English stage tradition by representing a non-effeminate gay man. Yet Orton was so aware of the outrageousness of depicting a homosexual as masculine that he attended very little to other aspects of the characterization; and Ed's character embodies many clichés about the homosexual as sociopath. Ed's comic misogyny seems merely displaced effeminacy, a sexual prudery that stands in for the more traditional prissiness of popular imagination. Structurally Ed's homosexuality is compared to the licentiousness of Kath, although her appetites are comically (and meanly) overstated, while his are represented less hyperbolically. This understatement makes Ed more appealing than Kath only by implying that homosexuality is so overstated in its initial choice of sexual object that further overstatement is unnecessary.

The character of Ed is as trapped in the stereotype of masculinity as previous stage homosexuals were in that of effeminacy.[22] Orton's sub-

sequent plays deal more subtly with questions of sexual preference. They argue principally that heterosexuality is itself a convention by which society imposes uniformity on a psychologically diverse and economically polarized population. Yet Orton's embrace of polymorphous perversity does not so much increase understanding of homosexuality as declare it irrelevant. *What the Butler Saw*, Orton's final play, frequently considered his masterpiece, revolves around multiple misidentifications, and at least three characters spend much of the play in clothes of the opposite sex. These inversions reveal the arbitrary nature of sexual desire. The most frequent butt of the humor is the character bent on stabilizing sexual difference: "There are two sexes. The unpalatable truth must be faced. . . . Rampant hermaphroditism must be discouraged" (pp. 415, 419). And rationality is represented by those characters who are able to face sexual ambiguity with equanimity: "Have you taken up transvestism? I'd no idea our marriage teetered on the edge of fashion" (p. 373).

Yet the ambiguity of desire in the play resides entirely at the level of plot. The sexual preferences of the characters are overt and immutable. The characters are all straight, and they never doubt their heterosexual allegiances. All the laughs in fact depend on a straight person's being falsely accused of deviance. The odd result is that homosexual desire is a punch line in the play; and although the humor resides in the falseness of the accusation, laughing at a false identification becomes indistinguishable from laughing at the idea of homosexuality. The sexual transformations on stage clearly intend to question the security of the audience's own sexual identity. But farce may not hold that kind of power over its spectators. Gender confusion does not confuse the play's characters; they are not disoriented by their changes in costume and identity, though they are irritated by the others' misreading of the significance of these changes. Orton's invocation of *The Bacchae* in the play's final moments does not reproduce the revolutionary sexual implications of the Greek original. When Dionysus forces the king to cross-dress in Euripides, a whole society and its moral code are left in ruins. The (unintentionally) transvestite sergeant who leads the cast offstage in Orton takes them back into middle-class morality, where police authority and compulsory heterosexuality reign.

The absence of homosexuality in *What the Butler Saw* suggests merely that Orton's primary target here was not sexual preference. The limitations of his mode of sexual characterization are more central, however, in *Loot*, his most commercially successful play and arguably his most polished. In *Loot* the traditionalism of the recently widowed McLeavy is played off against the unconventionality of the other characters—his larcenous gay son Hal, Hal's bisexual lover and fellow thief Dennis, the murderous nurse Fay, and the sadistic Inspector Truscott. The quintessentially "Ortonesque" plot employs maternal corpses and glass eyes to disguise a series of crimes for which the innocent McLeavy is finally incarcerated and presumably executed. Yet the plot's scapegoating of McLeavy can itself mask the play's central dramatic flaw—the thematic and even psychological inconsistency of the protagonist, his son Hal. To keep the plot moving, Orton saddled Hal with an unexplainable (and unplayable) character peculiarity, the inability to lie. He tries to defend himself against his lover's attack on this vestigial morality.

> DENNIS: Why can't you lie like a normal man?
> HAL: I can't, baby. It's against my nature. (p. 207)

Hal's very allusion to "the natural" seems out of place in a play whose more characteristic gesture is to destabilize any concept of nature. More in tune with the "Ortonesque" is Fay's normalization of lying: "Your explanation had the ring of truth. Naturally I disbelieved every word" (p. 223).

Hal's incongruous morality casts in an odd light his homosexuality, which lies at the intersection of his belief in nature and the play's more general distrust of the concept. Unlike the more overtly criminal Dennis, Fay and Truscott, Hal deviates from convention most in his sexual preference. Moreover, while for Dennis and Truscott (and probably Fay) sexual desire is purely situational, Hal is unequivocal and even monogamous in his choice of sexual object. Unlike the others, he speaks for the naturalness of homosexuality, not the unnaturalness of the natural. The inverted morality of the play forgives him his moral traditionalism (presumably his father's legacy)

only because of the criminality of his sexual interests. By the play's skewed logic the badness of homosexuality is its good. Yet such a characterization is not so much a redefinition of homosexuality as a redefinition of good. Even as the play attacks conventional notions of the natural, it leaves homosexuality in the space of the unnatural, where traditional morality has always placed it.

It is pointless to focus too exclusively on Orton's characterization of homosexuality. Satire may be a particularly difficult genre by which to effect a liberal critique. Its humor resides in the gap between how things at present are and how we all know they should be; without shared certainties the joke turns sour. Nor does the commercialism of the theater permit much deviation from accepted topics and narrative techniques. However carefully Orton inverted the generic conventions of the boulevard farces he wished to parody, he could never prevent later directors from blunting the satire by turning his pieces back into simple sex comedies. Objections to the politics of what Orton failed to do can miss the more fundamental truth of his achievement. To place gay characters of any sort on the English stage in the mid-1960s was an act of defiance.

The limits of Orton's rebellion are probably best understood not in terms of his politics but in terms of his literary method. A lack of contextualization characterized all aspects of his writing. The willed superficiality of his style made it difficult for him to construct fully imagined social environments. Orton's characters merely Ortonize, and his particular targets of satire are lost in his generalized satirical style. Early in *Loot*, Fay adorns a bier with an embroidered text of the Ten Commandments, saying that the dead Mrs. McLeavy "was a great believer in some of them" (p. 212). This good joke misses being a better one by failing to make clear which commandments Mrs. McLeavy broke and why Fay cares. Unlike Wilde, who would have individualized both Fay's morality and the corpse's, Orton has all his characters speak from the same position of deracinated rebelliousness.

It is anachronistic to attack Orton for failing to address political issues as they are currently understood. It is fair, however, to note more neutrally what battles remain to be fought. By constructing plays that would be commercially performable, Orton permitted his

audiences to escape the implications of his sexual rebelliousness. Attacking heterosexuality as a variety of gentility, Orton introduced a wider range of gender roles to the stage. But by implying the problem was gentility and traditionalism broadly conceived, and not compulsory heterosexuality as a cultural institution, he softened the blow. His plays do not require audiences to face the peculiarly stifling characteristics of sexual stereotyping. If anything they reinforce stereotypes—either in their traditional form or in a masculinized inversion that leaves the structures of repression unchanged. And by making individual nullification, not political activism, his preferred mode of reformation, Orton perpetuated a myth of individual initiative that may militate against social change.

There is no reason to assume that Orton's popularity derives from his political ineffectiveness or from his failure to make his work more irreducibly gay. Yet the inability of this most aggressively sexual playwright to keep the homosexuality in his work suggests one dilemma of transcultural dialogue, a dilemma of which the more obvious gap between Orton's life and his work is merely a symptom. The problem of writing a gay biography is finally the problem of describing an invisible life. A life not explicitly explained in terms of that gayness will not seem very gay. A life which makes that gayness visible, however, tends to convert it into something more easily known. To the extent that a life takes recognizable forms, it is difficult to demonstrate the influence of the gay subculture on those forms. Talent, affection, and hate can seem gender-neutral, independent of the sexual environment within which they operate. Only those characteristics demonstrably unique to the subculture appear to be part of it at all. Yet often these characteristics are not so much unique as unattractive. The authentically gay is too easily reduced to the pathological and, as in the representations of Orton, homosexuality can seem the failure of the personal.

It is impossible (and uninteresting) to seek the ultimate reason for such reductions. The problem may lie with Orton—his aesthetic choices, personal psychology, political naiveté, desire for commercial success—or with the various reinterpretations of his life and work by

friends, biographers, performers, and audiences both gay and straight. It is necessary, however, to identify these reinterpretations of his life and work extraneous cultural assumptions which do not so much explain Orton as explain him away. Without a clearer model for the intersection between the personal and the professional, we cannot hope to identify the influence of sexual preference on literature, or even its place in life. Gay biography must prove not only that a person was homosexual; it must establish homosexuality as a useful category with which to explicate individuality. Unless understood in terms of the cultural position it affords, sexuality will seem "just" personal, and gayness merely the backdrop before which some lives are played.

3

THE BEAST OF THE CLOSET

Sedgwick and the Knowledge of Homosexuality

*A*lthough long studied by scholars with "special interests," homosexuality has only recently reached a wide academic audience. In part a result of 1970s activism, this increased visibility marks as well the extent to which gay work has moved beyond its original historicist focus to address the kinds of theoretical issues relevant to other disciplines. In America the theoretization of gay male material in literature was pioneered by the work of Eve Kosofsky Sedgwick. Her books *Between Men: English Literature and Male Homosocial Desire* (1985) and *Epistemology of the Closet* (1990) took the examination of homosexual themes beyond the preliminary stage of cataloguing and consciousness-raising to make it a subject of serious theoretical interest.[1] Sedgwick's talent for conceptualization, in particular, uncovered in male-male relationships a series of interpretive categories that, by locating homosexuality within a larger sexual dynamic, lay the foundation for a truly ecumenical study of gender. It is difficult today to talk critically about sexual preference without reference to "homosocial desire," "homosexual panic," "paranoid gothic," or many of the other terms Sedgwick has read into our theoretical vocabulary.

Nevertheless, in creating virtually single-handedly a theory of gay literary discourse, Sedgwick also embedded in it certain assumptions about theoretical discourse, the history of difference, and the relation between categories and knowledge. The vocabulary that so enlivened her approach to identity unwittingly sacrificed some of the historical

precision and political urgency that made the study valuable in the first place. And while one would not want to deny her contribution, her assumptions must be examined (even unpacked) if gay studies are to continue to expand. For a critique of Sedgwick's work does not simply clarify the limitations of the most powerful academic model for treating male homosexual themes in literature. It defines more generally the models by which homosexuality is most commonly (and comfortably) conceptualized for a general readership.

Between Men and History

Sedgwick's project is to place male homosexuality and its attendant homophobia within a wider dynamic of social relationships. In *Between Men*, she studies from an explicitly feminist, implicitly post-Foucauldian perspective how the categories for conceptualizing same-sex interactions "between men" determine the character of a much broader spectrum of behavioral norms for men and women alike. Choosing literary examples from Shakespeare's sonnets through Whitman's leaves, with a particular emphasis on the gothic novels of the late eighteenth century and Victorian works by Dickens, Thackeray, and Tennyson, Sedgwick focuses on the category of the "homosocial," or social bonds among people of the same sex. She is especially interested in what she labels "male homosocial desire"—the potential for eroticism in male-male bonds, a potential that includes not only homosexual desire, but also feelings of fraternity, male bonding, and even homophobia. Stressing the continuity throughout these experiences, she explores the ways in which disruptions and oppositions within cultural definitions of "the homosocial" and "the homosexual" structure and shape what counts as sexuality. In particular she argues that the similarity between (socially acceptable) homosocial desire and (socially condemned) homosexuality lies at the root of much homophobia, and that this tension is misogynist to the extent that battles fought over patriarchy within the homosocial world automatically exclude women from that patriarchal power.

Even as Sedgwick offers a sophisticated model for understanding the social function of "homophobia," however, she may permit misreadings of a more elementary sort. Some of her vocabulary is

troubling both in its self-conscious anachronism and in its ironic deployment of words—like "campy" or "bitchy"—that have traditionally served as terms of ridicule. This incautious use of slang is compounded by Sedgwick's ambivalent relation to sexual clichés. Her point throughout, of course, is to overturn stereotypes, both by showing how the relations between men are more complex than the terms "homosexual" and "homophobic" imply, and by demonstrating how all such categories are themselves historical constructions. Nevertheless, in her attention to cultural constructs, Sedgwick treats as sociologically inevitable the same clichés concerning effeminacy, transvestism, promiscuity, and prostitution that she rejects as psychologically inaccurate.

Sedgwick surely has no desire to condone sexual stereotypes. In her conclusion she demonstrates their inherent falseness by deconstructing as ahistorical and antisocial the category of the "natural" on which they all depend: "the 'natural' effeminacy of male homosexuals, their 'natural' hypervirility, their 'natural' hatred of women, their 'natural' identification with women—this always-applicable reservoir of contradictory intuitions, to which our society is heir, must not be mistaken for a tool of analysis" (*BM*, 215). Yet clichés are powerful, if only in their linguistic compactness; and the associations they foster tend to linger like smoke after fire. Four pages before this disclaimer, for example, Sedgwick argues of Victorian sexologist John Addington Symonds that "[his] lack of interest in women as sexual partners seems to have allowed him to accept unquestioningly some of the most conservative aspects of his society's stylized and constricting view of them." Her admission a few sentences later that "his misogyny was not greater and may well have been less than that of an identically situated heterosexual man" (*BM*, 211) does not erase the initial yoking of homosexuality and woman-hating: Symonds's aberrant sexuality "allowed" his gender stereotyping, but is not similarly named as the cause of his comparative lack of misogyny.

Sedgwick's ambiguous use of stereotypes marks her more general tendency to blur the line between life and literature, ignoring the ways in which, once constructed, categories can in time take on lives of their own. In analyzing the motif of male rape in late nineteenth-cen-

tury fiction, for example, Sedgwick builds to T. E. Lawrence's graph-
ic description of his rape by the Turks in *Seven Pillars of Wisdom*.
Sedgwick emphasizes the literariness of this description of a "real
rape," and its troubled relation to English notions of empire and the
oriental (*BM*, 193-96). One might, of course, challenge the general
assumption that autobiography as a genre deals with the real rather
than the literary. Sedgwick's willingness to accept the reliability of
this particular autobiographical account, however, is even more sur-
prising. Lawrence has always been a problematic historical figure,
both for his sexual ambiguity and for his willingness to cooperate (at
least) with his transformation into the mythic "Lawrence of Arabia"
by the accounts of Lowell Thomas and other romanticizers. That
Lawrence may be an active propagator of the homophobic discourse
Sedgwick is trying to deconstruct (and that the notorious "real" rape
may not have taken place, at least as Lawrence describes it) compro-
mises his value as cultural barometer.

The limitations of Sedgwick's language and historiography are most
obvious in her chapters on the gothic novel, where many of the cen-
tral concerns of her book come together. Here Sedgwick argues that
the gothic novel arose at roughly the same time that homosexuality in
England took on the character of a distinct subculture. The rise of this
subculture was, she insists, part of a larger process of definition,
involving not only all homosocial bonds between men but also the
relation between the sexes in modern society. To characterize these
homosocial tensions, Sedgwick introduces one of her most celebrated
terms—"homosexual panic." Borrowing from Sigmund Freud's 1911
account of the paranoid psychosis of Dr. Daniel Paul Schreber, Sedg-
wick defines this panic as the homophobic blackmail experienced by
men who fear that their "homosocial bonds" might be perceived as (or
even actually be) antisocial "homosexuality." She then locates the fic-
tional equivalent of this homosexual panic in the "paranoid" plot of
certain gothic novels, in which a man stands in a life-threatening rela-
tion to a male double (*BM*, 88-92).

The linking of "homosexual panic" and the "paranoid gothic" to
develop a "homophobic thematics" is an interpretive move of consid-
erable power for a theory of the novel. Yet the relation of these

thematics to historical homosexuality is less clear. Arguing that the rise of a homosexual subculture cannot be understood apart from what she earlier called the "larger question of 'sexual politics'" (*BM*, 5)—in this case, the sexualization of political or social relationships—Sedgwick offers a model for such a "larger" reading in terms of the literary representations of homosexual panic as paranoid gothic.

> The Gothic novel crystallized for English audiences the terms of a dialectic between male homosexuality and homophobia, in which homophobia appeared thematically in paranoid plots. Not until the late-Victorian Gothic did a comparable body of homosexual thematics emerge clearly, however. In earlier Gothic fiction, the associations with male homosexuality were grounded most visibly in the lives of a few authors, and only rather sketchily in their works. (*BM*, 92)

The analysis is inconclusive, both in its shift of focus from the homosocial to the homosexual and in its delineation of the audience's relation to a homosexual thematics.

But more disconcerting is Sedgwick's introduction of an *ad hominem* argument—her final admission that this thematics rests less on plot contrivances than on the "visible" sexual preferences of the authors. Earlier in the same paragraph, Sedgwick begins to talk for the first (and in this book virtually the only) time about the sexuality of the authors. Three of the major gothic writers were perhaps gay: in Sedgwick's characteristically slangy formulation, "Beckford notoriously, Lewis probably, Walpole iffily" (*BM*, 92). Yet the authors she identifies as gay are not those who wrote the novels she identifies as paranoid. All the novels she mentions are written by heterosexual men, except for the two written by a heterosexual woman. The issue is not really Ann Radcliffe's relation to homosexual panic (although one would like to hear how that might work). Instead one wonders what positive purpose is served by naming (as gay) writers who have no direct relation to the argument. Sedgwick's answer—that readers knew some authors to be gay, other plots to be (faintly) homophobic, and then conflated the two categories—seems both unlikely and

inconsistent. It requires that the audience be preoccupied with the very category of "the homosexual" which Sedgwick claims has not yet been constructed. Yet the only other answer—that she herself enjoys naming the names—positions Sedgwick less as analyst of homosexuality than as informant for heterosexuality.

The chapter's problem differentiating between gay thematics and gay people suggests a more general confusion throughout *Between Men* about the epistemic status of analytic categories. Exactly how do concepts like "homosocial desire," "homosexual thematics," or "the homosexual" illumine (or even hook up with) sexual preference as an historical reality? Part of the problem rests in an occupational hazard of literary critics—our tendency to read fiction as an unmediated record of the society that produced it. In Sedgwick, this tendency is compounded by her Foucauldian sense that sexuality *is* textuality, that there are no social realities behind sexual categories. By this view, "sexuality" is not a constant or even a concept, but an ideologically determined way of talking about sex, a network of "discursive practices" which in their deployment of power virtually make sex disappear. For this reason Sedgwick, like most post-Foucauldians, is skeptical about "anachronistically" labeling male-male desire "homosexual" before the second half of the nineteenth century when the term (and discursive formations attending it) first appeared (*BM*, 38). And, like some, she reads textual formulations about sexuality not as exemplary but as constitutive: literature and life are interconnected fictions, and all terminology defining social relations exists implicitly within quotation marks.

Social constructionism may itself tend to overstate: that the categories of race, class, gender, and sexual preference are constructed by society does not necessarily imply that they do not build on prior empirical realities or define subsequent ones. More troubling than constructionist nominalism, however, is Sedgwick's inconsistent application of this principle of discourse theory. Of her four central categories—"homosexual," "homosocial," "homosexual panic," and "paranoid gothic"—the Victorian term "homosexual" is, as she herself acknowledges, the oldest. "Homosocial" and "homosexual panic" are relatively recent neologisms, drawn from mid-twentieth-century writings

in sociology and psychiatry respectively. ("Paranoid gothic" is, of course, her own invention.) Yet the central thrust of Sedgwick's argument—to place the homosexual within the larger context of male homosocial desire—treats "homosexual" as a cultural construction and "male homosocial desire" as a timeless entity. Even if one cannot speak of "the homosexual" before 1869, that still leaves the term more than a century before it can be placed in the context of 1985's "homosociality." Similarly, Sedgwick's discussions of the paranoid gothic and of homosexual panic are surprisingly positivist, depicting a world of "crystallized dialectics" and "emergent thematics" around a sexual identity still struggling to be constructed.

The Closet and the Confidante

There is, then, throughout *Between Men* a fundamental tension in Sedgwick's use of the vocabulary of homosociality. On the one hand, she wishes to address the previously silenced question of sexuality in literature by showing the influence of categories describing male-male relations on a whole range of cultural assumptions about gender, class, and national identity. On the other hand, she avoids a more direct demonstration of the social operation of these categories by treating them as linguistic phenomena, implying that there is no sexuality outside of language. It might be possible to resolve the apparent contradiction between the claims that sexuality counts and that it is a fiction. Yet in terms of her treatment of homosexuality this general paradox is complicated by two problematic moves: her desire to subordinate homosexuality to "larger questions" of society and sexuality; and her attempt to thematize homophobia and the homosexual/heterosexual dichotomy that underwrites it as "homosexual panic."

Sedgwick implicitly addresses these limitations in her later, more sophisticated account—*Epistemology of the Closet*. The book begins by defining as antinomies what I have marked as tensions within the earlier work. Stigmatizing as "universalizing" her previous reading that the distinction between homo- and heterosexual is of interest to people across a wide range of sexualities, Sedgwick contrasts this view to the equally limited "minoritizing" sense that the distinction is important only to those most directly experiencing the effects of this

discrimination. She similarly problematizes both her former tendency to read same-sex object choice transitively "between" genders and the complementary "separatist" emphasis on dynamics "within" a single gender. Rejecting such contradictory readings as irresolvable, she proposes instead to read in a unitary fashion the bifurcation of sexual identity effected by the dichotomy between "hetero-" and "homo-." She argues that, at many major intellectual points, Western culture is structured around the "crisis of homo/heterosexual definition," and that failure to consider this definition "damages in its central substance" our understanding of all aspects of modern Western culture (*EC*, 1-2).

This revised formulation avoids the more obvious paradoxes of *Between Men*. By paying less attention to her categorical neologisms, especially "the homosocial," Sedgwick is able to argue more consistently for the nominalism of her social constructionist position. Moreover, by focusing on the "homo/hetero dichotomy," she avoids explicitly subordinating homosexuality to heterosexuality. As a result, the second book deals directly with self-identified gay writers without reference to abstractions like "male homosocial desire." Yet the greater precision and facility of the theoretical terminology does not eliminate the ambiguities of intention and position that inform the earlier book's delineation of homosexual thematics. Nor does it reverse the process by which historical events are subsumed by intellectual categories. To understand more precisely how these concerns affect Sedgwick's representation of homosexuality, however, we must consider how they inform one such extended reading—her pivotal analysis of Henry James's "The Beast in the Jungle."

James's short story presents John Marcher's search with his friend May Bartram for the "something rare and strange, possibly prodigious and terrible" that he feels is his special destiny, his "beast." The narrative of the story intertwines the pair's long discussions about Marcher's self-definition with May's attempts to suggest for him other social possibilities. May's subtle suggestions—epitomized by her courageous walk from the chair to the fireplace at the height of her illness—remain unnoticed by the self-involved Marcher, as does her waning health. In the final chapter, while visiting May's grave,

Marcher sees in the face of another mourner the emotional intensity that he himself has lacked. He concludes that his fate is an empty one, that "he had been the man of his time, *the* man, to whom nothing on earth was to have happened." Readers often connect this vision of emptiness with his failure to love May, a love that in the final pages Marcher himself feels would have allowed him to "escape" into "life."[2]

It is this last sentimentalized reading—with its universalizing equation of the "everything" that Marcher has missed with the spurious universal of prescribed heterosexual desire—that Sedgwick wishes to challenge. Recontextualizing the story within both homosocial tensions and (less emphatically) James's own sexual ambivalence, Sedgwick argues that the absence in Marcher's life is not general but specific. His secret is in fact two secrets: first the belief in his specialness, which he shares only with May; and second the nature of that specialness, a mystery to everyone including Marcher. Sedgwick then associates the unnameability of that second secret with the less mysterious but equally unnameable "Love that dares not speak its name." This reduction works, according to Sedgwick, both ways. Not only does the notion of the mysterious effectively silence homosexuality; but the implication that all silences are homosexual reduces homosexual meaning to a single thing, a "We Know What That Means." Marcher's outer secret, "the secret of having a secret," functions as a closet within which hides not a secret homosexual, but "the homosexual secret—the closet of imagining *a* homosexual secret" (*EC*, 205).

This reading offers a healthy correction to the impressionistic metaphysical readings of Marcher's absence as divorced from any context, either his own or his author's. Yet Sedgwick's characterization of Marcher's dilemma as "homosexual panic" has its own limitations. It does not of course aspire to simplicity or even verifiability: such an interpretation turns on their heads most readings of Marcher's psychology. Usually Marcher is accused of an excessive intellectualism that separates him from reality and especially blinds him to love. For Sedgwick, however, the problem is not too much thinking but too little. Her precise identification of Marcher's beast may have the paradoxical effect of making him seem less obtuse: Marcher's igno-

rance is psychologically understandable if there is a real beast he is avoiding. Nor is it encouraging that Sedgwick's subtle pairing of Marcher's personal sense of specialness with a culturally ubiquitous homosexual panic tends to reduce so quickly to the claim that Marcher simply fears his own homosexuality. It is in this form that Ruth Bernard Yeazell, the editor of the anthology where the article first appeared, summarizes the argument in her own introduction.[3]

But more important than argumentative inelegance is the way in which Sedgwick does not take seriously the dilemma of the panic as she herself defines it. Sedgwick implies that greater self-knowledge would help Marcher overcome his panic. Yet both our understanding of the historical moment and her own reconstruction of it show the difficulty of such a resolution. Resolution of the panic in the direction of overt homosexuality was at the time of the story theoretically possible but socially suicidal. Locating the story when "the possibility of an embodied male-homosexual thematics has . . . a precisely liminal presence," epitomized by the "Wilde trials" (*EC*, 201), Sedgwick acknowledges the existence of Wilde's "thematic discourse" without admitting the punitive authority of its setting. Marcher, like Wilde, could triumph over his panic in this direction only by leaving the closet for the gaol. The alternative choice of heterosexual love, however, is likely to look more expedient than self-knowledgeable in this context. Far from resolving the individual's panic, it would only direct that panic outward; and questions about "which do I desire?" would merely redefine themselves as a similar anxiety about "why do I desire what I desire, or pretend to?" Given such a dilemma, Marcher's uncertainty seems less self-ignorance than political and epistemological self-preservation.

Sedgwick's simplification of Marcher's psychological situation is compounded by her complication of May's. Although most readings emphasize May's love for Marcher and her hope that he will reciprocate, Sedgwick sees such interpretations as repressive in their prescribed heterosexuality. For Sedgwick "homosexual panic" arises from having cut up the sexual world into homosexual and heterosexual in the first place. In such a context heterosexual love can afford Marcher no solace. May can only dissolve Marcher's panic by offering

a "more fluid" representation of sexual options, one in which hetero-
sexual desire is merely one pole in a continuous range of sexual
possibilities. Yet such a rereading of May's intentions is troubling. Not
only does it ignore those scenes, like the famous cross to the mantle,
where May does seem to offer her (heterosexual) self emotionally to
Marcher; it makes the reticent May even more passive than in con-
ventional readings. However much May's lessons in sexual fluidity
may profit Marcher, they do her little practical good. And rather than
attending to her own emotional needs she is reduced to disinterested-
ly explaining Marcher's to him.

As Sedgwick herself confesses, this reading of May is not simply too
passive; it is problematic on its own terms. In substituting the idea of
May as teacher for that of May as lover, Sedgwick seems to make May
the apologist for the very hetero/homo dichotomy she means to over-
turn:

> It leaves us in danger of figuring May Bartram, or more gen-
> erally the woman in heterosexuality, as only the exact, heroic
> supplement to the murderous enforcements of male homo-
> phobic/homosocial self-ignorance. . . . She seems the woman
> (don't we all know them?) who has not only the most delicate
> nose for but the most potent attraction toward men who are
> at crises of homosexual panic . . .–Though, for that matter,
> won't most women admit that an arousing nimbus, an exces-
> sively refluent and dangerous maelstrom of eroticism, some-
> how attends men in general at such moments, even otherwise
> boring men? (*EC*, 209)

The kind of woman here discussed is stigmatized in gay slang with
the unpleasant term "fag hag." Whatever the sources of other forms
of gay misogyny, this concept of the "fag hag," with its particular con-
tempt for the sympathetic female, arises primarily from a self-hatred
so intense as to reject all incoming affection. The gay man supposes
himself to be so repulsive that the affection of any woman is read as a
mark of her abnormality, a psychotic attraction to the inherently
unlovable. (A similar catch-22 infects any straight man's friendship:

by liking a gay man, the heterosexual male proves himself secretly gay, and therefore contemptible.)

As Sedgwick insists, May is not in any simple sense a fag hag. Yet May, who never before needed a reason for her actions, now needs to be protected from the obvious ones. Her project, as Sedgwick understands it, is to help Marcher come "out of the closet—whether as *a homosexual man*, or as a man with a less exclusively defined sexuality that nevertheless admits the possibility of desires for other men." Such self-acceptance is to be achieved through "a genuine ability to attend to a woman . . . to perceive the attention of a woman as anything other than a terrifying demand or a devaluing complicity" (*EC*, 206-207). Thus even May's "less exclusively defined" sexual world is heterocentric, figuring desire "between" men as ultimately "about" women. Sedgwick's "Beast" remains very much a boy-girl story, and May's desire that Marcher come to terms with women sounds dangerously like the traditional (misogynist) assumption that fag hags hope to convert gay men to heterosexuality. As in her use of stereotypic language, Sedgwick may simply concede too much. Herself admitting the accuracy of the category of the fag hag—"(don't we all know them?)"—and acknowledging that "most women" feel this pull at times, Sedgwick makes it difficult to distinguish between May's nobility and sexual opportunism.

The pitfalls of Sedgwick's account of May's "cognitive advantage" as a heterosexual woman in "fostering . . . homosexual potential" (*EC*, 210) are matched in her representation of Marcher's ignorance as a closet. The notion of the closet that Sedgwick imports from gay propaganda is itself anachronistic—the construct of a culturally specific mid-twentieth-century rhetoric of paranoia and repression, and of a 1960s and '70s attempt to overturn that oppression through "coming out." In assimilating this rhetoric to her "homophobic thematics," Sedgwick shifts the emphasis from self-acceptance to the preliminary stage of self-knowledge. Not the closet in which a homosexual traditionally hides from public persecution, Sedgwick's "closet" involves instead the very nature of homosexual meaning, the "closet of imagining *a* homosexual secret." Her italicized "*a*" presumably points to the purported singularity of homosexuality: culture's false conviction

that "we all know what *that* means." But in collapsing cultural constructions of sexuality with Marcher's sense of self-importance, Sedgwick minimizes the practical reasons for being in the closet. Her reading of discourse stigmatizes as traumatic what may be for Marcher merely private: no one thinks of himself as in a closet, however much others "know" him to be there.

The salient feature of Sedgwick's closet, and its difference from the closet of gay propaganda, is not only that there is no homosexual inside it, but that there must never be. Thus in some senses Yeazell's misreading of Sedgwick's interpretation is not erroneous but inevitable and necessary. Yeazell merely focuses on Sedgwick's most striking silence: her "homosexual meaning" can never mean homosexuality. By redefining the nature of the relationship between Marcher and May in terms of "homosexual panic," Sedgwick ignores the complementary possibility that Marcher might be unanxiously gay but simply unwilling to tell May of his (dis)interests. Such a reading of Marcher as actively homosexual is not a "better explication"; it probably illumines the story less than Sedgwick's account. But given her own presuppositions, it seems one that Sedgwick should consider, if only to reject. That she ignores it suggests that, in her psychologized closet, only confused heterosexuals or latent homosexuals can hide. The definition of homosexuality as an internal problem of self-knowledge rather than an external one of social intercourse is itself her entrapping closet.

The presence of this always-already-absent homosexuality is felt clearly in the most extravagant of Sedgwick's analyses: her account of the non-cruise at the cemetery. In Sedgwick's reading, Marcher's final turning away from the grief-stricken man in the graveyard is more precisely "his desire for the male face" only afterward turned into "an envious identification with male loss" (*EC*, 212).

> The path traveled by Marcher's desire in this brief and cryptic nonencounter reenacts a classic trajectory of male entitlement. Marcher begins with the possibility of *desire for* the man Deflecting that desire under a fear of profanation, he then replaces it with envy, with an *identification with* the

man in that man's (baffled) desire for some other, presumably female, dead object. (*EC*, 211)

What is striking about this reading is how little it has to do with the kind of sexual anxiety previously attributed to Marcher. It may be that the sequence of man's-desire-for-man-subsequently-deflected is a "classic trajectory of male entitlement"; it invokes surely the traditional model of the closet as a place to hide forbidden love. It is not, however, the model of Sedgwick's closet of homosexual panic, where overt homosexual desire is avoided at all costs. The more likely reading in terms of homosexual panic would have Marcher first experience homosocial grief, only to suppress it for fear that it would appear indistinguishable from (or even secretly be) a form of homosexuality. And, of course, once again Sedgwick ignores the actively homosexual reading that her categories seem to invite: Marcher turns away from the man out of not cowardice but decorum. Nice gays don't cruise graveyards.

The final paragraph of Sedgwick's analysis epitomizes the difficulty she has dealing with unapologetic forms of gay male experience.

> When Lytton Strachey's claim to be a conscientious objector was being examined, he was asked what he would do if a German were to try to rape his sister. "I should," he is said to have replied, "try and interpose my own body." Not the joky gay self-knowledge but the heterosexual, self-ignorant acting out of just this fantasy ends "The Beast in the Jungle." To face the gaze of the Beast would have been, for Marcher, to dissolve it. To face the "kind of hunger in the look" of the grieving man—to explore at all into the sharper lambencies of that encounter—would have been to dissolve the closet, to recreate its hypostatized compulsions as desires. Marcher, instead, to the very end, turns his back—recreating a double scenario of homosexual compulsion and heterosexual compulsion. (*EC*, 212)

We need not mention yet again the political naiveté of believing the

problem of sexuality will dissolve when faced. Still, one must note the disproportion between the supposedly twin compulsions. The "heterosexual compulsion," as Sedgwick states in her preceding paragraph, is society's insistence on heterosexuality as compulsory, what is more customarily called "compulsory heterosexuality." The nature of the "homosexual compulsion," however, is less well defined. Not previously explained, it seems an ominous outgrowth from terminology that started as "homosexual panic" and progressed to "homosexual potential." It is unclear exactly where *this* compulsion lies, except perhaps in an alleged promiscuity which leads homosexuals to leave no gravestone unturned. That it does not lie in a self-accepting homosexuality is clear in Sedgwick's treatment of Strachey. She does not merely squelch his campy joke by misapplying it to a scene of greater seriousness. By labeling his quip a mark of "gay self-knowledge" (did Strachey *really* desire the Hun?), she effectively reduces gay self-knowledge to a camp.

Ethnography of the Closet

It would be inappropriate to submit to microscopic interrogation the formulations of work whose mode is both revisionist and hyperbolic. Yet however hypnotic Sedgwick's use of James's "The Beast in the Jungle" as an allegory for sexual self-definition, one must recognize that in at least one respect she does not take seriously enough her insight that certain discourses make certain concepts inconceivable. Sedgwick optimistically imagines that May can somehow dissolve Marcher's dilemma by explaining it to him. Similarly she ignores the extent to which her own critique of an "epistemology of the closet" does not evade that disciplinary metaphor but makes it more central. At the start of his history of sexuality, Foucault warns that repression works not through silence but through "discursive explosion."[4] In demonstrating the impossibility of homosexuality within a nineteenth-century epistemology of desire, Sedgwick may have replicated the repressions of that homophobic discourse. Focusing on straight pathologies, she does not escape closet rhetoric but proliferates it. Her categories minimize the role of the healthy, well-adjusted male homosexual while affording pride of place to two chief myths of gay

self-contempt—the fag hag and the closet queen. The question is not why Sedgwick has so fully invested in these categories, but what assumptions allow her to see these stereotypes as potentially gay-affirmative.

Sedgwick understandably tells the story of sexuality in terms of those critical models—Freudian, Foucauldian, feminist—that she has found most useful in other work. Although there is no way to predict before the fact whether or not these methodologies will illuminate sexual preference, there is, she suggests, no reason not to try (*EC*, 27). At the same time, her account suffers from what might be called a genetic fallacy—the belief not simply that others can learn from the findings of these disciplines but that the learning process must duplicate the procedures by which those conclusions were reached. That Gay Studies depends on the findings of feminism, for example, is undeniable. It is less certain, however, that it "still has a lot to learn from asking questions that feminism has learned to ask" (*EC*, 32). Not only might one learn the answers without repeating the questions. The warning that Gay Studies still has "a lot to learn" imposes too clearly a model of teacher/pupil on the relation between disciplines. In Sedgwick's analysis education works in only one direction: Freudianism, Foucauldianism, and feminism never learn from homosexuality.

Sedgwick's prescriptive pedagogy is compounded by an unwillingness to consider her own cultural position in relation to the topic she studies. Her refusal to support the discriminatory mentality that divides the world into heterosexual and homosexual is, of course, laudable. But one may not be able simply to overturn historical categories (even such relatively recent ones) unilaterally by collapsing them into neologistic binarisms like "homo/heterosexual." There is nothing wrong with Sedgwick's sexual self-definition as heterosexual, nor does it disqualify her as a student of other sexualities. Yet the privileges she derives from her socially sanctioned position should be acknowledged. When she claims, for example, to live "in a state where certain acts called 'sodomy' are criminal regardless of the gender" (*EC*, 47), her (accurate) definition of North Carolina's penal code obscures the political fact that the law is never directed against people of her

sexual self-identification. Whatever its explicit definition, "sodomy" has always functioned primarily as a code-word for gay male intercourse, so much so in fact that the actual practices it identifies are not at all clear.[5]

In repressing her sexual position Sedgwick does not banish heterosexuality from her analysis but unwittingly invites it to "return" disguised as a cultural universal. Her formulations regularly imply the normative character of heterosexuality. In defining male homosexual panic as "the normal condition of the male heterosexual entitlement" (*EC*, 185), she conflates normalcy and homophobia in a way that necessarily excludes homosexuals as both disempowered and abnormal. Heterosexism informs her sympathetic statements as fully as her more stereotypic ones. Reviewing recent advances in sexual toleration, Sedgwick warns:

> The number of persons or institutions by whom the existence of gay people—never mind the existence of *more gay people*— is treated as a precious desideratum, a needed condition of life, is small, even compared to those who may wish for the dignified treatment of any gay people who happen already to exist. Advice on how to make sure your kids turn out gay, not to mention your students, your parishioners, your therapy clients, or your military subordinates, is less ubiquitous than you might think. (*EC*, 42)

The passage is a throwaway—and wholly antihomophobic. Yet it addresses only the straight component of Sedgwick's audience. It is perhaps overscrupulous to worry that Sedgwick so quickly places homosexuality under the tutelage of the family, ignoring those gay (and straight) people who operate outside a family model and those who are skeptical about parents' educative capabilities. It is, however, impossible to ignore the implicit exclusion of gay people from the constituency of the passage's "you." Homophilic advice is not less ubiquitous than gay people "might think" (we know its scarcity all too well). Moreover, such advice is, within the gay community, more common than Sedgwick realizes. And the whole pedagogic thrust of

"advice" raises questions about Sedgwick's tonal relation to her gay readership. Who is teaching whom about what?

There is, of course, nothing inherently wrong with limiting one's audience or even with writing heterocentric analyses of gay culture. The difference between Sedgwick's antihomophobic formulations and their implications for gay readers, however, does raise questions about the importance of cultural positioning in general. The issue is not the crudely psychobiographical one of how and why Sedgwick came to know what she knows, but instead how that knowledge is affected by her position toward her object of study. What does it mean for any-one to "know" an "other" and what are the procedures by which that other is known—the epistemology of Sedgwick's own "epistemology"? To consider these more political, even ethical questions, we must shift methodologies—from the literary theory used to illumine texts to the ethnographic theory traditionally used to speak of other cultures.

Interest in others is intimately connected to the exploration and colonialism undertaken by Western civilizations since the late fif-teenth century. It is, at least, at the height of the English empire in the nineteenth century that the modern discipline of anthropology was born. The motives for cultural studies varied. Some were crassly economic or ideological. In this context the search for knowledge merely reinforced the territorial imperatives of the exploring society. The mastery of another culture made it easier for missionaries to con-vert and colonizers to exploit. Even those who preferred the foreign cultures to their own usually sentimentalized the other as a noble sav-age or an Adamic innocent. To counter ethnography's tendency to foster the nationalism it meant to critique, twentieth-century anthro-pologists emphasized the empirical dimensions of their work. The model ethnographer was neither missionary nor primitivist but a dis-interested fieldworker-theorist or "participant observer," who, in James Clifford's able summary, engaged "in a continuous tacking between the 'inside' and 'outside' of events: on the one hand grasping the sense of specific occurrences and gestures empathetically, on the other stepping back to situate these meanings in wider contexts."[6]

Recent anthropological theory has questioned whether participant observation wholly escapes the problem of cultural imperialism or

even accurately describes what happens in studying other cultures. In part this critique registers a general sense that the category of "disinterestedness" obscures the interestedness of any endeavor—the unstated intellectual and cultural presuppositions that all researchers necessarily bring to their work. In part it marks a more specific dissatisfaction with the ways in which the model unintentionally privileges certain ways of knowing over others. Some theorists have even questioned the coherence of "fieldwork" as a concept. The dichotomy between "field" and "home" mistakenly implies that the "field" is not also a home to some culture. The notion that "we" as scientists study "them" as social phenomena misrepresents how data is gathered. Scientists can never be certain that their information is not censored, or at least shaped, by the personal prejudices of their tribal "informants," who in summarizing and translating cultural traditions function as indigenous collaborators.

Comparable questions about sources and informants might be raised about Sedgwick's work in the "field" of homosexuality. In a resonant passage for theorists of cultural difference, Mikhail Bakhtin has explained:

> Language, for the individual consciousness, lies on the borderline between oneself and the other. The word in language is half someone else's. It becomes "one's own" only when the speaker populates it with his own intention, his own accent, when he appropriates the word, adapting it to his own semantic and expressive intention. Prior to this moment of appropriation, the word does not exist in a neutral and impersonal language (it is not, after all, out of a dictionary that the speaker gets his words!), but rather it exists in other people's mouths, in other people's contexts, serving other people's intentions: it is from there that one must take the word, and make it one's own.[7]

It is this notion of exchange between cultures that is most noticeably absent in Sedgwick. There is little sense of dialogue or collaboration in Sedgwick's presentation of her analytic categories and

especially the language she uses to describe gay culture. Her account of "The Beast in the Jungle" minimizes the extent to which May and Marcher conspire together in defining the beast. Instead May's "cognitive advantage" depends on her status as outsider, the extent to which "it is always open to women to know something that it is much more dangerous for any nonhomosexual-identified man to know" (*EC*, 210). Not even a "participant observer," May is cast as the hectoring missionary bringing the word to the benighted. Such an allegory loses much of the texture of James's narrative, whose meaning is so much less important than its manner of unfolding. Whatever we think of the characters' search for a beast, our pleasure in the story rests in exactly that aspect that Sedgwick slights—the imaginative richness of the dialogues between May and Marcher and the improvisatory freedom with which the two endlessly consider (and reject) possible interpretations for the beast.

As Sedgwick oversimplifies the exchanges between May and Marcher, so she underimagines the complexity of cross-cultural discourse. A richer account of multiethnicity would acknowledge the collaborative quality of all language, the way in which terms are always "half someone else's." Take, for example, the history behind one of Sedgwick's central concepts, "homosexual panic." The term derives from a now discredited psychiatric association between homosexuality and paranoia. The association began in Freud's analysis of the paranoid Dr. Schreber, an account some modern critics find homophobic.[8] Whatever Freud's intentions, his followers tended to take as axiomatic that homosexuality caused paranoia, and many early studies of homosexuals were instead studies of paranoids. In the psychiatric establishment after World War II, the term "homosexual panic" characterized this problematic relation between paranoia and homosexuality. Most neutrally it described the rage males express as a result of their confusion over sexual desires. Less sympathetically, it sometimes ascribed that rage to the paranoia all homosexuals were presumed to feel.[9]

In her recuperation of the term, Sedgwick represses the fact that at least for gay readers "homosexual panic" already has a history. She downplays the extent to which the psychic phenomenon it defined

traditionally resulted in gay-bashing, oddly choosing the meditative Marcher as the exemplar of psychic violence. Although in its original psychiatric use the panic could also be experienced by homosexuals, Sedgwick makes it exclusively the problem of sexually embattled straights: "the treacherous middle stretch of the modern homosocial continuum, and the terrain from whose wasting rigors *only* the homo-sexual-identified man is at all exempt" (*EC*, 188; cf. *BM*, 116). Sedgwick means this exclusion to be empowering for gay males. Yet in terms of the psychiatric context from which the term derives, the claim that anxiety is always heterosexual reproduces another homo-phobic commonplace of post-war therapy—the insistence that a patient's homosexual longing is imaginary, merely the customary growing pains of heterosexuality. Thus the concept at the center of Sedgwick's encouragements to come out of the closet sounds danger-ously like that traditionally used to encourage gay people to stay hidden.

"Homosexual panic" then can mean different things (or mean in different ways) to gay and straight readers. These very differences, whose repression makes Sedgwick's use of the term seem heterocen-tric, might if acknowledged make it a powerful tool in antihomophobic discourse. The same equation of paranoia and homo-sexuality that psychiatrists have used for homophobic purposes has been used by students of post-colonialism to destabilize the language of authority. Homi Bhabha, for example, has argued that "paranoia" defines the psychology less of the disenfranchised than of the empow-ered. The native's silent refusal to authenticate colonial authority is redefined by the oppressor as unmotivated aggression on the part of the other: "He hates me."[10] So similarly one might use the concept "homosexual panic" less to describe the psychology of sexually embat-tled males than to reveal the strategies by which society renders sexuality as a site of embattlement. The true panic arises not when an individual fears abnormal desires; it appears when society fears for its concept of normalcy.

Other Knowledge

A fuller acknowledgment of her cultural position and of the dialogic

dimension of language might diffuse the heterocentrism of Sedg-
wick's formulations. Yet Sedgwick's relation to her material only raises
more fundamental questions about what it means from any position
to "know" homosexuality. At the heart of Sedgwick's epistemology of
the closet is the belief that knowledge and homosexuality are inter-
connected: "the *special* centrality of homophobic oppression in the
twentieth century, I will be arguing, has resulted from its inextricabil-
ity from the question of knowledge and the processes of knowing in
modern Western culture at large" (*EC*, 33-34). Such questions and
processes, however, cannot be separated from the social conditions of
their knowing. Knowledge itself depends on cultural power, and the
ways in which the disempowered know the empowered are not mere-
ly inversions of the ways in which the empowered know them. To
avoid the prejudices built into universalizing models of knowledge,
then, we must consider not only how dominant culture knows others,
but the ways in which minorities themselves know.

One of the finest explicators of the conditions of minority knowl-
edge (for the American tradition at least) is W. E. B. Du Bois. In his
The Souls of Black Folk (1903), Du Bois examines the "strange experi-
ence" of "being a problem":

> After the Egyptian and Indian, the Greek and Roman, the
> Teuton and Mongolian, the Negro is a sort of seventh son,
> born with a veil, and gifted with second-sight in this
> American world, a world which yields him no true self-con-
> sciousness, but only lets him see himself through the revela-
> tion of the other world. It is a peculiar sensation, this double-
> consciousness, this sense of always looking at one's self
> through the eyes of others, of measuring one's soul by the
> tape of a world that looks on in amused contempt and pity.
> One ever feels his twoness, an American, a Negro; two souls,
> two thoughts, two unreconciled strivings; two warring ideals
> in one dark body, whose dogged strength alone keeps it from
> being torn asunder.

Racial inequality does not reside solely in the "peculiar institution" of

slavery and its aftermath. Equally "peculiar" is the psychic doubleness that leads African Americans to see themselves reflected in the false standards of the dominant white culture. "Compulsory ignorance" keeps blacks from both cultural advancement and psychic integration: "the would-be black *savant* was confronted by the paradox that the knowledge his people needed was a twice-told tale to his white neighbors, while the knowledge which would teach the white world was Greek to his own flesh and blood."[11]

Like Bakhtin's "double-voiced discourse," Du Bois's "double-consciousness" focuses on the experience of self as other. This doubleness of minority knowledge received its fullest literary examination half a century earlier in *The Narrative of the Life of Frederick Douglass, An American Slave, Written by Himself* (1845). On their guard against censorship by their Northern editors and extradition by their Southern masters, the authors of slave narratives always used language self-protectively. In Douglass, this authorial caution shows narratively in the mismatched paradigms he uses to tell the story. Douglass's basic literary model—of the secular success story from rags to riches—casts him as a Romantic individualist, a cross between Captain Ahab and Benjamin Franklin. His comparison of his experience to a religious conversion—an escape not from sin, but from slavery and the South—recasts social injustice as spiritual failing. Despite the inconsistencies in such a tonal mix of entrepreneurial aggression and Christian humility, both paradigms assuage the racial guilt of the white Northern audience Douglass addresses.

The tensions between Douglass's two literary paradigms underline the epistemological difficulties of his narrative position. Douglass's rhetorical skills as a lecturer initially convinced his listeners that he could never have been a slave, and many denied the accuracy of his speeches. The *Narrative* was intended at least in part to "prove" that he was once a slave by giving a fuller account of that earlier life. Yet if his political position required as credential a narrative of his personal experience of slavery, that narrative could not create for Douglass a coherent identity. As a history of his past, Douglass's account inevitably distanced him from the present self he wished to authenticate: the personal story merely established the existence of a slave self

from which by definition he had "escaped." Moreover the same objections raised openly to his speeches could potentially have been redirected against the accuracy of the autobiography: the literary skill with which he shaped these past experiences drove a wedge between the ignorant self who experienced and the knowledgeable self who wrote, leaving largely unexplained how Douglass got from one state to the other.

For Douglass the doubleness of his secular and religious narratives represents the cultural dislocation all slaves feel. He addresses this dislocation most explicitly in recalling the music of slave culture.

> [These exulting words] they would sing, as a chorus, to words which to many would seem unmeaning jargon, but which, nevertheless, were full of meaning to themselves. I have sometimes thought that the mere hearing of those songs would do more to impress some minds with the horrible character of slavery, than the reading of whole volumes of philosophy on the subject could do.
>
> I did not, when a slave, understand the deep meaning of those rude and apparently incoherent songs. I was myself within the circle; so that I neither saw nor heard as those without might see and hear.[12]

Wishing to overturn the slaveholders' argument that slave songs demonstrated the blacks' contentment, Douglass questions the continuity of form and content, tone and sentiment, pathos and rapture. But more important his distinction between participation in the songs and knowledge of them anticipates Du Bois's differentiation between blacks as watchers and blacks as watched. Here more explicitly than anywhere else in the *Narrative*, Douglass contrasts his youthful experiences "when a slave" to his subsequent recollection of those experiences. The difference does not for Douglass mark the growth of knowledge. The mature narrator's understanding is subordinated to his clear nostalgia for that time "within the circle" of the black community. Knowledge of difference regrettably reinforces the differences within oneself.

Henry Louis Gates, Jr., has seen in the *Narrative*'s epistemological doubleness a model for a specifically "black hermeneutic circle," a "declaration of the arbitrary relationship between a sign and its referent, between the signifier and the signified."[13] Yet a similar duplicity and discontinuity characterize most forms of ethnic self-definition. Although the ways in which (and intensity with which) the dominant culture represses minorities vary, there are striking resemblances between what it feels like to be an "other." And without denying differences among minorities, we can use the concept of black doubleness—Du Bois's "sense of always looking at one's self through the eyes of others"—to explicate both gay self-knowledge and the narrative models that make it visible to mainstream audiences.

Since at least the late 1960s, gay self-affirmation has been characterized by the rhetoric of "coming out." To overcome the paranoia and repression of hiding one's identity in a "closet," gay activists urged people openly to announce their otherwise invisible sexual preferences. As an initial stage in the forging of gay pride, such calls for visibility were necessary and invigorating. The hope was that a statistically significant other would be redefined as normal; if enough admirable people declared their homosexuality, then the masses would be educated out of their homophobia. The political prediction was probably optimistic. Knowledge does not entail approval. Whatever their importance as personal statements of self-worth, comings out by celebrities and the masses have not noticeably improved heterosexuals' opinion of homosexuality as practice. Nor is sexual openness necessarily empowering in the post-AIDS generation. Recent demands for compulsory testing and public access to HIV status suggest that visibility can lead as easily to quarantine as to compassion.

In defining an ongoing political project, the rhetoric of coming out somewhat shows its age. As a narrative of self-identity, "coming out of the closet" internalizes some of the same dislocations as did "coming up from slavery." It is not clear exactly what "coming out" means, on which of the many moments in sexual formation it focuses. The primary emphasis is on self-awareness and self-acceptance. Such rhetoric imagines the closeted life to be either one in which the sexual self is repressed altogether or one in which gay activities and desire are

denied and hidden, often under the camouflage of a heterosexual identity. This cliché of homosexuals as divided selves undoubtedly represents accurately the psychological distress and self-loathing of some gay people. And, for such, coming out is a way to escape the anger (and often homophobia) that would otherwise result from repression.

Yet there are intellectual, even literary, limitations to this account of sexual identity. It takes fundamentally the form of a Puritan conversion narrative, one of predetermined essences and cataclysmic reversals. The true self, known from the first as gay, fights a phantom self that desires to be straight. Salvation comes when the self abandons its former ways, accepts its true identity, and finds in acceptance a psychic wholeness. Such an allegorical account is philosophically primitive, and strikingly at odds with the anti-essentialism of most recent accounts of identity formation. Nor does it describe well the experience of those homosexuals for whom recognition of their non-traditional sexual identity is less catastrophic, those for whom coming out does not serve to repair the damage of previous false existences. Like Douglass's "conversion" from slavery, it denies the value of any experience before the "coming out." The phrase "coming out of the closet" derives from the religious expression "coming out of sin." Yet the experiences are not truly parallel: the closet is no more sin than was slavery. The imprecision of the metaphor results in a model for integration that is itself self-alienating. As a psychologized version of the medieval *psychomachia*, it represents self-knowledge as a ritualized fight between mental faculties. Identity formation becomes not a creative process of discovery and development, but merely a mechanical trial by ordeal, a getting the right peg in the right hole.

The notion of "coming out" as self-acceptance depends on a series of questionable distinctions—between knowing and accepting, self-knowledge and the self known. Even more problematic are the less psychological meanings of the term. "Coming out" can refer not only to a private recognition but to a public action as well. One "comes out" both in admitting preferences to oneself and in telling them to family and friends. The similarity of the term should not obscure the differences in the two situations. Coming out to oneself is a psycho-

logical activity, and its perils and rewards are largely internal. Coming out to others, too, may be psychologically taxing; but it is chiefly a social activity, whose character is defined by the limits of cultural decorum. Private thought tries one's psychic strength. Public announcement challenges society's standards of normative behavior (and in some cultures its legal codes). The tendency to collapse the social meaning of coming out back into the psychological one marks dominant culture's desire to deny its complicity in discriminatory treatment of gay people. The danger in being visibly gay, they would have us believe, is really only how it can make you feel, not what others will do in response.

The ambiguities of coming out as a metaphor for social confrontation are clearly embodied in the narrative form used to represent the event. The internalized plot offers itself as a conversion—"I now see who I truly am." Public announcement takes the more self-abnegating form of confession—"I am not what you think me." The psychic benefit of such a formulation is not clear. Hardly the customary paradigm for self-affirmation, confession is at best an embattled mode of communication. It announces as its sole motivation a disinterested love of truth. Yet one need not reread Freud or Poe to realize the moment's psychological complexity, and to recognize that confession can as easily be an enactment of self-loathing as an escape from it.[14] Nor is confession an efficacious literary genre for social activism. Explanation presupposes the need for explanation; and public confessions of one's otherness may only reinforce society's sense of normalcy. "Confessing" to homosexuality seems to grant the very guilt that it means to deny. Far from asserting the importance of gay sexuality, it presupposes the normative power of heterosexuality, casting the listener in the role of priest-absolver. And however useful it may be to inform one's friends of one's sexuality, the whole metaphor of coming out of "a closet" may strike many as demoralizing. To people fully adjusted to their sexuality and not accepting the social definition of the normal, there simply is no closet to leave.

The confessional narrative's emphasis on self-abnegation is particularly insensitive to the status of sexual self-declaration as a linguistic utterance. The statement "I am gay," like other self-affirmations—"I

am woman, hear me roar" or "Give me liberty or give me death"—does not function primarily as part of an ongoing conversation, or to exchange information. The subjectivity of such statements is in some senses more important than their context, and they cannot be converted to their third-person equivalent without altering the meaning. Positioning in these statements is determinant. However liberal one's intentions, no one can actually say of another, "Give him liberty or give him death." So the statements "I am gay" and "he is gay" carry very different implications, however similar their syntax. The one affirms the validity of homosexual subculture; the other marks the distance between homosexuality and normalcy. The coming-out sentence functions more as action than as proposition; and like many "confessions" its content is often known by all before it is spoken. The speaking *is* the meaning, and in this way the coming out statement works like a performative—a statement, such as a promise or a curse, whose formulation does not merely convey content but enacts it.

It is this difference between coming out as enactment or performance and coming out as narrative that is obscured by Sedgwick's treatment of coming out (and homosexuality more generally) as an epistemological problem of knowledge.[15] However necessary a stage in the development of gay individuals, the metaphor of coming out plays a relatively small part in their formal self-narratives. Although gay people are forever telling stories about how they came out, the psychological moment of coming out is seldom the organizing metaphor in gay autobiography. Apart from popular accounts of the kiss-and-tell variety, such accounts rarely concern themselves at all with the issue of public self-revelation of a preference assumed from the start. It is not simply that coming out is too other-directed a moment in gay experience, too much a concession to the straight world. It is more that, as narratives of conversion and confession, comings-out internalize static patterns of knowing that privilege hierarchical power over more transformational resistance. Finally sexuality, like any minority position, is more something to be engaged with than something to be examined. Unlike Plato's "Good" or Kant's necessary preconditions of perception, homosexuality may just not be the sort of thing one wants to have a theory about in the first place.

Authenticating Difference

Differences in the procedures of knowledge raise doubts as to whether "knowing difference" is the best way to understand it. At the start of her second book, Sedgwick provides a parable for her model of closet discourse.

> I think of a man and a woman I know, best friends, who for years canvassed freely the emotional complications of each other's erotic lives—the man's eroticism happening to focus exclusively on men. But it was only after one particular conversational moment, fully a decade into this relationship, that it seemed to either of these friends that permission had been given to the woman to refer to the man, in their conversation together, as *a gay man*. Discussing it much later, both agreed they had felt at the time that this one moment had constituted a clear-cut act of coming out, even in the context of years and years beforehand of exchange predicated on the man's *being* gay. What was said to make this difference? Not a version of "I am gay," which could only have been bathetic between them. What constituted coming out for this man, in this situation, was to use about himself the phrase "coming out"—to mention, as if casually, having come out to someone else. (*EC*, 3-4)

The passage displays most of Sedgwick's limitations. In its Jamesian convolution, it stands as a trial run for the reading of Marcher and May later in her book. It focuses on the least affirmative form of coming out, the confession. And as always Sedgwick obscures her own position in relation to her material. How does she "know" so well the private moments of this man and woman? The passage is uncomfortably personal (even exhibitionist) and makes the reader an unwilling voyeur. The most likely explanation for Sedgwick's knowledge of the incident—that she is herself the woman and that the moment is in fact one of closeted autobiography—sits oddly in an analysis that everywhere else places such a premium on self-revelation

and the saving grace of coming out.

Yet the most unusual characteristic of the passage—its curiously passive depiction of gay self-revelation—is inadvertently the most astute one in the analysis. For Sedgwick, coming out is not a moment of self-acceptance or self-affirmation. The man and the woman had long ago both identified and accepted the man's "being gay." Coming out is that moment, beyond mere existence, when that identity becomes the subject of public discourse. Such an exchange is not a conversation. The gay man never actually says, "I am gay"; this, Sedgwick says with painful bluntness, would be "bathetic." Coming out is not a moment when a homosexual says anything. The man has no voice of his own in Sedgwick's account. Even in his paraphrased dialogue he treats himself indirectly, as the participant in a conversation elsewhere, and Sedgwick leaves unexamined his ambiguous motives in making his indirect admission. Not the moment when homosexuality speaks, coming out is instead that when heterosexuality does, when the straight friend is given permission to name the gay man "gay." Although the passive formulation "had been given" obscures the fact, it is the friend who gives herself permission; the heterosexual interprets the homosexual's declaration as an invitation to speech. Someone must speak first, and if "I am gay" is bathos, then "you are gay" is the only other possibility.

This is not a passage I admire, or a relationship I would celebrate. And to complement Sedgwick's parable of coming out I would recall an anecdote from the career of singer Edna Thomas. Thomas was a talented white mezzo-soprano who in the early 1920s devoted concerts to Southern folk music—both the melodies of white Southerners and the secular and religious songs of free and enslaved blacks. In such performances she entertained her audiences and preserved oral traditions that might otherwise have passed out of sight. Her recordings of the chants of New Orleans street vendors are among the few documentations we have of this now forgotten folk music. One can only be grateful for the records Thomas made. At the same time, the status of those performances must be examined critically. Thomas was not, after all, directly involved in the culture she reproduced, and she tended to present her material as quaint and

exotic. Her audience was of course almost exclusively white; and the crinolines she wore in her stage costume as Southern belle marked her distance from the (largely) African American music she memorialized.

Thomas implicitly acknowledged the ambiguity of her position in an anecdote of authentication she told about herself. Of all the praise she received, Thomas claimed, she valued most that of her black nanny, who, having originally taught her the folk melodies, subsequently said of her singing, "Lor', honey, for a moment, I fergat yer color!" There is no reason to disbelieve the story. Yet one can fault Thomas's failure to consider the variety of reasons that a servant might make such a statement to an employer. Even if the sole motive were an outpouring of heart-felt enthusiasm, we should not wish to divorce that single moment from a history of interracial discourse—one in which inequities in power affect the ways in which the disempowered speak, and control which minority statements pass into history. The very language of the anecdote undercuts its authenticating power. Although perhaps a sentence in which a subaltern speaks honestly and accurately, it is also one in which she speaks anonymously. And while her dialect may accurately reproduce the speech patterns of her servant, Thomas condescends in rendering the black woman's sounds as ignorant misspellings. For the black woman to speak a dialect is one thing; for Thomas to reproduce it is another.

I read Sedgwick's coming out story as a similarly un-self-conscious narrative of self-authentication. Her nameless gay man stands like Thomas's nameless nanny primarily to affirm her own right to speak. That Sedgwick has that right is undeniable. Every point of view, however positioned, can contribute to our understanding of a cultural position. And Sedgwick's long and careful study of the borders between gay and straight culture makes her opinion more valuable than most. At the same time, however, Sedgwick's use of the gay testimonial for self-empowerment suggests that while she has thought about the structures of otherness, she is less interested in the politics of knowledge. Her unnuanced reading of the man's motives for coming out to his straight friend seems a failure of psychological insight at the very point where it might be most revealing. And her unwill-

ingness to examine the very real, even judicial, limits placed around what and when gay people can speak compromises her own sense of her "permission" to speak for them.

"(Don't we all know them?)" Sedgwick asks in reading James (*EC*, 209). No, we do not. Not only because the pronouns "we" and "them" reconstitute the very dichotomies Sedgwick seeks to dissolve, but because "knowing" is the wrong way to understand an other. Knowledge of a minority position is always in danger of re-colonizing that minority, obscuring its particularity with paradigms more congenial to the dominant culture than to its subjects. Ethnographers have come to realize that the participant-observer "participates" less in the culture studied than in the imperialism of the culture that knows. As Judith Butler has warned, a comparable "epistemological imperialism" attends any representation of gender that fails to acknowledge the specifics of hegemonic oppression.[16] Sedgwick's fine eye allows her to expose the historical processes by which the construction of "the homosexual" problematized sexual object-choice. But her acceptance of the metaphors and modes of analysis by which exclusion was effected fails to consider the extent to which she unwittingly perpetuates that exclusion.

To this extent, Sedgwick's focus on an "epistemology" of "the closet" is unfortunate. Sedgwick is surely right that "the *special* centrality of homophobic oppression in the twentieth century. . . has resulted from its inextricability from the question of knowledge and the processes of knowing in modern Western culture at large" (*EC*, 33-34). Yet this "inextricability" of otherness from knowing does not explain homophobic oppression; it is one of the foundations upon which that oppression is built. Knowability is one of the categories by which others are kept other; and in terms of their ability to alienate, knowing and not knowing are structurally identical. In wishing to "know" homosexuality rather than to converse with it, Sedgwick compounds the traditional conflation of homosexuality and knowledge. Even as she denies the validity of the homo-/heterosexual dichotomy, she profits from the inequity which has always favored the knowledge of heterosexuals. Such longstanding cultural differences are not to be annihilated through language, however antihomophobic. Only an

analysis that accepts more honestly its complicity in culture and treats more overtly the tensions and compromises that occur when minorities speak can hope not merely to know homosexuality but to learn from it as well.

4

THE BODY NEGATIVE

AIDS in the Academy

*T*here was a joke common in gay circles in the early days of the current health crisis: "What's the hardest part about having AIDS? Convincing your parents that you're Haitian." The humor is not racially sensitive. Only recently have gay white men begun to address the need for a fuller sympathy with those "other" groups threatened with infection, or even to recognize the racial, ethnic, and class diversity of a sexual preference too often glossed as exclusively WASP and middle-class. Yet as one of the few instances of AIDS humor generated from *within* the community, the joke does highlight some fundamental issues underlying gay men's experience of AIDS—especially the problematic visibility that accompanies both specific manifestations of and general interest in the disease.

The joke draws on a social reality. AIDS has forced many men to be more open about their sexual practices. The public announcement of one's infection to family and straight friends often became the tacit admission of a sexual preference until then concealed, or at least unspoken. The media trauma surrounding Rock Hudson's relation to the so-called "gay plague" was reenacted more locally in numerous, less celebrated illnesses. More generally, the disease placed under intense scrutiny a subculture whose access to power had previously traded on its invisibility. Not only were specific sexual activities that could lead to viral transmission officially labelled "unsafe." The whole culture in which these activities took place was dissected in the media. Fisting, amyl nitrate, and the Mineshaft became part of postmodern cultural literacy.

It is probably too soon to conceptualize the overall effect of such changes on gay male identity, and the best practical responses to the crisis proceed piecemeal (not to say guerilla-like) through trial and error. Yet it may be possible without controversy (or clinical remoteness) to generalize about a single aspect of the shift effected by the conjunction of disease and visibility: the role of AIDS in shaping the rise of gay studies in the academy. AIDS did not create gay studies; the health crisis clearly postdates recent scholarly interest in sexual preference. Nor did academics invent the study of gay culture. As long as there have been homosexuals, there has been interest in defining what constitutes the subculture, if only as a means of identifying possible sexual partners without fear of legal prosecution. One always had to understand a fair amount about gay patterns of behavior to know whom to cruise.

Without overstating the importance of either AIDS or academic gay studies, one can discover in their simultaneous rise how disparate perspectives influence the ways homosexuality becomes visible. The convergence of two vocabularies of sexuality and immunology has encouraged misreadings that can be identified and diffused. More important, the inability of academic theory to correct some of those errors itself suggests limitations in the models currently employed to discuss sexuality. Studying the stages by which two invisibilities became one will not resolve specific issues concerning either health or sexuality. But it may make visible some of the hidden presuppositions of the process of visualization itself.

Disease and the Marketplace

Before AIDS, the history of gay studies in the academy was generally comparable to that of other minority disciplines. Haphazard study of homosexuality in America became more systematic after World War II, especially as part of gay liberation's pursuit of visibility following New York's Stonewall Rebellion of 1969. In the earliest stage of recent gay studies (the period roughly from the late 1960s to the late 1970s), journalists and scholars offered popular accounts of previously invisible homosexuals. The forerunner of such work was Jeannette H. Foster's pioneering study in 1956 of "sex variant [les-

bian]" women in literature. More than a decade later book-length histories started to appear, often in conjunction with grassroots organizations like San Francisco's Lesbian and Gay History Project or New York's Lesbian Herstory Archives. Jonathan Katz and Martin Greif compiled overviews of gay men and women in history. For the popular press, Vito Russo explored the "closeted" presence of homosexuals in film, while Kenneth Anger tattled on the sexual misdeeds of a Hollywood "Babylon." And in the late 1970s, to counteract the soft-core porn of Alex Comfort's heterosexual best-seller, Edmund White, Charles Silverstein, Emily Sisley, and Bertha Harris all proclaimed the more complex sociological "joy" of gay and lesbian sex. These early commercial efforts were primarily intended to educate straight culture and embolden gay. They overturned homophobic misconceptions, and offered historical profiles in gay courage to those isolated lesbians and gay men unaware that their sexual preference was shared by approximately one-tenth of America.

Such efforts at consciousness-raising were followed in the late 1970s and early 1980s by more academic social and literary histories. The relocation of the center of gay studies from the grassroots movements (primarily in urban communities) to the academy entailed certain predictable shifts in form and emphasis. Many of the historical studies addressed specific issues, not all explicitly gay. Making space for sexuality in scholarship were (among others) Estelle Freedman's work on American prison reform; John D'Emilio's on pre-Stonewall community groups; Guido Ruggiero's on Renaissance Venice; Judith C. Brown's on an Italian nun; and B. R. Burg's on Caribbean pirates. Some histories took a broader perspective. John Boswell's encyclopedic account of early Christian tolerance toward homosexuality became the key reference for early Church opinion. In a wide-ranging series of articles, Martin Bauml Duberman and Carroll Smith-Rosenberg studied, respectively, same-sex male and female relations in nineteenth-century America. And more recently Freedman and D'Emilio turned from their particularist work to co-author a survey of the history of American sexuality, gay and straight.[1]

The difference between these histories and their popular predecessors was as much one of method as of meaning, and academic work

was fully compatible with the popular campaigns for "gay pride." In chronicling the social oppression of homosexuals, scholars implicitly defended gay civil rights. Analyzing earlier periods to demonstrate the existence of a positive attitude toward homosexuality, they used the precedent of the past to counter contemporary attacks on sexual "unnaturalness." Historians have become increasingly nervous about the static image of homosexuality in some of these accounts, claiming that homosexuality was less a single transhistorical "essence" than a network of "constructs" created by and adapting to specific historical and sociological conditions. But here, too, the epistemological differences in historiographic methods should not obscure the similarity in the political projects. As concerned as former historians with a positive depiction of homosexuality, the "social construction" revisionists add that gay apologetics require explicit renunciations of the negative implications of essentialism.[2]

The work of professional historians was supplemented somewhat later by studies of gay aspects of literature. Some of these—like Lillian Faderman's sweeping studies of lesbian culture, Martha Vicinus's of the Victorian working-class, G. S. Rousseau's on Enlightenment Englishmen, or Shari Benstock's on the Left Bank female modernists—approached literature with an eye to social history. Others—like Robert K. Martin's survey of a gay male continuum in American poetry—were more concerned with aesthetic issues. Biographers, too, began to pay more attention to the role of sexuality in such writers as Lord Byron, Walt Whitman, Willa Cather, and even such fellow intellectuals as Ludwig Wittgenstein and Alan Turing. This study of homosexual writers and literary traditions soon broadened to a more philosophical consideration of the theoretical implications of sexuality. Here the catalyst was less the popular movement of gay liberation than the academic establishment of women's studies in the mid- to late-1970s. Among historians, the relation between feminist accounts of gender and Michel Foucault's implicitly gay historiography of sexuality had always been close. In literature, the influence of feminism on gay studies increased in the late 1980s, when such scholars as Eve Kosofsky Sedgwick and Elaine Showalter called for a broadening (and renaming) of their discipline to include a

greater variety of ways to "speak of gender." Subsequent readings by gay male critics responded explicitly to this call, adapting the categories of feminist theory to the study of male homosexuality.[3]

This transformation of a popular political movement into a more fully theorized academic discipline is a fairly familiar process, recalling earlier developments in the study of both women and African Americans. What distinguishes the growth of academic gay studies in America from that of the others is the contemporaneous explosion of popular interest in gay culture following the appearance of AIDS. The earliest reported cases of AIDS-related infections in America, in 1979, of course, antedate most book-length academic work in gay male studies (and much of the feminist theory that sponsored it). The naming of the disease (in 1982) and identification of the HIV virus (in 1983-84) occurred after the publication of many groundbreaking historical studies, but before most of the theoretical studies of gay literature. And more widespread interest in the disease (roughly dating from the publicity surrounding Hudson's death in 1985) was almost exactly contemporary with the movement to rename feminism as "gender studies."

In no case, of course, was there a causal relation between the spread of the disease and the rise of gay studies. Given the lag time in scholarly research (and publication), it is safe to assume that academic work appearing early in the health crisis derived from research that considerably preceded it. Yet if AIDS did not affect the germination of this work, it did affect its reception. After 1985 it might have been possible to care about AIDS without caring about homosexuality; it was impossible to care about homosexuality without caring about AIDS. Since the mid-1980s, at least three commercial presses have issued special lines of gay fiction, both original and reprinted. In the most explicitly gay-identified of these series, the Stonewall Inn Editions of St. Martin's Press, approximately one-fourth of the initial publications focused on the health crisis. Academic interest, though slower, has followed roughly the same pattern, and by 1989 no less than three university presses had inaugurated series in gay studies, with AIDS figuring prominently among the early topics treated.

Publishers' need to strike while the virus was hot marks the wholly

sympathetic fear of both gays and straights that a cultural tradition is endangered, perhaps on the verge of annihilation. Other effects of the prominence of AIDS, however, do not so clearly work to the advantage of gay studies. Most obviously, the emphasis on AIDS as a gay male experience has deflected attention from homosexual women. Distinctions between gay and lesbian theory were always implicit in the different positionings of gay men and women with respect not only to patriarchy but to feminist theory. Unlike gay men, lesbian theorists did not learn "from" feminism; early statements by Adrienne Rich, Teresa de Lauretis and Carroll Smith-Rosenberg (among others) were equally fundamental to feminist, lesbian, and gay male theory. The health crisis has only widened this epistemological gap, and the AIDS discourse so influential in nascent gay theory has had less impact on the already well-developed paradigms of lesbian theory.

Preoccupation with AIDS does not simply foreground the problems of men over women; it attends only to a narrow aspect of gay male experience. Transmitted by certain sexual practices but not others, the virus has moved unevenly through the community, exposing the varieties of gay male sexual activity. These morally neutral differences have on occasion been foolishly overread, with critics both inside and outside the community self-righteously interpreting others' contamination as inevitable or deserved. AIDS has become an occasion to attack any sexual practice found distasteful, from relatively viral-free activities, like fisting or water sports, to totally safe ones, like sadomasochism or transvestism. Varying tastes in sexual activity have been compounded, in the second decade of the crisis, by generational differences. For some younger gay men, raised entirely under a regimen of safer sex, AIDS can seem a less overwhelming problem than for older men, who have seen their generation decimated by the virus.

That AIDS has not made all aspects of homosexuality equally interesting is evident in the anomalies of recent publishing history. Perhaps predictably, there has been comparatively little attention paid to lesbian fiction. Contemporary male authors have received only slightly more attention; reviewers prefer the sentimentalized accounts of Alan Hollinghurst, Armistead Maupin, and David Leavitt to the

more politically engaged work of Ethan Mordden, Robert Ferro, Melvin Dixon, and Samuel R. Delaney, without really admiring any of it. No concerted effort has been made to reprint the classics of early gay and lesbian literature, comparable to the editions of African American women's texts or American feminist fiction from Oxford and Rutgers University Presses. Nor, apart from a fascination with problematic martyrs like Oscar Wilde, has there been an extensive re-reading of gay and lesbian authors already canonized. In this absence of a clearly defined literary tradition, AIDS seems not simply a crucial moment in gay history. It has become the sole object of study, the only gay "text" of interest.

Yet even as interest in the AIDS text increases, the status of sexuality within that text is ambiguous. The association of sexuality with infection can fuel homophobia, reviving an outmoded medical vocabulary which stigmatized homosexuality as a disease. The association may not even still be accurate. The groups first targeted as "high risks"—gay men, Haitians, hemophiliacs—are no longer the sole groups threatened, while the naming of certain parts of a population as "risk groups" has had the unfortunate effect of persuading others that they are not now, nor will ever be, at risk. Aware of these dangers, gay studies has nevertheless been reluctant to relinquish the topic that first cast it in the limelight. While official propaganda insists that the AIDS virus is *every individual's* problem, AIDS scholarship continues to be published in lesbian and gay series, filed under "sexuality" in book stores, and hailed as "turning points in the development of gay studies." One gay theorist apologizes that his study of nineteenth-century texts could not address AIDS directly; a reviewer praises the same study for its implicit relevance to AIDS.[4] The implications are both clear and contradictory: gay men are not sick; gay studies is.

Visualizing the Virus

Disheartening though it may be to think that academic discourse in any way benefits from the health crisis, it is overly scrupulous to worry about the spin AIDS has put on scholarly arguments when the long-range effect of the disease is to silence voices altogether. More central

than what the disease has done to our studies is what our studies may have done to the disease. Here too the evidence seems mixed. Academic voices have been raised powerfully to support political activism (especially the work of ACT UP), and thus helped maintain the visibility of both the health crisis and its opponents. At the same time, in theorizing AIDS we have ourselves participated in the commodification of the disease begun in the media. Although academic analysis of the disease employs the most sophisticated interpretive models available, that sophistication does not of itself determine the applicability of the paradigms. And in critiquing the academic analysis of AIDS we must consider how theoretical models affect what can and cannot be said about the disease.

Employing postmodern epistemologies associated variously with neo-Marxism, Foucauldianism, feminism, and new historicism, most theories of AIDS focus on the social construction of the disease, and especially the media's ambiguous role in representing AIDS. This position is ably summarized in the introduction to one of the most influential academic responses to the crisis—the special issue of the journal *October*, "AIDS: Cultural Activism/Cultural Analysis."

> AIDS does not exist apart from the practices that conceptu-
> alize it, represent it, and respond to it. We know AIDS only
> in and through those practices. This assertion does not con-
> test the existence of viruses, antibodies, infections, or trans-
> mission routes. What it *does* contest is the notion that there
> is an underlying reality of AIDS, upon which are constructed
> the representations, or the culture, or the politics of AIDS. If
> we recognize that AIDS exists only in and through these con-
> structions, then hopefully we can also recognize the impera-
> tive to know them, analyze them, and wrest control of them.[5]

The passage works to overturn the myth of scientific objectivity—the positivistic faith in science's access to an absolute realm of truth (or at least of mathematical predictability). According to the constructionist argument, truth does not divide into undeniable facts (the stable domain of science) and impressionistic interpretation (the

shifty grounds of literary theory). Instead science and theory are epistemologically equivalent interpretive languages ("representations" or "experiences") with equally problematic relations to an uninterpreted absolute. Behind this specific assault on scientific factuality lies a more general nervousness about any essentializing rhetoric—any talk about "underlying realities"—for the ways in which such rhetoric has tended to serve in discussions of AIDS (and of homosexuality itself) as a prelude to discrimination.

Few would challenge the basic tenor of this passage. Yet the formulation itself is troubling. Most obviously it tends to identify the extant with the knowable. The statement that we "know" AIDS only through its representations is not the same as the claim that AIDS "exists" only in those representational practices, although the passage's opening sentences seem to equate the two assertions. This conflation of knowledge and existence may, despite the author's clear acknowledgment of the reality of viral pathology, inevitably minimize certain biological facts. The recognition that all sorts of prejudicial presuppositions are passed off as factual in the scientific discourse of AIDS does not establish that there is nothing that we would want to call a "fact" about the disease or even that some of these so-called facts are adequately represented in that scientific discourse. Furthermore, the "hope" that representations can be known through "analysis" and that such analysis will moreover "wrest control" over these constructions is optimistic at best, imperialist at worst.

It would be foolish to worry too precisely the implications of a single paragraph whose main thrust is clearly correct. Yet some of the troubling tendencies of this formulation have been realized in other more extreme analyses. The substitution of the study of representations for the study of etiology has occasionally led AIDS theorists to stray far from the evidential and even moral dimensions of the crisis. Reading early theories of HIV transmission as a "hegemony of the magical projectile penis," for example, one critic has argued that AIDS discourse reinforces the sexist image of women as "merely passive vessels without the efficient capacities of a projectile penis or syringe for shooting large quantities of the virus into another organism."[6]

It is certainly true that misogyny and phallocentrism inform the supposedly "factual" scientific discourse of AIDS. It may be problematic, however, to identify sexism as a primary cause of conclusions that also agree with the best statistics and etiological models now available to us. So far as we currently understand it, the HIV virus is most easily transmitted through direct injection of contaminated semen or blood into another blood stream, a situation more common in intravenous drug use and anal sex than in vaginal intercourse. For this reason, epidemiologists suppose that women do transmit the virus less frequently to their sexual partners than men do to theirs—a conclusion fully compatible with the available statistics. It is unclear what is gained by exposing this model as implicitly phallocentric, and what follows from such a claim. Faulty models of female transmission—such as the uninformed discussion of heterosexual fellatio in the film *Boyz N the Hood* (1991)—can revive misogynist biomedical clichés about the female body as a pool of contagion. At the very least one would want to remark the moral obliquity of the unstated implication of the argument—that the increased ability to transmit disease would be a mark of female empowerment.

Again, one would not want to critique too rigorously a brief moment in a complex (and generally sympathetic) argument. At the same time, one must recognize that the constructionist account of AIDS has its limitations as well as its strengths. While not wishing to pronounce the "failure" of the account, I would at least like to suggest three problematic tendencies in its own construction of the argument. The first derives from the necessarily negative character of its analyses. To the extent that constructionism focuses on the practices of AIDS representation, it inevitably becomes a history of *mis*representations. This bias is not political but epistemological: only the construction that shapes the evidence in an unusual way can be identified. Any construction that did not seem in some way wrong—to which no one could imagine an alternative explanation—would be invisible, or at least unanalyzable in any non-trivial way.

There is of course nothing inherently wrong with a methodology that privileges negative cases. Nevertheless, this tendency does suggest a second interpretive bias to constructionist accounts—what I

have been calling the shift in focus from experience to representation. This shift too is not of itself problematic: no one would deny that the possibility for misrepresentation is part of our experience of reality as represented. Still the shift involves less an epistemological clarification than a change in topic, a redefinition of the object to be studied. To the extent that representations of AIDS are necessarily misrepresentations of AIDS, the study of representation cannot increase our knowledge of AIDS itself: the identification of misrepresentations of an object presupposes the object itself to be already known by other means. Thus in the critique of phallocentrism quoted above, the lack of interest in the details of viral transmission may be not faulty analysis, but symptomatic of a necessary displacement from the object known to the conditions of its knowing.

This second tendency towards displacement could be dismissed as a specific instance of the hermeneutic circle. Yet it points toward a third difficulty—one that marks constructionist accounts as not merely biased but potentially self-contradictory. In directing attention away from "underlying realities," social construction theory tends to deny the existence of those realities—the assertion, for example, in the first passage quoted that AIDS exists only in and through its constructions. But in fact such a denial is inconsistent. As P. F. Strawson and Richard Rorty have demonstrated in their explications of Kant's "objectivity thesis," demonstrations of the phenomenality of experience do not deny the possibility of an underlying noumenal reality. The very notion of representation entails a distinction between being and seeming—between how things are in the world and how they are construed. This distinction between being and seeming in turn requires at least the logical possibility of being—of the existence of unconstructed things, which may or may not be knowable. The concept of representation takes the general form "something seems to me to be X but it may not be X." In the very formulation "seems to be X but is not X" lies the definition of a reality underlying X; "seeming to be X but not being X" is all we really mean by "underlying reality." Thus even as they reduce AIDS to its representations, social constructionists implicitly reaffirm the existence of a reality not reducible to those representations.[7]

After Representation

There is a tension then between these last two tendencies as I have outlined them. On the one hand, the nominalist emphasis of social construction implies that AIDS exists only in its representations. On the other hand, the realist epistemology of social construction presupposes the stable foundation it would deconstruct. It would be pointless to overemphasize the implications of this logical tension. As I have suggested, one of the limitations of AIDS theory is its tendency "hopefully" to speak as if understanding the epistemological situation were tantamount to curing the disease. And in deconstructing constructionism I would only perpetuate that misleading hope. But the time may have come to ask exactly what we want to accomplish in studying AIDS in the academy and what are the best interpretive strategies to realize that goal.

First, we need to define precisely the object of our study. Although understanding misrepresentation is surely part of understanding the disease, it is only a part. The identification of the ideological assumptions of scientific discourse was a necessary preliminary. Additional such studies may, however, be counterproductive. They seem naively (even disingenuously) to grant to science and popular representations greater authority than either deserves. The inaccuracy of the media surprises nobody; as scholars we read the *New York Post* primarily to find errors, and discretely avert our gaze from the few facts it gets right. Readers who missed the point the first few times around are unlikely to be convinced by further examples of journalistic bias. With repetition, moreover, the part begins to stand for the whole, and the topic of study shifts. With each new exploration of the sexism, racism, and classism of scientific discourse, the health crisis itself becomes increasingly remote. Although this study of discrimination is interesting, it does not take AIDS as its object or ending the crisis as its goal. Eliminating the misconstructions of AIDS discourse would not eliminate the disease. People die of opportunistic infections, not misrepresentation.

At the very least, we should begin to consider those aspects of scientific discourse less immediately accessible to political analysis. Take,

for example, the concept of a medical cure as it is currently under-stood. Most AIDS research assumes that diseases are caused by specific, usually single, organisms and that cures work by attacking that organism before it has a chance to damage the host. Current information suggests the HIV virus to be the single (known) cause of AIDS. At the same time, the secondary assumption of AIDS etiolo-gy—that cures attack causes—can still be challenged. One way to "cure" AIDS surely would be to discover a vaccine that could inca-pacitate the HIV virus before it attacks T-cells. Another, however, would be to develop ways of controlling the opportunistic infections that most commonly follow T-cell degeneration. Such a purely reac-tive treatment of symptoms is not so thrilling (or grant-garnering) as going *mano-a-mano* with a killer virus. Yet in terms of the practical goal of retarding the death count, the reclassification of AIDS as not a "lethal," but only a "chronic" infection would also have to count as a "cure."[8]

Questions about those aspects of AIDS discourse not self-evident-ly political raise more subtle questions about the political efficacy of our most self-consciously liberal reformulations. Recent attempts to address the presence of the virus throughout the Third World have stressed the importance of understanding the epidemic in global terms. Yet this international perspective may be misleading to the extent that it emphasizes the spurious universals of statistics and biol-ogy over the culturally specific manifestations of the virus. It is, for example, true that the wide-scale use of condoms is the most efficient and economical means of preventing further viral spread. Yet the self-congratulatory simplicity of this solution ignores the extent to which it is practicable only in post-industrial, urban settings. Not only do religious sanctions make the use of condoms impossible for some cul-tures, but in rural Africa, where such devices are literally unavailable, a condom is essentially as utopian a solution as is a vaccine in the United States.

The global perspective, moreover, neutralizes the key insight of social constructionist readings of disease—the recognition that the intellectual paradigms used to conceptualize a disease are as constitu-tive as biomedical data. In this respect, despite our revised

understanding of the mechanics of viral transmission, AIDS remains a "gay disease." There is of course no necessary connection between HIV and homosexuality, and its initial statistical predominance in America among gay men was not biologically predetermined. Yet the misperceptions that originally conceptualized the disease as gay cannot simply be read out of the historical record. Revisions of those misunderstandings do not erase former mistakes; retraining oneself not to think of the disease as sexually specific is not the same as never having thought of it as such. Much current AIDS discourse continues to build upon the legacy of those original misconceptions. The preoccupation with the reasons for sexual appearance of HIV recalls the degree to which the study of homosexuality has always been tainted by the language of psycho-social determinism, and discussions of the disease replicate earlier discussions of sexual preference. The definition of AIDS as a disease of "life style" perpetuates this problematic notion of homosexuality-as-ethnicity inherited from the gay-affirmative formulations of the post-Stonewall period. And debates about testing for and disclosure of antibody status revive in a more coercive context the traditional gay rhetoric of coming out.

The ways in which AIDS continues to remain conceptually "gay" are most evident in the motif of victimization that informs discussions of the disease. Early Euro-American attempts to trace the origin of the virus back to Africa were explicitly racist in their desire to transfer blame from white middle-class gay men. Even the misidentification of Haitians as a "risk group" was unintentionally prejudicial. Haitians were originally seen as a separate risk group because the infected were unwilling to admit their homosexual practices or injection of drugs. Yet science's failure to factor in the cultural difficulty of Haitians' admitting to their sexual activity or drug use depended on a willful blindness to the role of vacationing Western homosexuals in the sexual exploitation of impoverished West Indians (and more generally to the complicity of the United States in Caribbean drug traffic). Subsequent attempts to correct the racism of earlier formulations have only responded with a complementary homophobia. The accuracy of the charge that "what was originally perceived as a disease of white middle-class homosexuals has also been the unnoticed tragedy of the

minorities, the disadvantaged, and the disenfranchised" is compromised by the statement's failure to acknowledge the ways in which homosexuals are themselves a disadvantaged, disenfranchised minority.[9]

This exchange of recriminations suggests the differing cultural assumptions of endangered subgroups. In the United States, the need to accept these differences is most painfully evident in recent health advertisements directed primarily at the African American and Latino communities, in which the virus is spreading at an alarming rate. A national campaign concerned with reassuring people about the value of viral testing has targeted Latino men and black women. Implicitly acknowledging the nervousness of such groups about their relation to a "gay" virus, the campaign has seldom addressed white gay men. Even more explicit in recognizing the tensions between white homosexuals and people of color is a New York campaign directed at Latinos. In an ongoing series of subway cartoons, Marisol and her friends challenge Julio's unwillingness to use condoms. When she first broaches the topic, Julio objects, "What do you think I am?" [Figure 4]. When explaining his position to his friends, he asks, "Do I look like *I* need to use a condom?" [Figure 5]. Although the specific meaning of his statements is left vague, Julio's references to his identity and appearance admit of a reading that disapprovingly associates viral infection with homosexuality.[10]

The point is not to emphasize the implicit homophobia (and explicit misogyny) of media representations, but to recognize the different needs of the constituencies addressed. All AIDS rhetoric makes choices about its relation to its imagined audience, and while one need not criticize those choices, one must examine the hierarchies they establish. Some cases of hierarchization are not without their humorous sides. In 1990, to conclude its programming for Gay Pride Week, New York PBS aired *Red, Hot and Blue: A Tribute to Cole Porter to Benefit AIDS Research and Relief.* An anthology of rock videos targeting racial and ethnic minorities, the film avoided gay images, including only one explicit representation of male-male sexuality and an implicit one of lesbianism (in the performance of k. d. lang). More interesting than PBS's repression of homosexuality in courting the

Figure 4: The opening episode of a cartoon from the New York City subways.

Figure 5: The second episode of a cartoon from the New York City subways.

MTV crowd were the assumptions that linked a health crisis with an anthology of videos "covering" Porter songs in the first place. The association began in the recognition, rarely made in print and wholly absent in the television program, that Cole Porter was homosexual. Whether gay or not, the snobbish Porter is an odd spokesperson for either multiculturalism or safe sex. Although rumored to prefer black partners, Porter in his music encourages the very sexual tourism that has accelerated viral spread. In the particularly unfortunate finale of "Katie Went to Haiti" (not included in the anthology), Porter chuckles that "Katie still had Haiti/And practically all Haiti had Kate." Nor can Porter's celebrations of hopeless love be easily reformulated to advocate prophylaxis; and rap artist Neneh Cherry had to stand Porter's lyrics on their head for "I've Got You Under My Skin" to be reborn as a warning against the use of intravenous drugs.

Hierarchizations among various constituencies are not always so well-meaning or so immediately evident. In 1988, California voters quietly passed Proposition 96, a resolution that allowed alleged victims of sex crimes to request the involuntary viral testing of their accused assailants. These results, contrary to the confidentiality provisions of the health code, would be made available to both the alleged victims and to correctional officers in charge of the defendant. The proposition was characterized as a victim's rights measure, protection for (among others) sexually assaulted women and children. Yet despite this characterization, the bill merely invaded the privacy of the accused felon without protecting anyone. The statute could not reasonably be seen as a deterrent (not to say prophylactic) measure. Knowledge of HIV status is only useful to partners when the sex is consensual; it is unlikely that testing would encourage rapists to use rubbers. In equating viral transmission with an act of intentional violation, the law encouraged the public to think of people who are HIV positive not as innocent victims but as potential criminals. Focusing on the viral status of the alleged assailant, the proposition implicitly discouraged testing the alleged victim, though such tests would be the only possible way to determine if a virus had been transmitted. This (perhaps minor) infringement of legal rights paved the way for more sweeping restrictions, such as the recent bills to make health workers

declare their viral status, even in situations where no disease transmission is possible. The effect of all such legislation is to redefine the infected as the criminal, and to appropriate victim status for the unendangered and the well.

Invidious distinctions between assailants and victims do not only pervade public rhetoric; they also mar academic debates. Since his death in 1984 there has been considerable concern about the moral implications of the sadomasochistic bathhouse activities of French philosopher Michel Foucault. Critics have argued that Foucault engaged in unsafe sexual practices after he became aware of his seropositivity, even deliberately infecting his bathhouse partners. Most defenses have rightly challenged the notion that Foucault could in 1982 have understood a viral etiology not as yet fully articulated by the medical establishment, and ranked the improbable image of his heartlessly stalking the bathhouses with other paranoid myths of infection. The defenses should overturn as well the assumption that uninfected partners are not responsible for any hazardous activities in which they engage. Whatever Foucault intended to do cruising the Slot, he could not corrupt innocents, for his partners were agents, not victims. Safe sex is the responsibility of every individual, the uninfected as much as the infected; and any attempt to equate transmission with assault fails through its use of an untenable model of criminal/victim to depict the process of viral exchange.[11]

The pejorative uses of the rhetoric of victimization suggest that AIDS discourse should examine more closely its own more sympathetic uses of the metaphor. Generally activists tend to deny the notion of responsibility in reference to "Persons Living With AIDS (PLWAs)." While such denials primarily offer sympathy to the sick, they are not consistent with either the politics or epistemology of AIDS theory. Even those exposed before the virus was identified are in some way "responsible" for their infection. The concept of "safe sex" insists that all individuals should protect both themselves and their partners from infection. One must be held accountable for all acts committed, even those whose consequences have not yet been determined. Any defense founded on one's "not knowing" confuses issues of responsibility with notions of consciousness and choice, notions

which fly in the face of the antisubjectivist bias of social construction theory. It is simply Romantic sentimentalism to imply that although AIDS exists only in its representations, I am still the master of my fate.

Logical inconsistencies in the rhetoric of gay victimization disguise its even more suspect exploitation of class and racial privilege. Gay activists traditionally argue that AIDS gets as little attention as it does because the primary group affected is a disenfranchised one, one with which it is dangerous for politicians to sympathize. There is a rough-and-ready truth to this argument. Ronald Reagan's indifference to AIDS resulted at least in part from his constituency's characterization of homosexuality as immoral. And the reticence of New York's Mayor Ed Koch on the issue probably measured his own fears that apparent support for homosexuals might encourage politically crippling rumors about his own unmarried status. Yet the identification of the ways in which gay men are victimized requires a complementary acknowledgment of the ways in which they are privileged. However underfunded, AIDS receives as much attention as it does because initially the primary group affected was composed of middle-class white men. The difficulty with which infected white women and people of color in America have made their particular problems known is only the most obvious sign of white male privilege. And to the extent that gay rhetoric does not expose this silencing of other endangered groups it is complicit with it.

Finally AIDS discourse has to be more self-conscious about its conflation of victimization and death. At times, publicity seems to suggest that the health crisis is discriminatory because death is wrong, or because no one should die young, or because bodily disfigurement is criminal. All such statements arise from an admirable sensitivity to the pain experienced by PLWAs. Yet AIDS pain cannot be distinguished from other forms of suffering without making prejudicial assumptions about one's right to life. Everyone dies, most unwillingly so. The relative invulnerability of youth and bodily integrity are conditions that are not equally available to all cultures or to all groups within American culture. Gay male rhetoric, then, must guard against formulations that, in complaining that "we" are not supposed to die

this way, implicitly posit the existence of a number of "theys" (the aged, the economically underprivileged, other races or nations) whose comparable deaths are more in line with the nature of things.

The health crisis then could be the occasion for raising fundamental questions not only about race, class, and gender, but about complicity, responsibility, consciousness, and death. But finally the dilemma posed by academic considerations of AIDS is less one of methodology or focus than one of intention. Whatever may be the most expedient way to formulate the question, we must be clearer about whom we imagine to be our audience, and what we wish to tell them. In deconstructing the ideological assumptions of the health establishment and its founding myth of scientific factuality, AIDS theorists expose the weaknesses of current accounts of viral transmission. The political project here is to overturn misrepresentations which, through fostering a false sense of security, can actually accelerate the spread of the virus and perhaps ultimately increase the death count. Only a proper understanding of the etiology of the disease can correct the errors implicit in earlier characterizations of AIDS as a gay plague.

This message is politically engaged. Yet it is also addressed necessarily to those as yet uninfected with the virus: for those already testing positive, the issue of misrepresentation is overshadowed by the threat to the immune system. However much our analyses may talk of a "body positive" (and of our solidarity with the infected), the primary audience for our discourse is in fact "the body negative"—those not as yet at risk, and falsely encouraged to read this temporary safety as absolute. Even this targeted group may not be our audience—either empirically or linguistically. The participants at academic conferences or the readers of *October* are not all that likely to be misled by the hidden agendas of governmental agencies. They do not really need lectures on the importance of safer sex or the dangers of homophobia and heterosexism. Conversely, social construction theory is not couched in a language usefully directed at those who might make those errors. Few drug users are effectively convinced of the immediacy of risk by telling them that AIDS does not exist apart from its constructions.

The academic argument against AIDS identifies other academics as its primary (and perhaps sole) audience—both through its sites of presentation and its argumentative strategies. In focusing on the process of misrepresentation it displaces the object of study from the constructed disease to the discriminatory practices of that construction. Parallel to this displacement in object is a double displacement in audience—from those actually endangered to those potentially at risk, and to a small professional (largely unexposed) subgroup within that body negative. Unlike other theoretical "criticisms in the wilderness," AIDS discourse is isolated not because no one understands the message but because, like Boccaccio's storytellers, we spin our tales in retreat from the cities of the plain/plague.

Moreover, one wonders, given this pre-selected audience, whether AIDS analyses are even primarily about the sexism, racism, and classism embedded in constructions of the disease. The academy is perhaps the American institution most sensitized to (and legally protected against) discrimination. Whatever the behavior of its individual members, there is clearly no place within this system as such for public displays of, for example, misogyny or homophobia. In the context of this compulsory liberalism, it may be simply smug to unmask additional instances of discrimination. Truly "oppositional" discourse can only occur where an actual opposition is in attendance. And, for this particular audience at least, we may not so much use social construction to deconstruct the assumptions of scientific discourse as we use the (easily agreed upon) limitations of AIDS representations to validate social construction as a method of cultural critique.

None of these observations is meant to disqualify AIDS analysis as a potentially valid academic activity. At the same time, we do have to ask whether in studying AIDS we ameliorate the situation or merely appropriate the crisis. To return to the suggestive subtitle of the *October* anthology, what do we mean by "Cultural Analysis/Cultural Activism"? "Cultural analysis" presumably marks our current interest in the political prejudices of even the most apparently apolitical of analytic methods. And surely deconstructing the assumptions of the health crisis does help characterize cultural ideology. But to what

ends? The identification of discrimination does not end it: people are not likely to be talked out of homophobia. Moreover, social construction may not itself be the best methodology for such a critique. In arguing for the complicity of all discourses, social construction at best denies the possibility of the neutral space from which AIDS theorists view their material (and at worst flirts with a cultural determinism at odds with its own reforming impulse).

The real difficulty, however, lies less with the method of "cultural analysis" than with the definition of "cultural activism" and the conjunction between the two. The question is not whether constructionist analysis can be cultural but in what ways any analysis can itself be activism. On this point academic exchanges can turn divisive and self-protective, ranking the efficacy of the various methodologies. AIDS scholars have shown a distressing tendency to scapegoat some of their own more theoretical formulations as a means of asserting the political engagement of AIDS scholarship in the academy. But the issue cannot be reduced to a simple dichotomy between the remoteness of theory and the immediacy of polemics. The vocabulary of "activism" must itself be scrutinized. The term "AIDS activism" tends to be applied only to the activities of ACT UP, and "AIDS activist" is the preferred self-designation of the group's members. To the extent that such a use of "activism" is directed against the inactivity of governmental agencies, it is politically empowering. But to the extent that it is directed against other (earlier) forms of mobilization—an implicit slur, say, against the non-confrontational (implicitly racist and classist) programs of New York's Gay Men's Health Crisis (GMHC)—the term is merely self-congratulatory. ACT UP is to be praised for its accomplishments in drug deregulation; as is GMHC for its achievements in intracommunal support, most notably in the initial delineation of "safe sex." Both groups are a source of pride for grassroots politics; one would not want to choose between them.

Finally the question is not "whose activism?" but "for whom?" even "how?" The differences among theories—the high abstraction of deconstruction, the middle-brow determinism of social construction, the unregenerate empiricism of historicism—are less troubling than their symptomatic use of the health crisis to make larger socio-political

points. All analysis that attempts to define the significance of the cri-
sis—to "study" AIDS—flirts with displacing the pain. In this regard,
radical deconstructions of the disease are no more alienating (and
apolitical) than other readings. Traditional accounts of the place of
HIV in the history of illness may encourage a passive acceptance of
AIDS as merely an epiphenomenon of *fin-de-siècle* experience—"our"
cholera or syphilis. And annexation of AIDS to a postmodern critique
of the self can minimize the extent to which the ravages of that dis-
course are not experienced equally across group borders—the
assymetries of that "our."

AIDS discourse must never lose sight of its human responsibility,
and of the tenuousness of the "/" that links "analysis" and "activism."
Although the restricted character of our audience is once again trou-
bling, here I wish finally to share in *October*'s basic hopefulness. It
would be simply "negative" of *me* to deny the importance of discussing
AIDS in the academy. In writing this chapter, not only do I reproduce
all the interpretive errors I have identified; I share the construction-
ists' most elementary goal: to keep visible an issue which even in the
liberal academy is already beginning to seem someone else's problem,
or yesterday's news. Nor am I ready to conclude, as one theorist
poignantly has, that in the face of a more immediate biological threat,
analysis may be simply "an indefensible luxury"; and in epidemiology
as in epistemology what we cannot speak about we must pass over in
silence.[12]

Yet we must temper enthusiasm with skepticism and constantly test
the efficacy of our activism, in terms of its logic, its audience, and
finally its results. From this highly visible (not to say commodified)
vantage, it is all too easy for good arguments with time to become less
effective. As one gay scholar has sadly acknowledged, analysis tends
to produce "a discourse in which the horrors experienced by my own
community, along with other communities in America and abroad,
become the material for intellectual arabesques that inscribe those
horrors within the neutralizing conventions of literary criticism."[13]
And should we ever fully lose sight of the individual pain and suffer-
ing upon which all such discourses are constructed, analysis would
become not activism, but only a louder form of silence.

5

WHAT LOLA GOT

Cultural Carelessness and Minority Convergence

*T*o clarify the relation between sexual identity and cultural visibility, the previous essays have discussed sexuality as if it were a discrete, isolatable entity. While such an approach may be initially necessary to focus in on gay culture with any precision, it understates the extent to which homosexuality occupies merely one stretch along a sliding scale of "sexualities," which itself delineates just one among many kinds of cultural difference. Despite the tendency of minority scholarship to concentrate on subcultural particularity, no group stands fully independent of any other and, far from cleanly differentiated, minorities more nearly come bundled together. I wish, then, to conclude by returning to the popular materials of my first chapter. But this time rather than following a single group's surreptitious "queenings" of mainstream culture, I would consider how exchanges among minorities can be used to reconceptualize their relations to each other and to dominant culture.

Recent criticism has begun to read dialogues between disenfranchised peoples as a form of transgressive discourse, one not determined by dominant cultural norms. Marjorie Garber identifies in gay and straight cross-dressing the marks of a general "category crisis," by which she means "a failure of definitional distinction, a borderline that becomes permeable, that permits of border crossings from one (apparently distinct) category to another."[1] Celebrating the exhilaration of transitional "border culture," Gloria Anzaldúa posits a new "*mestiza* consciousness . . . a consciousness of the Borderlands," where

by developing a tolerance for contradictions and ambiguity, an ability to "juggle cultures," the new *mestiza* "turns the ambivalence into something else," the nightmare into the numinous.[2] And sensitized to the ways in which any "single-axis" conceptual framework erases the discrimination of dual minorities—both in the law and in more general cultural debates—Kimberlé Crenshaw has proposed the concept of "intersectionality" to represent overlaps in race, gender, ethnicity, and sexuality among minorities.[3]

Studying power at the margins, these readings bracket vertical exchanges between the empowered and the marginalized to track horizontal ones among the comparably disempowered. To complement my previous emphasis on homosexuality's stuggles with heterosexuality, I wish to explore another horizontal convergence among minorities—one caused less by the transgressiveness of the margins than by the incoherence of the center. Subcultural opposition occurs not only at sites of transformative crises but within the very consensus on which dominance depends. Cultures are as interesting for what they think is not a problem as for what they think is, and the very absence of anxiety can epitomize for subsequent generations the limitations of a previous age. Popular texts often trade comically on stereotypes not yet called into question. In the very casualness of their discriminatory assumptions—racist, sexist, classist—they register not crisis but complacency, the fact that no one cared at the time to challenge what can later seem obvious errors.

Although usually read as a mark of power, such indifference is also a sign of weakness. The complacency of the dominant culture encourages what we might call "cultural carelessness." At sites of complacency, where discipline is relaxed, the very confidence that allows a culture blithely to assume control permits oppositional voices to undermine that control undetected. In the carelessness that attends confidence, these apparently discriminatory representations can actually become occasions for a variety of minority voices to speak with comparative freedom. To exemplify the possibility for opposition within the conventional, I wish to untangle the ambiguities of a single case of cultural carelessness: Gwen Verdon's showstopping performance of "Whatever Lola Wants [Lola Gets]" from the 1955

Broadway musical *Damn Yankees*, filmed with Verdon in 1958. Although not artistically innovative, *Damn Yankees* does unintentionally raise questions about the relation between masculinity and sexual desire. And in its very *in*ability to answer these questions it permits a dialogue among play, performers, and audience on complex issues about cultural positioning and articulability.

Dancing Desire

Damn Yankees is a modernization of the Faust legend, drawn from Douglass Wallop's 1954 novel *The Year the Yankees Lost the Pennant*. Joe Boyd, an aging real estate broker, sells his soul to Mr. Applegate (the devil) in return for leading his hometown baseball team, the Washington Senators, to victory over the New York Yankees. Rejuvenated as "Joe Hardy," a twenty-two-year-old natural athlete, he joins the Senators and quickly becomes a national hero. But Joe longs only for home and his wife Meg. As a distraction, Applegate calls in his top "home-wrecker," the witch Lola. When Lola becomes more interested in protecting Joe than in seducing him, Applegate spreads the rumor that Hardy took a bribe while playing in the Mexican league. During the ensuing investigation, the devil's contract comes due, and Joe sadly joins Lola in eternal damnation. In one last attempt to outsmart Applegate, Lola drugs Applegate so that Joe can at least play the final game to clinch the pennant. Angry at being outwitted, the devil transforms Lola into a hag and Hardy back into the elderly Joe Boyd. Freed from the devil's power, Boyd makes the winning play and returns to his wife to live happily ever after.

The success of the show derives less from its shopworn plot or conventional score than from the talents of rising comedian-dancer Gwen Verdon, who made Broadway history near the end of the first act with her performance of "Whatever Lola Wants." The dramatic situation is simple. To distract Joe from his wife, Applegate introduces the seductive Lola into the men's changing room. While Applegate hides behind the lockers, Lola offers herself to Joe as his greatest fan. At first she appeals to him for protection, and is unable to climb off a bench without his assistance. When Joe remains politely oblivious to the sexual invitation in Lola's professed helplessness, she turns bully,

trying to cajole him into passion with a seductive song and dance:

> Whatever Lola wants
> Lola gets
> And little man, little Lola wants you.
> Make up your mind to have no regrets,
> Recline yourself, resign yourself, you're through.
>
>
>
> You're no exception to the rule,
> I'm irresistible, you fool, give in! . . . Give in! . . . Give in!⁴

The scene is curious from a number of angles. Most obviously, it is totally unnecessary in terms of the plot. Never does Lola present a sexual threat to Joe, or a viable alternative to Joe's wife. Instead the dance floats freely in the musical as a moment of pure performance— a declaration of coming-of-age by choreographer Bob Fosse and actress Gwen Verdon, both of whom first established their star credentials with this number. It is this narrative freedom that makes the scene so theatrically pleasing and interpretively rich. One need not care about *Damn Yankees* to enjoy the sequence, and that very looseness invites a wide range of readings. Two aspects of the dance deserve special consideration: its characterization of desire; and its use of ethnic stereotypes and of sexual innuendoes to reinforce that representation.

The number is a variation on the traditional strip tease. The strip tease's relation to desire is itself, of course, ambiguous. Sexual availability is not necessarily an aphrodisiac, especially when availability is read wholly in terms of visibility. Perhaps all strips are ironic, performing passion without proffering it. This distance is compounded by Broadway's condescending and finally duplicitous relation to the strip. Legitimate theater rarely alludes to stripping without implicitly distinguishing that low performance tradition from its own self-conscious artistry. If the strip tease may occasionally leer, its Broadway counterpart almost always smirks. The touchstone performance here is Mary Martin's stage debut, never quite removing her fur coat while singing Cole Porter's "My Heart Belongs to Daddy" in

the 1938 musical *Leave It To Me*. Many subsequent shows repeated this Broadway convention of the enacted, de-eroticized strip—*Pal Joey* (1940); *Flower Drum Song* (1958); *Gypsy* (1959); *Guys and Dolls* (1950); Marilyn Monroe's iconographic performance of "Diamonds Are A Girl's Best Friend" in the 1953 film version of *Gentlemen Prefer Blondes*; and Verdon's own Broadway debut as a soloist, the "Garden of Eden" sequence from *Can-Can* (1953).

Mary Martin, *Guys and Dolls*, and Marilyn Monroe (at least) are implicated in Gwen Verdon's performance as Lola. But the theatrical quotations buried in the performance free Lola's strip from traditional Broadway cynicism. Our awareness of the performance as a performance, however pleasurable, forces us to consider the seduction as a process and our relation to it as voyeurs. In the traditional Broadway strip tease, whether or not individual viewers are excited by disrobing, the audience is encouraged to act as if titillation were beside the point—to distinguish themselves as theatergoers from the crude vaudeville patrons, often shown onstage hooting in excitement. In *Damn Yankees*, however, audience sympathies are more complex. Narratively, of course, we want Joe to reject Lola. At the same time, his aloofness forces us to realize that unlike Joe we derive pleasure from the dance. In the movie version of the scene, the camera calls attention to the spectatorial complicity of both Joe and audience by aligning itself visually with neither position. Rarely do we see Lola's performance head on, either from Joe's standpoint or from our own. Instead we get shots over Joe's shoulder or ones that move diagonally across the horizontal frame of the screen (and implicit proscenium arch), shots that include the process of watching as part of the image.

The audience's uncomfortable relation to the strip is compounded by the ambiguity of Verdon's body language. Some of the dance's gestures might seem to imitate traditional sexual movements—hip swings, wrist and ankle flips, slow sensual turns. But this minimally mimetic character is overshadowed by the baroque heightening; what we remember is the stylization, not the movements they imitate. Such gestures, of course, were to become Bob Fosse's personal trademark, and his way of distinguishing his work from the more naturalistic and classical movements of previous choreographers like Agnes De Mille

and his own mentor Jerome Robbins. Even this early in his career, before such gestures came simply to signify "Fosse," they were more theatrical than erotic. At the very least, it would be hard to identify any sexual equivalent for the most bizarre of these movements—Verdon's hunched diagonal cross, her arms swinging like an elephant's trunk.

This desexualization of eroticism is most obvious in the dance's conclusion. The final step—a traditionally balletic if somewhat athletic backward arch—is simply theatrical, and a clear bid for applause. More interesting is Lola's movement at the number's climax. After a section of hyperactivity, Verdon freezes to recapitulate the (ungrammatical) refrain:

> I always get what I aim for
> And your heart'n soul is what I came for.

For these lines she adopts a stationary stance with feet spread and hands on hips [Figure 6]. Her position is anything but inviting. The line itself suggests not desire but competition. Delivered neither to Joe nor out front to the audience, it is sung three-quarter, to emphasize the character's self-preoccupation. To this extent, it recalls not the furry intimacy of Porter's fetishistic tease, but the megalomania of another Mary Martin stance—her 1954 show-stopper as an androgenous Peter Pan announcing that "[S/he] Gotta Crow" [Figure 7].

The tension between Lola's statement and Verdon's stance calls into question exactly what the claim claims. "I always get what I aim for/And your heart'n soul is what I came for" is, of course, one of the dull Faustian puns with which the script abounds. It further underlines the shallow irony of the scene. Lola will not get Joe, as she would easily understand if at this moment rather than turning away she looked at him to see his visible disinterest. But it also raises larger questions about the character of desire and of the "self" that desires. First, Lola's boast too easily links up desires and events. The projection forward in time by which we identify our goals is not the same as the tracing backward by which we characterize how we ended up with what we got. If we get it, we must in some sense have "aimed" for it,

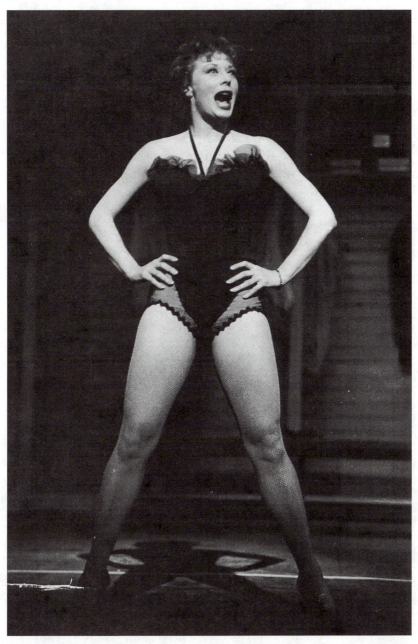

Figure 6: Gwen Verdon as Lola. (Billy Rose Collection; Fred Fehl, photographer)

Figure 7: Mary Martin as Peter Pan. (Billy Rose Collection)

or at least aimed at it. But that sort of historical necessity is not the same as desire, any more than the fact that we get what we deserve proves that we get what we want. More fundamentally, Lola's boast obscures the very ambiguity of motives that keeps this show going. As the plot makes clear, there may be a difference between why Lola came and where she aims, between why she came and why Applegate has her come, even between where she aims and where she wants to strike. And as the audience becomes less sure of what constitutes the "whatever" of Lola's wants, we suspect that our uncertainty mirrors her own indecisiveness.

Different Dances

The Lola scene, then, dramatizes an ambivalence about intention, a submerged pun on "desire" that exploits the discontinuity between discursive strategies and psychological needs: the question of what Lola really wants and whether she desires desire. Denying that externalized actions reflect deeper internal motives called "needs" or "desires," Verdon's Lola is all surface and gesture, without underlying character or essence. In its theatricality, the dance points to what recent feminist theory has called the "performative" aspects of sexuality, the degree to which all gender is "masquerade" and "drag."[5] Yet the sequence does more than simply dramatize the cultural construction of desire, for Verdon's theatricalizations are filtered through two additional performances—of ethnic identity and sexual preference. It is the cultural specificity of these secondary theatricalizations that most distinguishes the scene from the traditional Broadway strip tease. In using ethnicity and sexuality to explicate Lola's relation to gendered desire, the show unintentionally raises questions about what it means for these three categories to converge at a single point.

Of the two, the use of ethnic difference is the more explicit—and the more troubling. To seduce Joe, Lola dresses in an outlandish costume (topped with a ridiculous floral headdress), calling herself "Senorita Lolita Rodriguez Hernando, Miss West Indies of 1957." Throughout the scene, though nowhere else in the musical, Verdon speaks in the clichéd dialect of the Hollywood spitfire ("en leetel men, leetel Lo-la wan-chu"). This second masquerade underlines the the-

atricality of gender by doubling the performances, with Lola standing in the same relation to Lolita that Verdon stands to Lola. Yet the two forms of difference are not truly equivalent, and in treating them as identical, the show makes ethnicity an extension of gender, and subordinate to it. The ethnic motif has no special effect of its own on Lola's audience: Joe and Applegate so fully accept the conflation of gender and ethnicity that they seem not to notice Lolita's difference from the Anglos around her.

Lola's music is as ethnicized as her performance, drawing on elements of the habanera, the tango, and the bolero. Latin rhythms influenced popular music in the United States at least as early as the mid-nineteenth century, when Louis Moreau Gottschalk incorporated Puerto Rican and Cuban elements into his otherwise Chopinesque piano pieces. This appropriation accelerated in the early twentieth century, with Irene and Vernon Castle's popularization of the tango— from Argentina by way of Paris—and continued with similar importations of (among others) the Cuban rumba, the Afro-Cuban mambo, the Afro-Brazilian samba, and the hybrid chachacha, probably a variant of the Cuban danzón. From the 1930s to the 1950s, mass-culture performers like Carmen Miranda, Desi Arnaz, and especially Xavier Cugat were successful proponents of this Latinized music in Hollywood and on the band circuit. Broadway regularly imitated the trend. After a somewhat slow start with Cole Porter's rumba "Begin the Beguine" (*Jubilee*, 1935), by the 1950s Broadway was filled with Latinized hits: Leonard Bernstein's "Conga!" (*Wonderful Town*, 1953); his tango "I Am So Easily Assimilated" (*Candide*, 1956); Mark Charlap's "Captain Hook's Tango" (*Peter Pan*, 1954); Jule Styne's "Mu-Cha-Cha" (*Bells Are Ringing*, 1956); Mary Rodgers's hybrid "Spanish Panic" (*Once Upon a Mattress*, 1959); and of course the tango "Hernando's Hideaway," from Adler and Ross's *Pajama Game*, the year before *Damn Yankees*.[6]

Although some ethnic stereotyping always occurred whenever Latin rhythms were used to epitomize exoticism, sensuality, and romance, Lola's song is more offensive than most. On Broadway the ethnicity of such moments was usually understated: an innocent Anglo was simply taught a new "foreign" dance step, with greater or lesser suc-

cess; or the cast suddenly appeared, dancing at a club like Hernando's Hideaway, a Chinese restaurant with a salsa band. In *Damn Yankees*, however, the specificity of the Lolita persona attributes to ethnicity distinct, negative characteristics. Finding no pleasure in this aspect of performance, Lola characterizes "Lolita" as a sexual chore, her "standard vampire treatment." More generally the script's conflation of seduction and ethnicity trades on the cliché of Latin sexual voraciousness, and the irresistibility Lola claims in her song becomes a property of her Latinness. Such characterizations set up a dichotomy between American purity and Latin degeneracy, one by which even the damned Lola can demonstrate her essential innocence. When during the seduction Lola begins to admire Joe's fidelity to his wife, Verdon registers her emotional growth by a momentary return to her normal "Lola" voice. Such shifts from a Latin accent into an American one identify Spanish as the language not only of seduction but of deceit and adultery, leaving English as the sole domain of fidelity and family values.

Similar negative stereotyping attends the scene's linking of seduction and homosexuality. Questions of sexual orientation often arise in connection with Faust, whether the historical personage or his fictional counterparts in Marlowe, Goethe, and especially Thomas Mann and his son Klaus. In *Damn Yankees* such issues are largely centered in the devil, Mr. Applegate. Throughout the script, Applegate is described with words that in the 1950s were coded as gay. He is called "slight" and "dapper," while his apartment in the second act is characterized as "flamboyant." His appearance similarly suggests his deviance. Although not gay-identified, Ray Walston, who performed the part both on Broadway and in Hollywood, has a slight body type and wooden line delivery suited to roles emphasizing strangeness. Costuming transforms Walston's customary stiffness into a sign of homosexuality. His closely cropped hair is an affectation of youthfulness frequently associated with gay men. His red pocket handkerchief simultaneously alludes to his demonic origin and is a traditional emblem of post-war homosexuality. And if Lola's strip masculinizes (or desexualizes) her, Applegate's wardrobe feminizes him [Figure 8].

With the encouragement of this visual coding, the script reads

Figure 8: Ray Walston as an effeminate Devil. (Billy Rose Collection)

Applegate's demonic intentions as a form of displaced sexual desire. Throughout the musical, Applegate tries to woo Joe to the joys of demonism by expressing contempt for both women in general and marriage in particular. He explains this hatred in terms of the ways in which wives always muck up his plans. Indeed both Joe's wife Meg and Lola do foil Applegate's attempts to trap Joe's soul. Yet his expression of this misogyny in snide one-line wisecracks drawn from the camp tradition tends to underscore its sexual dimension. This gay "bitch wit" is particularly evident in his relations to the reporter, Gloria. In her desire to expose Joe's dishonesty, Gloria is the only character in the show to aid Applegate in his plans for Joe's damnation. Yet Applegate's relation to her is purely antagonistic, and she is in fact the subject of his nastiest asides, most of which deal with her unfeminine behavior.

It is in light of the gay coding of Applegate that we must read the sequence following the "Lola" number—the devil's brief parody of it. Angry that Joe has gone off with his wife, Applegate appears from behind the lockers to critique Lola's performance. Objecting that "your methods are old-fashioned," he contemptuously reprises a few measures of her seduction. Although, like Lola's dance itself, this very brief coda is multi-faceted, it is most striking for its allusion to the camp tradition of quotation and female impersonation. The imitability of female performance always, of course, calls attention to the constructed character of gender identity. At the end of *Gentleman Prefer Blondes*, for example, Jane Russell can become "Marilyn Monroe" through reprising in a platinum wig Monroe's "Diamonds" number.[7] In *Damn Yankees*, however, the imitation is across gender lines. The mini-reprise asks us to imagine Applegate momentarily as a woman. Although the script has already coded the devil as gay, Walston refuses to adopt those performance styles most closely associated with gay gender-crossing. Studiously avoiding the falsetto voice traditionally used in drag representations of women, he sings entirely in his own register, reproducing neither Lola's intonations nor her accent. His movements transform the dance back into a bump-and-grind, with only the arm thrown across his shoulder even glancing at the irony of the drag review. His fury incapacitates him, and the scene ends with

him petulantly stamping his feet. The joy the audience feels in Verdon's performance of gender is denied Walston's performance of homosexuality, which appears merely childish and impotent by comparison. It is not Lola's method but Applegate's that is "old-fashioned."

Reconceiving Carelessness

Damn Yankees represents the theatricality of desire by reading ethnicity and homosexuality as similarly theatrical. There are in the "Lola" scene at least four variations on normative sexuality—Latin performance, Verdon's burlesque of those performance traditions, drag performance, and Walston's de-ironization of those traditions. In these revisions the musical flirts with a whole set of demeaning cultural stereotypes—foremost among them, the primitivization of Latin culture as natural and exotic, and the trivialization of gay male culture as flamboyant and infantile. These limitations cannot be explained away. Yet the carelessness with which the show reproduces the sexism, racism, and homophobia of its culture exposes the vulnerability of those assumptions. The moments when the show trades most on stereotypes are often those when traditional values are least authoritative. And in the performance's conflation of gender, ethnicity, and sexuality, this complacent dance becomes a potential site for rethinking the meaning of all three.

Gender stereotyping is the most obviously threatened, and is so by the very linchpin of the show's commercial success—the presence of Gwen Verdon. Verdon's personality is as disruptive as it is entertaining. Although a successful performer on Broadway, *Damn Yankees* is Verdon's only screen success, and one of her few film appearances. In general her talents were felt too hyperbolic for the greater intimacy of the screen, and when her other stage triumph, *Sweet Charity* (1966), was filmed in 1969, the role went without success to Shirley MacLaine, who was overtaxed by the part's singing and dancing. In Verdon's Lola, we get not simply the performance of a first-rate dancer and a comic singer of considerable charm; we get a female image that, unlike MacLaine's, was not primarily directed at a male sensibility. By the time *Damn Yankees* was filmed, Verdon was neither

especially young nor particularly pretty, and she appealed as much to female viewers as to males. Moreover, Verdon's limitations themselves make space for an even more unusual female performer—Shannon Bolin, who played the wife, Meg, on both stage and screen. As with many dancers, Verdon's considerable talents do not extend so far as lyric singing, and in *Damn Yankees* all the love ballads had to be given to Joe's wife. But since Meg need not dance or flirt, the part went to an unprepossessing middle-aged actress, whose chief performance strength was a rich singing voice. The part was, and is, unusual in its notion of type, and Bolin herself won praise but no further roles.

Any show built around Verdon is likely to require an imaginative relation to 1950s gender categories, and *Damn Yankees* in fact offers more interesting women's roles than most Broadway musicals. Not only Lola, but even Meg and Gloria actively advance the plot as do none of the ballplayers, including Joe. More strikingly, the musical is one of the few not to have a love story at its center. Although Joe's love for Meg is unflagging, his fidelity has little effect on the plot. The women are more fully characterized by their jobs than by their sex lives. When her husband disappears, Meg quickly becomes financially self-supporting by taking in boarders. Gloria is a reporter whose interest in ballplayers is not sexual but professional. And for Lola, of course, sex is her job. Regardless of its effect on Joe Boyd, the devil's pact frees the show's women from economic and emotional dependence on men.

This unintentionally innovative characterization of women undercuts the intended celebration of the masculinity of sports. The very carelessness with which the show accepts contemporary clichés about the once "unbeatable" Yankees reveals how professional baseball was striving to mythify a middle-class notion of masculinity on the eve of that notion's death at the hands of sexual liberation (and the rise of football). Although paying lip service to the traditional dichotomy in which Joe and baseball stand for masculinity, and Meg and home for femininity, the show is unable to sustain it. Not only does the plot finally side with femininity, rejecting baseball and masculinity for home. The individual characters subvert the dichotomy. None of the women fulfills the stereotype of wife and mother with any precision.

Walston's devil is as domestic as any of them, and the set depicting his "home" is more middle-brow than Meg's suburban living room. Nor do Joe's teammates embody traditional masculine values. Inept athletes with comic physiques, they speak not for skill or even brute strength but (in the show's other hit song) for "Heart."

The show's inability to sustain its masculine/feminine dichotomy is clearest in the publicity department's uncertainty about how to represent Verdon herself. The show's most famous poster offered the image of the undressed, desexualized Lola and (again) alluded in image and layout to a similarly masculinized use of Mary Martin's Peter Pan the

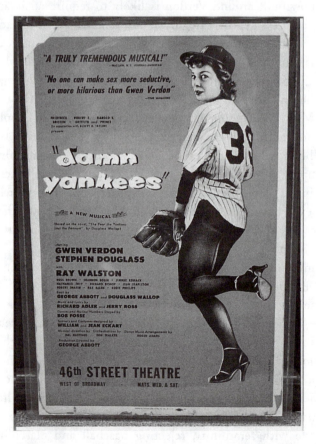

Figure 9: Original image for Lola in *Damn Yankees*, replaced by Figure 6. (Billy Rose Collection, Gene Cook, photographer)

year before. But, in fact, the first poster for the show challenged more directly the traditional characterization of baseball as masculine [Figure 9]. Here an image of Lola in a baseball uniform—the badge of masculine empowerment—eroticizes her more than any of her more explicitly seductive female clothes in the show proper. The subsequent repression of this photograph suggests that even the show's creators understood how such an image might erode the show's complacent faith in the masculinity of sports.

Similar tensions complicate the show's use of ethnicity. The score undermines the script's stereotypes by the musical respect it affords them. Whatever it thinks of its Latin origins, "Lola" is after all the show's finest song. Traditionally, the theatrical strip tease satirizes its source in burlesque—most commonly, as in *Gypsy* or Monroe's "Diamonds," through the parodic accompaniment of the blaring trumpet and crude percussion licks. "Lola," however, employs complex orchestral effects that allow the music to seduce even as Lola does not. Nor is Adler and Ross's score monochromatic in its appropriation of Latin rhythms. The parodic use of Latinness in the strip tease is modified by the later use of the mambo in the dance number performed to celebrate the team's winning streak and by the return of a domesticated form of tango in the love duet between Joe and his wife.

The middle-American book of the show also makes surprising concessions to ethnic politics. The libretto is preoccupied with place, and with cultural differences among American cities—New York, Washington, Hannibal, Providence. In this show, the national pastime of baseball fosters regional competition and antagonism. Even nationalism itself is implicitly criticized. The rumor about Joe's dishonesty in the Mexican league invites the audience to think about the moral implications of such an ethnicized "bush" league. Even the show's title functions as a pun, directing its damnation not only at a New York baseball team but (in Spanish) at American political intervention more generally. A musical that appears to engage in cultural appropriation alludes in its title to the epithet by which Latin America traditionally reviled the United States as culturally and politically imperialist—"Yanquis."

Such ambiguities are compounded whenever the show links ethnicity to its equally ambiguous gender representations. Gender revisions defuse ethnic stereotyping most at the moment which most fully equates the two—the Lolita caricature itself. As first conceived, the scene is racist: authors, directors, and actors all assume that for Broadway's largely white middle-class audience the humor of the spitfire stereotype will more than override its prejudice. Yet in some ways such prejudice only makes explicit the racial inequities in all ethnicized music. Most bandstand and Broadway performances presuppose Anglo superiority in silently assuming their audiences' understanding of, and entitlement to, ethnic materials. Some musical appropriations—including "Hernando's Hideaway"—make no mention of the rhythms' origins; and in *Wonderful Town* Rosalind Russell, as Ohioan Ruth McKenney, actually teaches the conga *to* Brazilians. In Lola's dance, the racist distinction between Latin voraciousness and American purity at least acknowledges that ethnic groups might be significantly different. By depicting Joe's moral superiority to Lolita, the show inadvertently admits that Lolita knows some things Joe does not.

The racism of the stereotype is further undermined by the implicit contradictions between the ways ethnicity is used in the scene. As a stage accent, Lolita's Latinness stands for fraud, against the authenticity of Lola's Rhode Island origins. Yet, as irrepressibly sexual, Lolita symbolizes the exotic's access to original innocence, a natural shamelessness lost through acculturation. The tension between the Latin as true and this Latina as false is compounded by the fact that, though offered as irresistible, Lolita's Latinness is in fact resisted. The seduction fails, of course, because Joe loves only his wife. The easy triumph of marital fidelity, however, does not explain the failure of the concept of Latin irresistibility, and though we intuitively know that Meg will win, we must still consider the implications of Lola's defeat. Her failure might show the so-called irresistibility of Latin sexuality to be a myth, the racist construction of white middle-class culture. On the other hand, Joe's disinterest might suggest that ethnic difference, though real, resides in the Latin's different cultural relation to sexuality, a cultural difference that would not speak to the very WASP Joe.

Verdon's own indifference to her failure, moreover, permits an even more radical reconceptualization of ethnic sexuality. A very talented dancer and comedian, Verdon was physically incapable of the voluptuousness of a Monroe. Casting this skinny pale actress, however momentarily, as a sultry Latina only compounded the joke of her own sexlessness. To maintain audience sympathy and avoid self-parody, Verdon does not distance herself from her character, but places Lolita in control of the joke. In so doing she extends the musical's ironic approach to gender to its ethnic stereotyping as well. The same performativity that puts Lola in charge of her seduction allows Lolita to control her ethnicity. Verdon's Lolita is not a cartoon spitfire but a figure of playful knowledge and power. Lolita exploits the theatricality of Latinness to destabilize ethnic caricature, much as Verdon uses dance to explode clichés of female desire.

In treating ethnicity and gender as comparable acts of performance, then, *Damn Yankees* can seem even more perceptive than the most sophisticated and sympathetic of the Latin musicals, Bernstein's *West Side Story* (1957). Although that play's Puerto Ricans are psychologically complex, they are still primitives, and the show is unironic in its use of rhythmic syncopation and flashy colors. The Sharks dance with unexamined naturalness the exotic dances of their native culture. They can be passionate, tortured, conflicted, and angry, but not self-reflective or hyperbolic. By mixing Latinness with other sexual performances—like those of Betty Boop or of teenagers on the telephone—Fosse and Verdon suggest the self-consciousness with which Lolita performs all sexual activities, both "natural" and borrowed. Their Latina is not trapped by stereotypes but revels in them. She celebrates the irony by which Latin sexuality understands and underscores its own artificiality. More performing than performed, this Lolita refuses to win or lose at sex, and instead envisions seduction simply as an entertaining game.

Homosexual Silence

Just as the intersection of gender and Latin sexuality opens a space for rethinking the musical's ethnic stereotypes, gender ambiguities complicate the work's crude use of homosexuality. Though unadmirable, the

demonic Applegate is in the play a figure of considerable power and, as in many *Fausts*, he upstages the hero. When Walston won New York's Tony Award for his performance, he won as best leading actor, not supporting actor. To attribute homosexuality to so strong and unconflicted a character is an advance over many Cold War representations. The relation between Applegate and Lola reinforces this sexual revisionism. Traditionally, of course, witches are the devil's concubines. Although in his misogyny Applegate predictably shows only professional admiration for Lola's sexual skills, the two are emotionally coupled, and their fights stand as the show's most sexualized moments. While not homosexual, their exchanges suggest that gender relations need not take the culturally sanctioned form of heterosexual marriage.

The real threat to heterosexuality, however, is not Applegate, but Joe Hardy. Joe is a difficult and finally a thankless role. The play's moral center, he remains pure despite his demonic pact. His goodness, however, is passive, and his refusal of temptation looks like the absence of desire. He cannot express passion in his scenes with his wife, because a 1950s audience would be made uncomfortable by a young actor's making love to a woman over twenty years his senior. Similarly, Lola's seductions are fun for the audience only if they have no effect on Joe himself. Rather than recognize and refuse temptation, Joe must ignore it, denying that temptation is tempting, even as Lola and the audience revel in the fantasy of being bad.

On Broadway, the virility of Stephen Douglass's Hardy made his sexual reticence incomprehensible, and his four-square masculinity derailed the show's more playful approach to desire. It is in portraying the absence of passion that Tab Hunter's movie performance works so well. During the strip tease, Hunter remains oblivious to Lola's offer, politely observant but uninvolved, as if uncertain of what she wants (or what she wants him for). While Lola discards her costume, his gaze dutifully follows the inanimate pieces of cloth and ignores the flesh stripped bare. The performance is not psychologically realistic: after many years of marriage, Joe Boyd/Hardy cannot claim sexual innocence. But Hunter's blandness eliminates any threat of moral transgression that might interfere with our pleasure in Verdon's performance.

The exploitation of Hunter's innocence depends on the overlap between the ambiguities of the role of Joe Hardy and the ambiguities of Hunter's position in Hollywood as an invisible gay man. The movie asks us to believe the contradictory propositions that a certain sexual situation would be by definition irresistible, and that in one particular case a man resisted it. It then uses Hunter's inability to represent heterosexual passion to finesse that contradiction. Wherever the tensions between masculinity and morality increase, so does the homosexual subtext. The setting of Lola's failed seduction implicitly recognizes that locker rooms are traditional sites of homoerotic tension. The film underscores this irony by photographing the ballplayers clothed only in towels. Himself seated in his underwear with legs spread—a traditional crotch shot—Hunter begins the sequence more sexualized (and more nude) than Verdon ever is, and the scene really involves complementary teases, Hunter's dressing and Verdon's undressing.

By using Hunter's passionlessness to leaven the character's moral and physical superiority, the film trivializes homosexuality as an emotional vacancy verging on imbecility—the absence of passion, rather than passion for a non-traditional object choice. Even while merchandizing Hunter's boyishness, energy, and blondness, the film implicitly devalues these traits as stereotypically homosexual. Encouraging audiences to believe naively in the possibility of sexual disinterest, for skeptical (savvy) viewers the film offers as alternative the probability that this particular sexual disinterest has a simple though unspoken cause. "Innocence" in this context functions, like "bachelor" in the nineteenth century, as a euphemism for homosexuality. Perplexed by Hardy's fidelity, audiences are invited to translate feelings of moral inferiority ("I don't know how he can resist that") into sexual complacency ("We all know what that means").

Whether directed at Tab Hunter, Montgomery Clift, Anthony Perkins or (in a different way) at Rock Hudson, James Dean, and even Cary Grant, sexual innuendo and sight gags often accompany the use of gay male performers to represent an ideal of heterosexual male sensitivity or sophistication.[8] Despite the film's sneers, however, Hunter is a surprisingly appealing homosexual, especially compared to the stereotypic Applegate. Hunter's Joe is not, like Walston's devil,

"coded" gay. Yet, without crudely distinguishing Walston's "playing" gay from Hunter's "being" gay, we can read the two more neutrally as contrasting ways of playing gay in the 1950s. Walston represents the visible "queen," a campy homosexual who openly fulfills social stereotypes. But, as Hunter's performance and career suggest, there can also be a homosexuality which, while not exactly "closeted," is only visible negatively, in the absence of heterosexual emotions and affects. Walston's devil is defined and damned by the heterosexual norms he inverts. Hunter's Hardy is simply something else, to which such social strictures do not apply.

In hinting at Hunter's homosexuality, the movie trades on homophobic stereotypes to disguise irregularities in plot and characterization. Thinking to profit from the cultural taboo against homosexuality, however, the filmmakers only silence themselves, while affording Hunter indirect access to power. The film cannot actually mention homosexuality. Open examination of Joe's implied deviance would undermine the show's idea of faithfulness. Adultery threatens the generation's morality less than the admission that not all marriages build on heterosexual passion. Moreover, while the filmmakers are trapped by their silence, Hunter is liberated by his. His refusal to state his preferences—to Lola and his fans—indicates comfort with his social compromises: he does not explain his sexual orientation simply because he does not think it needs to be explained. Even his "innocence" and "blandness" may be strategic. By adopting certain clichéd forms of homosexual behavior, Hunter can use to his own advantage the very cultural stereotypes meant to stigmatize him, obscuring his wants as fully as Lola/Lolita does hers.

Tab Hunter's performance is then surprisingly necessary to the success of *Damn Yankees*. Not only does his marketability as a Hollywood star permit the casting of relative unknowns in the other key roles. His restraint and dramatic inexpertise sanction the hyperbole of Verdon's and Walston's star turns. His un-self-conscious underplaying is at times better served by the camera than their calculated overacting. Most important, it is his point of view that lies at the center of the film. In one sense the characters perform for (or even at) a passive immobile Joe. In another, however, Joe's consciousness actively shapes

and controls how those performances appear to the audience. Although grounded in the moral sensibility of his alter-ego Boyd, the movie spends most of its time with Hardy. And in the show's conflicting injunctions to watch Lola and return to Meg, the audience regularly finds itself caught in the middle, sharing with Hunter the spectatorial space of the bemused homosexual.

At this point we must reconsider exactly what is the devil's pact in the show. In contracting trivially to win at baseball and more generally to recapture youth, Joe Boyd abandons conventional culture for a neutral territory in which moral absolutes become merely performative possibilities. As is customary in such utopias—from Shakespeare's forests on—transformations move across sexuality, and the heterosexual Boyd becomes a homosexual Hardy as easily as Rosalind, in *As You Like It*, becomes a boy. Joe's metamorphosis invites us to rethink the more general ambiguity of sexual identity in the musical. The reporter Gloria plays a relatively small role, leading one dance number and sponsoring the investigation into Joe's alleged dishonesty. Nevertheless, she leaves her mark. As a woman more interested in work than love, she is regularly teased by the devil and the team manager for her inability to perform wifely duties. This teasing, however, always accepts her lack of sexual interest in the players, whom her reports objectify and demasculinize. As with Joe Hardy, her sexual disinterest is explained in ways that complacently reaffirm cultural stereotypes: sexually repressed, she substitutes work for men. But as with Joe Hardy, the carelessness of the explanation raises more troubling questions about the sources and effects of her "tomboy" sensibility. Although the show avoids these questions, and surely does not code her as lesbian, the failure to provide Gloria with a convincing heterosexual psychology leaves open the possibility that she has a commonplace homosexual one.

A comparable silence complicates the seduction scene with which we began. The show takes the seduction lightly, teasing Joe's sexual reticence and laughing at the absurdity of Verdon's performance. But rather than reduce that performance to a caricature of normative sexuality, we might consider it on its own terms—not as parody but as a new form of pleasure. Verdon's lack of voluptuousness redefines what

constitutes sexual appeal. The strip that from one angle seems to masculinize her, from another angle liberates her from the control of male voyeurism. At the end of the song her competitive aggressive pose is not really asexual. It rejects desire as possession to re-embrace it as power. And while the show's producers surely had no interest, however implicit, in activating the lesbian subtext in its gender characterizations, it is also true that Lolita's sexual dominance anticipates rather closely some affirmative images in contemporary lesbian S/M culture.

Joe's passionlessness, then, supports the musical's cultural complacency only finally to undo it. The show invites us to indulge in fantasies of youth, celebrity, infidelity, even miscegenation, incest, nudity, and damnation. This moral holiday is authorized by Hardy's stability—the possibility that a character offered such temptations would merely long for age, home, clothes, and Meg. Joe stands in for the shared consciousness of the decade, those unstated but purportedly universal cultural and moral norms against which we measure the deviance of women, devils, Latins. The problem with such moral rectitude is not that it could not exist but that it would have no identifiable characteristics if it did. Discriminatory dichotomies—female/ male, black/white, Latin/Anglo, gay/straight—are defined primarily in terms of the supposed traits of the disempowered half. "Male," "white," "Anglo," and "straight" only take on meaning reflexively: they lack the characteristics that make the other categories inferior. As an invention of the devil, the playwrights, and of dominant culture, "Joe Hardy" has no performable characteristics of his own.

So long as shared cultural assumptions are not challenged—so long as audiences accept Joe's fidelity to Meg as sufficient explanation of his passionlessness—then the indefiniteness of his values passes unnoticed. Once they are called in, question, however, it becomes clear that the show cannot defend its universal truths. And when the producers try to establish their validity negatively—through invidious comparisons with unwanted femininity, Latinness, and homosexuality—they actually provide those minority cultures a voice in the very process meant to ostracize them. The carelessness with which the show characterizes the culture's shared wants is epitomized by the ambiguity of Lola's unspoken "whatever." At first the ambiguity

seems trivial. Since we all know what she is after ("what *that* means"), speaking is unnecessary. The unsaid is simply sex. But as faith in shared cultural assumptions breaks down, the meaning of the unsaid broadens. "What we all know" is transformed into competing ways of knowing, and we come to fear that we do not know what "that" means at all.

"Whatever Lola Wants" presents itself as a scene of comic double failure: Joe is ridiculed for not responding; and Lola, for wanting him to. The film complicates these personal failures by comparing them to the traditional sexual misalliance between the deluded heterosexual woman and a closeted gay man. Such comic readings, however, depend on normative standards of sexual behavior—the truths universally acknowledged that all women want husbands and all men want women. They are the point of view of the devil, or of the male heterosexuality that he upholds through his very attempts to subvert it. Minorities performing the scene can overturn this discriminatory reading simply by expanding the "whatever" of desire so carelessly left unspecified. In their performances, desire does not fail but is instantaneously gratified. The unspoken represents less some goal to be reached than the process of reaching it. Lola's desire is performance as dance; Joe's, performance as innocence. Verdon wants to kick and Hunter to grin. Both get their wishes, and, despite the plot of the devil, they authorize a moment in which the Yankees do not win— they do not even appear on stage.

Passing Over Boundaries

The contradictions and lapses in *Damn Yankees* permit an approach to difference not focused on victimization. Bracketing vertical questions of power, we can talk more horizontally about the mutual support that results when "others" come bundled together. Yet not all minority intersections are liberating; the potential for oppositional readings depends on dominant culture's failure to regulate those convergences. While the producers of *Damn Yankees* simply lump women, Latins, and homosexuals together as objects of ridicule, most intersections are more consciously constructed. At the carefully patrolled borders of culture, minorities do not "come" bundled together, but are

made to seem related for a variety of purposes. While some likeness-
es foster cooperation among subordinated groups, others function to
set minorities against each other and consolidate the power that
oppresses them all. I would like to end, then, by briefly considering
apparent intersections in three texts more self-conscious (and cultur-
ally valuable) than *Damn Yankees*. Only after we examine critically
why things do or do not seem similar—for what reasons and to whose
benefit—will we be able precisely to locate, read, and activate the
potential for opposition that lies throughout the margins.

The first text is Nella Larsen's *Passing* (1929), one of the literary
masterpieces of the Harlem Renaissance and, with James Weldon
Johnson's *The Autobiography of an Ex-Coloured Man* (1912), the finest
novel of racial crossing. Clare Kendry, married to John Bellew, a white
man who thinks her white, is increasingly drawn to black society after
a chance encounter with the narrator Irene Redfield, a childhood
acquaintance who, though equally fair, lives in Harlem with her dark-
skinned husband, Brian. His suspicions aroused upon accidentally
discovering that Irene is black, Bellew interrupts an all-black party at
the Redfields and accuses his wife of being "a damned dirty nigger."
Clare falls to her death out an open window, apparently committing
suicide in shame.

Although in rough outline a familiar narrative of the tragic mulat-
to, the novel, as Deborah McDowell has shown, employs a form of
double plotting common in African American women's writing to
envelop in the "the safe and familiar plot of racial passing" the more
dangerous "subplot of Irene's developing if unnamed and unacknowl-
edged [lesbian] desire for Clare." In Judith Butler's powerful reformu-
lation, "it is unnecessary to choose whether this novella is 'about' race
or 'about' sexuality and sexual conflict, [for] the two domains are inex-
tricably linked."[9] Yet the question remains of why the domains are
linked, and of how to discuss that linkage without making one
domain a version of the other. Reading the story less as the narrative
of a tragic mulatto than as Irene's attempt to conform her complex
social situation to the conventions of the passing metaphor, we might
profitably ask what happens when homosexuality, race, and gender are
described as if indistinguishable.

Irene's dependence on the trope of passing derives from her discomfort with black upward mobility. A quasi-Jamesian comedy of manners, the novel is preoccupied with the social rituals of "what called itself Negro Society" (p. 157)—the teas, dinners, dances, and vacation resorts. Irene fears such black imitation of white middle-class values to be a species of racial disaffection. When first speaking of "this hazardous business of 'passing,'" she, without reference to color or race, characterizes it as a "breaking away from all that was familiar and friendly to one's chances in another environment, not entirely strange, perhaps, but certainly not entirely friendly" (p. 157). To downplay the similarities between the social conventionalism which allows her to pass freely in white society and the intentional duping of white individuals, Irene vilifies the latter. Although she condones passing "for the sake of convenience," as in the opening scene of her taking tea in a segregated hotel, she regrets having "gone native" in misleading Clare's husband (p. 227). Yet her rhetoric betrays her attempted distinction: not only does sympathy seem wasted on the loathsome Bellew, but Irene's use of the term "going native" to describe its very opposite—the repression of all visible signs of race—suggests her decision to read black behavior as a species of black appearance. Believing that one can "act black" as well as "look black," she treats as a form of passing any departure from the "jungle" manners of the Cotton Club.

For Larsen, Irene's commitment to passing rhetoric does not demonstrate racial self-awareness, but only internalizes white standards of judgment. As Irene suggests to her white confidant Hugh Wentworth, passing is not really a problem for the black community. Not experiencing racial identity primarily as appearance, blacks are not likely to be fooled by other blacks' passing. Nor do they have much to lose if so deceived. For whites, however, whose empowerment depends on an ability to distinguish between races, invisible crossings-over pose both the sexual threat of miscegenation and the economic one of job competition. In the concept of passing, the dominant culture recasts this paranoia about contamination as a betrayal of racial solidarity. White inability to identify blackness is redefined as black desire to be white in spite of oneself. Internalized within

blacks as a psychic conflict between personal needs and racial identi-
ty, the concept of passing functions as an effective means of social
control, invalidating the desire for self-advancement as a species of
self-hatred.

By Larsen's skeptical account, then, the passing narrative is one of
the strategies by which white culture subordinates blacks. The
rhetoric presupposes an untenable essentialist reading of race. An
individual of mixed lineage is unambiguously black only by the same
racist standard that sees a single drop of black blood to contaminate
the absolute purity of whiteness. Moreover, although men can pass as
easily as women, the passing narrative as a tactic of social control is
disproportionately directed against women. This predominantly
female character may originate in racist assumptions about dominant
culture's right to look at black female bodies. Yet, like the psycholo-
gization of the motif, the repression of male passing redefines a social
threat as a personal maladjustment. Ignoring the workplace where
passing black males endanger white employment, the female plot cen-
ters the deception in marital relations, and casts passing as sexual infi-
delity, epitomized by the possibility of a dark child.[10]

In accepting a narrative which subordinates black to white and
female to male, Irene situates her own feelings of personal inferiority
within a more general myth of white cultural dominance. By coupling
this narrative to her ambivalence about female sexuality, she does not
discover a true similarity between race and lesbianism but only com-
pounds her self-hatred. It is of course trivially true that the same
metaphor of "passing" has been used to describe certain types of invis-
ibility available to some black and many homosexuals. Yet ignoring
this most obvious continuity between blackness and lesbianism—their
ability to pass—Irene experiences homosexuality not as something
physically disguisable, but as something emotionally repressed. By
defining her fascination with Clare's social courage as a sexual urge
she feels to be deviant, Irene confirms her fears of social advancement
as psychological maladjustment. At the same time, in reading as emo-
tional her intellectualized search for blackness in Clare's features, she
reinforces the racial essentialism underwriting the passing trope.

Irene's conflation of race and sexuality, then, does not clarify real

minority intersections so much as compound her own sense that her feelings are wrong. Irene's inchoate fears about lesbian desire are both homophobic and racist. Showing no sense that femaleness might be attractive or even that desire might occur between whites or across races, Irene trivializes homosexuality merely as a mix of voyeurism and narcissism. In fearing a nascent lesbianism, she attributes to herself the hypersexuality and domesticity characteristic of white stereotypes of the black female. And by equating racial and sexual invisibility she only further represses the way in which the cultural taboos against invisibility serve the interests of the empowered—the extent to which "passing as what" is really about "passing before whom."

Larsen's novel is not complicit with these repressions and, behind Irene's unreliable interpretations, offers alternative, less self-hating models of passing—like religious conversion (a black's religious "passing" as a Jew) or expatriation (Brian's desire to "pass" as Brazilian). The most telling challenge to Irene's notion of passing, however, rests with Hugh Wentworth. An apparently minor character with no real plot function, Wentworth receives a disproportionate amount of Irene's attention. It is to him that she directs her taunts about the inability of whites to pass or to recognize black passers. It is in defending him to her husband that she first suspects Brian of sleeping with Clare, and it is Hugh's glance at Brian and Clare later the same evening that confirms that suspicion. Yet in each case, Irene wrongly projects onto him her own preconceptions. Modelled on Carl Van Vechten—the white gay novelist to whom, with his wife, Larsen dedicated the novel—Wentworth stands as the white man who resists white paranoia about passing. Interested in racialized bodies only as sexual partners, not as economic threats, he refuses to play Irene's game of determining Clare's true color, and any glances he casts at Irene's husband are less suspicious than lustful.

As uncloseted, married, white, and gay, Wentworth overturns many of the assumptions underwriting Irene's concept of passing. Men can pass, men can be homosexual, and in desiring across racial boundaries, homosexuals need not be narcissists or voyeurs. Most simply, he proves that invisible identities do not mark psychic disorder or social dishonesty. When at his first appearance Clare wonders at

Wentworth's presence in Harlem, Irene tells her that he is there for "the same reason you're here, to see Negroes" (p. 198). Yet Irene cannot face the ways in which Wentworth truly is like Clare, and, like her, tries to make Irene understand that every desire "to see Negroes" is positioned. As a gay man, Hugh has particular motivations; at the Negro Welfare League Dance he makes clear his sexual desire for black males. But as a white one, he reminds Irene that the white gaze is never so disinterested as her passing narrative implies. His insistence that all knowledge is positioned threatens Irene's world view as much as does Clare's indifference to passing. Together they represent the extremes of judge and judged that propel her narrative. And just as Clare rejects her role as tragic mulatto, so Hugh declines his as the white man decrying racial deceit.

It is Hugh's refusal to supply a white judgment on racial invisibility that determines Irene's behavior in the novel's "revelation" scene. Clare merely smiles when her boorish husband announces her "true" identity: because she has already decided to leave Bellew and return to black society; or does not consider herself essentially black; or does not accept his right to judge. In a voice mixed with "rage" and "pain," Bellew himself seems unsure of the implications of his discovery. Bellew's personal ambivalence reveals a larger social irony. The very context that allows him to know his wife as black—her presence at an all-black party—robs this charge of its power. In the absence of whites, his sense of betrayal finds no support: "You're the only white man here," he is warned. He is outnumbered epistemologically as well. His own appearance at the party robs it of the uniform blackness that proved Clare's color: wherever one person *is* white, two might be; and though he is "the only white man," Clare may be the only white woman.

Identity requires a standard against which to measure discrete occurrences, whether as members in a construct called "race" or as experiences in a construct called "person."[11] Since such a standard is not only absent but impossible, racial identity can be secured only by the ideological assertion which has always sustained it—white privilege. And though the others present withhold that privilege, Irene assents to it. Believing that a concept of racial visibility can stabilize

her marriage, sexuality, and class aspirations, Irene supports Bellew's
right to name what he sees. Employing the melodramatic conventions
of the passing narrative, she simply reinterprets the moment "*as if*
everyone were . . . staring at [Clare] in curiosity and wonder" and "*as
if* the whole structure of [Clare's] life were . . . lying in fragments
before her" (p. 238; emphasis added). Irene's acting "as if" passing
were a crime is what kills Clare. Whether or not, as some critics
argue, she actually goes on to push her friend out the window is irrel-
evant. By making black identity a white judgment, she annihilates
Clare more completely than could any defenestration, sacrificing as
well all gender, sexual, national, and class alternatives that resist that
privileged gaze.

Charting the Center

Passing explores ambiguities about racial identity to clarify the rela-
tion between minority visibility and social subordination. Through
the narrator's discomfort with her place in the black community, the
novel traces fears about racial mobility back to their source in white
paranoia and uses purported similarities between passing and lesbian-
ism to expose identifiability as a technique of cultural surveillance.
Irene's insecurities remain our own, and contemporary debates among
minority positions continue to be complicated by their unconscious
reinforcement of cultural hierarchies. To conclude my discussion of
intersectionality, then, I would like to review two such controversies.
My intent is not to adjudicate among competing interpretations, but
only to suggest how, even when not revealing in and of themselves,
the lines drawn between minorities can serve to map out the subtle
vertical influences which oversee and sanction these conflicts.

First, the photographs of Robert Mapplethorpe. Key texts in dis-
cussions of homosexuality, sadomasochism, racial fetishization, post-
modern aesthetics, and AIDS representation, Mapplethorpe's images
might seem to epitomize the multicultural ideal of minority intersec-
tionality. The two major scholarly approaches, focusing on his aes-
theticized sadomasochists and on his hypersexualized black males, both
praise Mapplethorpe's use of the tension between the images' classical
form and their forbidden material to unmask cultural hostility to

certain ways of looking.[12] Yet such agreement has not led to further exploration of intersectionality in Mapplethorpe; each approach shows little interest in (and is in fact embarrassed by) the images the other admires. Without reading Mapplethorpe's choice of subjects as proof that sadomasochism is "like" racial objectification, we can still wonder why that intersection remains undiscussed in readings apparently so similar. What kinds of things do we have to believe to accept as revolutionary the neo-formalism of these photographs, and what in those beliefs makes it hard to see that anti-traditionalism simultaneously in representations of sex and race?

Part of the difficulty arises from the rapidity with which Mapplethorpe replaces his models as the subject of study. Mapplethorpe's personal biography is regularly offered as evidence of his closeness to his models—his membership in the sadomasochistic community and sympathy (at least) with black men. Who Mapplethorpe is justifies how he looks; where he looks defines what he is. Such an argument oscillates uncomfortably between identity and identification. Although not conclusive, Mapplethorpe's own statements suggest his identity with his leather models as part of the sadomasochist community. His identification with blacks is more complex, and Clare's question about Wentworth in *Passing*—"What is he doing here?"—could be directed at Mapplethorpe. The simplest answer is a version of the one Wentworth offers Irene: Mapplethorpe is continuing a gay white tradition, begun in fact by Wentworth's prototype Carl Van Vechten, of expressing interracial homoerotic desire through photography. Yet desire as a form of identification does not absolve the gay viewer of possible complicity in a long-standing white tradition of objectifying the black body through the gaze.

As Kobena Mercer has shown, some biographical specificity is probably necessary to delineate the particularized viewpoint of minority artists, and the special forms of intertextuality that characterize "the political imaginary of difference."[13] Yet defenses of Mapplethorpe's closeness to his models clarify the photographs' meaning only by taking it out of the hands of either. Readings pay no attention to the minoritized subjects of Mapplethorpe's images. We

never ask why sadomasochists and blacks posed, and although insisting on Mapplethorpe's ironic relation towards his audience in the avant garde, we deny his models the same irony towards their audience in him. Nor do critical explications deal seriously with the full range of motives a minoritized individual might have in taking such self-consciously outrageous pictures. Generalized identifications of Mapplethorpe as "sadomasochist" or "homosexual" do not address the specific ways in which persons position themselves within minority communities. The reasons why a man once posed bare-assed with a whip up his rectum are not exhausted by explicating the effect he has on his audience; and the same formalism that distances his images from their reality distances his person from his self-portraits.

Far from defining the meaning of their collaboration, the cultural specificity of both models and photographer merely encourages readers to look for it elsewhere. Deriving the power of the photographs from the discomfort they induce, postmodern readings of Mapplethorpe's irony shift attention from its images and imager to those shocked. This relocation has the odd effect of making minority experience irrelevant not only to the photographs' genesis but also to their interpretation. Depending as they do on shock as a form of mis-recognition—of being confronted with one's previously invisible discriminatory assumptions—the images can affect only those for whom their content is shocking. Unable to experience the mis-recognition that permits meaning, sadomasochists and black men cannot "understand" these photographs because they already understand them: one cannot be astonished by the visibility of what was never invisible. "Brian Ridley and Lyle Heeter" (1979), Mapplethorpe's portrait of two men formally posed in the paraphernalia of the master/slave relationship, disconcertingly juxtaposes the image's self-presentation as a "wedding" portrait, its middle-class setting, and its leather regalia. Yet the shocking abnormality of the photograph's juxtapositions excludes from its audience those for whom a leatherman in the living room is not unusual, and for whom sadism is not inconsistent with middle-brow aesthetics.

Even more discomforting is the relation of the racialized viewer to Mapplethorpe's blacks. In "Man in Polyester Suit" (1980), one of the

most complex (and racially charged) of the black images, a large uncircumcised black penis framed by a ring of white underwear hangs from the crotch of a headless torso in a grey suit. As black critics have commented, the shock depends on viewers' recognizing the image's racism as their own. For those black viewers finding the racism neither surprising nor theirs, the photograph merely repeats in a high gloss setting the racial clichés of popular culture. To experience as shocking the image's racism, black critics have to see something wrong in a penis sticking out of a suit. Yet accepting this contrast between flesh and fabric comes dangerously close to thinking blacks should not dress up—figuring the penis as "real" and the polyester as "artificial."

In its affinities with the suspect rhetoric of passing, "Man in Polyester Suit" makes explicit the more general extent to which readings of Mapplethorpe's irony depend on what we might call dominant culture's "anxiety of identifiability." Far from an acknowledgment of cultural specificity, Mapplethorpe's purported identity with his sado-masochisic and black models simply measures the distance of both from their viewers. In such a reading, the culturally empowered become the excluded, shocked by secret sympathies among minorities. Such a shock destabilizes without decentering. The rhetoric of shock is no less *for* dominant culture than is the rhetoric of appeasement. Without the belief that things should be identifiable to us, we cannot be shocked when they are not; shock reaffirms identifiability as a category, even if one particular situation is not immediately identifiable.

Viewers' faith in identifiability resolves any momentary anxiety, teaching them to recognize and assimilate what was at first shocking. Irony does not invalidate conventional categories but only stretches them to include subjects once taboo. By casting low materials in high forms, Mapplethorpe reaffirms the prestige of traditional aesthetics: his "un-exhibitable" photographs court the authenticating power of a gallery show; and their first publisher, *Drummer* editor Jack Fritscher, uses them to class up his magazine's pornography. Nor can the rhetoric of shock be long sustained. The black nudes of the early 1980s are less disconcerting than the sadomasochistic portraits of the

late 1970s, and neither shock upon repeated viewing. Learning to identify the situation, culture replicates the artist's identification with his models, until like the Mapplethorpe of the whip-filled rectum we all look back over our shoulders to wink at those not yet in the know. If the only person still shocked by these photographs is Jesse Helms, then the "margins" Mapplethorpe occupies are very spacious indeed.

The domesticating power of identifiability is clearest in the alliance through which advocates and critics constructed a workable Mapplethorpe after his death. Elevating questions of pornography and child abuse over those of sadism or race, the media debate over "The Perfect Moment"—the aborted and resurrected Corcoran show of 1988-90—marked the willingness of both sides to collaborate in reappropriating Mapplethorpe for the mainstream. Whatever the abstract implications of "Rosie" (1976), in which a child exposes her genitalia, only a culture obsessed with compulsory heterosexuality could read desire into such a photograph from a gay sadomasochist whose life and art showed no erotic interest in women of any age.[14] It is this urge to cultural consolidation that leads critics to ignore the intersection of race and sexuality in Mapplethorpe. Race and sado-masochism do not really intersect, and can play similar roles only in an argument which subordinates image content to audience response. At the crossing of race and S/M lies the recognition that, in the post-modern readings of the relation between the photographer and his audience, any particular shock is replaced by the effect of shock, and the cultural situations of specific sadomasochists and African Americans pass out of the discussion as irrelevant. By not examining the horizontal convergence of race and sexuality in Mapplethorpe, critics repress the more troublesome vertical hierarchy by which their readings (perhaps with Mapplethorpe's encouragement) subordinate the subjectivity of a disempowered artist and his models to the judg-ment of empowered viewers.

In his Broadway AIDS musical *Falsettos*, writer-director James Lapine placed over the bed of his seropositive gay protagonists a framed reproduction of a Mapplethorpe flower. The implied realign-ment of intersections is revealing. The bland couple has little in com-mon with the artist, whose contempt for their sexual timidity would

have matched their fear of his experimentation. Yet as calendar, poster, or obligatory house gift, Mapplethorpe's photographs of flowers have become the preferred sign of homosexual commodification—middle-class gay men's declaration of their domestication of sexual identity in return for heterosexuality's acceptance of them as "one of us." Lapine's flower is the opposite of a "queening" of America: not a subcultural motif silently passing into the mainstream, it is dominant culture's naming as gay the least confrontive image of an artist whose other work resists domestication. In *Falsettos*, as on catalog covers, such flowers stand as memento mori. The supposed overlap between homosexuality and AIDS both sentimentalizes the threat of HIV to gay men and camouflages convergences that might make visible the repressions attending culture's need to know. The transition from flails to flowers charts a process which, collapsing minority identity and identification among the minoritized into minoritizing identifiability, transforms sympathies between groups into sympathy for them.

Seeing White

Lack of attention to minority intersections characterizes many contemporary cultural debates—those, for example, surrounding Richard Rodriguez's *Hunger of Memory*, Marlon Riggs's *Tongues Untied*, David Henry Hwang's *M. Butterfly*, or Neil Jordan's *The Crying Game*. As in the Mapplethorpe controversy, so in each case, silence about complicated horizontal relations among race, ethnicity, gender, and sexuality obscures dominant culture's vertical role in witnessing and adjudicating the argument. I want to end, however, with a debate in which intersections are not repressed but overread. Recognizing diversity is not of itself sufficient, and interpretations which formulate minority convergence as conflict can be as misleading as those which trivialize it as sympathy and identification.

Jennie Livingston's documentary film *Paris Is Burning* (1990) examines the drag balls held by African American and Latino male homosexuals in New York between 1987 and 1989. After a limited run at festivals and a few cosmopolitan art houses, the film went into general release in 1991, was hailed as a triumph of human imagination and spirit over adversity, and grossed over four million dollars to become

one of the most successful and acclaimed American movies of the last five years. The documentary's popularity has (perhaps predictably) aroused suspicions about its ability to challenge and indict mainstream audiences. Yet these doubts have largely been directed at Livingston's relation to her subjects. Reading the balls as misogynist, critics attack the director's failure to position herself as white and privileged; reading drag as destabilizing, friendlier viewers compare Livingston's marginalization as white lesbian to the similar ostracization of women of color, both erased by the balls' stereotypic definition of "femininity."[15]

In focusing on the director's identification with her subjects, the debate attributes to Livingston limitations inherent in the way crossdressing itself conceptualizes cultural positions. Since crossing "from" one identity "to" another entails the relative stability of the two subject positions, the concept of cross-dressing tends to reinforce stereotypes about both straight femininity and gay masculinity. Whether dressing as a woman ridicules or worships femininity, it accepts femaleness as a thing, and Livingston's subjects express very conventional ideas about what women want. At the same time, the very term "cross-dressing" obscures gender differences by treating as a single phenomenon something that may have different consequences depending on whether the cross is from male to female or from female to male. Having internalized these ambiguities about positionality, the interviewees regularly refuse to distinguish among gender, race, and sexuality, and African American and Latino men dressing as women are said to pass as "straight" and even as "white."

The confusion arises less from cross-dressing's relation to gender categories than from its tendency to represent change as linear narrative—either spatially as a progression "from" A "to" B, or temporally as a distinction between "before" and "after." Narrative linearity is a poor model to describe the ways in which cross-dressers, rarely fixed in a single position, oscillate between identities. More important, narrativization favors a rhetoric of causality, and the question of "why do this?" is subtly rewritten as "what does it get you?"[16] Rejecting the possibility that individuals might enjoy gender transformation in itself, narratives recast cross-dressing as a defense against victimization,

where the cross-dresser, though disempowered, is imagined to want the same things as everyone else. The inadequacies of such causal interpretation are most obvious with respect to sexuality. Although cross-dressing is in the popular consciousness invariably associated with homosexuality, no convincing explanation has ever been offered of what cross-dressing is supposed to "get" gay men. It is impossible to cross-dress "as" straight, for there are no visible gay characteristics for clothing to hide. Cross-dressing more probably jeopardizes sexual invisibility, and Livingston's interviewees appear more identifiably gay in drag than out of it.

The dangers of converting crossing into narrative—of reading "from/to" as "if/then"—are apparent in the tonal ambiguities of the film's most authoritative voice, Dorian Corey. In his social history of vogueing Corey appears isolated, cynical, and disaffected—a clichéd image of the tired old queen. His explanations distance him from the younger generation of voguers and the discontent he projects onto them. Tracing the development of the balls, Corey implies that, unlike bowling, cross-dressing needs more justification than simply saying it is fun. In identifying drag as a form of passing Corey adopts the same essentialist metaphors of visibility that led Larsen to reject passing as a species of racial self-hatred. He conceives gay mannerisms to be naturally so overstated that they can only be hidden beneath the culturally sanctioned exaggerations of a *Dynasty* imitation. "Realness" by his account is the ability to blend, to give society what it wants, to erase the "mistakes" of homosexual behavior, finally to go back into the closet.

Corey assimilates drag to the narrative conventions of traditional anthropology, playing native informant to Livingston's participant observer. By considering drag's importance to the participants while ignoring its fascination for spectators, Corey affirms for white audiences, as Irene had for Claire's husband, the right of the empowered to know the marginalized. His emphasis on (in)visibility places white culture at the heart of cross-dressing, as that against which it reacts and that to which he explains. His argument is circular and, like the fear of black achievement as a subtle passing, tends to define as drag any non-identifiably gay behavior. The conflation of drag and passing

represses the extent to which imitations of Joan Collins and Linda Gray are culturally sanctioned only within or by gay subculture. Drag "hides" individual gay mannerisms only by subsuming them to a more general gay identity, and the balls make participants not less visibly gay but more so.

Whether or not convincing, Corey's explanations suggest the extent to which all representations of cross-dressing are grounded in a white anxiety about identifiability. The concept embeds within itself not only a range of troubling gender stereotypes, but a preoccupation with visibility that measures dominant culture's need to recognize difference. Attempting to calm fears and consolidate power, explanations of the phenomenon should be read in counterpoint with what dominant culture has to believe about it. "Real" women are absent in such conceptualizations less because of ethnic and gay misogyny than because female cross-dressing threatens masculine empowerment more seriously than does its male equivalent. Not finding much to envy in femaleness, white straight men seldom care whether women are really men. The possibility that a man might be a woman, on the other hand, endangers both patriarchy and one's own sense of entitlement as male. Even the pro-female attack on drag as misogynist internalizes dominant culture's contempt for women. The claim that cross-dressers really hate a femaleness they pretend to worship can explain motivation only within an intellectual context where hating women seems more plausible than adoring them.

In not interrogating the cultural assumptions that structure cross-dressing as concept, Livingston may be complicit with the white paranoia underwriting that interest. The very seriousness of her treatment downplays the camp humor that is one of the gay community's verbal resources. Her use of Corey as interpreter supposes the phenomenon to need interpretation and the audience to deserve one. Most important, her focus on the murder of Venus Xtravaganza restructures her diffuse documentary as a linear melodrama, with a preoperative transsexual as an undated version of the tragic mulatto. By not exploring how Venus's death implies that only during sex can a "false" woman threaten straight masculinity, Livingston may leave unchallenged the restriction of female power to intercourse. At the very least, fore-

grounding the murder obscures the extent to which the more perva-
sive health threat to this community—as to many racial and sexual
minorities—is not a disenchanted lover but a sexually transmitted
virus.

Such objections, however, concern less Livingston's place inside or
outside a community than the permission her explanations (wherever
positioned) may give to less responsible examinations of the phenom-
enon. Finally the issue is not what she is doing here but what we are.
The film's least successful sequences juxtapose the voices of black gay
men over images of empowered white people, offering a camera eye
implicitly black. By thus failing to admit her relation to empower-
ment, Livingston allows viewers to repress their complicity in white-
ness. Recognizing her similarity to them, white audiences are invited
to conflate the director's identification with her subjects and its iden-
tification with them. If she can be black, then we need not be white,
and oppression originates someplace else, somewhere not "us." The
documentary carries so little threat because the audience is freed of
guilt by the very act of viewing. Lacking even the shock of first
encounters with Mapplethorpe's photography, Livingston's film, like
reviewings of his images, conspires with and consoles its spectators.

Although reproducing crossing's internalization of dominant ideol-
ogy, however, *Paris is Burning* contains within itself the material for a
radical rereading of its constructs. While not challenging the content
of gender stereotypes, cross-dressing may disrupt their ideological
function. Stereotyping identifies putative physical and psychological
abnormalities to mark a group as inferior. In shifting horizontally
through minoritized identities, cross-dressers do not necessarily move
from positions of lesser power to those of greater, as Corey suggested.
As their conflations of race, gender, and sexuality imply, they may not
even have a sense of positions as distinct or of identities as "moving."
Yet, whatever they mean, such transformations do make minorities
harder for dominant culture to classify, and this unrecognizability may
threaten the mainstream more than does unstereotypic behavior.
Pepper Labeija recalls how, after discovering his cross-dressing by
chance, his father complained to his estranged wife, "Your son is a
woman." Labeija's gender-bending did not alarm his mother, who

found Labeija's femininity a "cute" complement to his moustache. Only when the transformation was complete (and the moustache discarded) did his mother confront him for "daring to have breasts bigger than mine." The anecdote represents cross-dressing as a crisis less of gender characteristics than of self-identity. Asserting his masculinity, the father blames the mother for his inability to tell "her" son from a woman. The mother feels threatened only when his imitation of gender makes her unable to believe in the authenticity of her identity as female.

Equally tantalizing is the documentary's occasional skepticism about its use of causality. Believing herself a woman trapped in a man's body, Venus Xtravaganza for the most part reinforces stereotypes about female traits and homosexual psychoses. Yet at times her skewed logic resists our sentimentalization of her as victim. In contrast to Corey's willingness to explain where drag comes from, Venus refuses to speak causally: preoccupied with the future, not the past, she represents herself as having goals rather than reasons. Late in the film, waiting for the kind of "date" who will murder her, she explains that the money such men give her is not payment for sexual favors already rendered but is an investment to improve her wardrobe at subsequent meetings. As an account of why a client pays a prostitute, the explanation is psychologically implausible. Yet Venus's indifference to the trick's real motives suggests how considerations of what cross-dressers get need not invoke the rhetoric of victimization and defense. Rather than letting his motives determine her actions, Venus makes her (future) actions define his (past) desires. Since he gives her the money and she gets a dress, by some very loose account of causality and syntax "he gives her the money [so as] to buy the dress."

Venus's momentary refusal of causality underscores the extent to which the documentary remains in some fundamental sense unintelligible: the film's analysis of cross-dressing never quite explains the balls themselves. Corey's definition of "realness" as passing cannot clarify a situation in which no one is deceived and everyone is gay. The balls, like the black party at the end of *Passing*, offer an environment whose existence confounds the very social hierarchies that supposedly create it. Voguers are not "cross-dressing" at the balls, any

more than Clare is "passing" at Larsen's party; the vertical hierarchies that inform both terms are not applicable in spaces where everyone is equally (dis)empowered. If in one sense *Paris Is Burning* does not represent fully enough the balls' connections to the world beyond, in another it represents such connections too fully. For empowered audiences the balls' attempt to construct a self-sufficient community without reference to an outside world epitomizes the invisibility of difference, both feared and worshipped as transgressive. But the invisible cannot be represented, and the in-itselfness of the balls disappears in any attempt to know them. In *Passing* the white man's own presence at the "all-black" party invalidates his insistence that his wife's presence there proves her racial essence. So footage on the secret balls does not record their self-sufficiency but merely ends it. These physical intrusions stand in for epistemological ones. Explanation as translation is distinct from experience as ownership: the one describes an event as something else; the other labels it as "mine." The discontinuity between the two vocabularies marks the limits of conceptualization: knowledge always addresses others, signaling an understanding of them as an absence from them. Whatever an "all-black" party means to its participants, it does not mean its own blackness. And "secret" balls are secret only to those not in attendance.

These comments about *Paris Is Burning* are not meant to identify specific problems of authorial position or interpretive paradigms but to summarize some limitations with the language of difference explored throughout this essay—and this book. Most obviously, the trope of visibility, in identifying one characteristic of minority experiences, obscures too many particularities. Minorities negotiate differently the ways in which they do and do not appear, both as individuals and as groups. The visible/invisible dichotomy flattens out these differences in strategy, conceptualizing as a steady state of being what is better understood as a changing process of self-presentation. Emphasizing horizontal similarities in strategies of representation, the dichotomy represses its vertical relation to an audience. It depicts a visibility solely determined by the subject, without acknowledging the role of spectators' visual acuity (not to say subcultural literacy) in perception.

Visibility's reticence about the importance of viewers suggests the degree to which the trope originates with them and for them. Our very grammar underscores the other-directedness of the activity. No active verb names the process of becoming visible: not able to "visibilize" myself, I can only passively "be seen." The uniformity of this condition is more evident to those looking than to those looked at; being visibly gay is not like being visibly Jewish to gays or Jews, but only to those who wish to keep their eyes on both. The neutrality of the dichotomy masks the power inequities which make an audience's seeing into an act of surveillance. It fails to admit the dichotomy's moral undertones, its tendency to read visibility as honesty, invisibility as cowardice. Finally the focus on sight objectifies, treating the minoritized as a thing to be seen rather than as a voice to be heard.

To foreground audience anxiety over identifiability, I have focused on some irregularities in our understanding of minority intersectionality. But the limitations of the visibility metaphor inform many aspects of a minority's relation to the mainstream. Recent scholarship has detailed the ways in which oppositional discourse unintentionally internalizes cultural ideology. We must similarly rethink the rhetoric of assimilation, with its assumption that invisibility means annihilation. Assimilation was always an embattled explanation of cultural exchange. Fearing ethnicity as a form of contamination, the narrative reconceptualized group differences as an opportunity for amalgamation, presupposing a quantitative imbalance large enough to transform the minoritized but not affect the empowered. Salt added to the soup became simply soup, itself dissolving without significantly changing the flavor of the broth. In the United States, the classic formulation of the process is Crèvecoeur's:

> What, then, is the American, this new man? He is either an European or the descendant of an European; hence that strange mixture of blood, which you will find in no other country. I could point out to you a family whose grandfather was an Englishman, whose wife was Dutch, whose son married a French woman, and whose present four sons have now four wives of different nations. . . . Here all individuals are

melted into a new race of men, whose labours and posterity
will one day cause great changes in the world.[17]

Such a model of assimilation confuses the effect on culture with the
effect on the acculturated. However assimilation alters dominant cul-
ture, its failure to eradicate the identities of those assimilated is evi-
dent even in Crèvecoeur's account. Despite metaphors of mixing and
melting, national identifications persist in his descriptions. Far from
forgotten, genealogy dominates his rhetoric; the English, the Dutch,
and the French do not blend in the American, but converge there. It
is in the mainstream's interest to think access to power erases subcul-
tural differences. Yet minority discourse must resist this equation of
empowerment with amnesia as fully as it rejects that of visibility with
identity. Language always lingers, and assimilated differences remain
to be seen; they are not so much erased as under erasure.

Near the end of *Paris Is Burning*, Livingston represents white appro-
priation of the balls by incorporating into her film a television report
about a vogueing "contest" at a midtown dance club before a panel of
celebrity judges. Like the shots of white people on Fifth Avenue, the
sequence fails by assuming too quickly the superiority of documentary
film to video news. More important it misses the opportunity to read
ambiguities into the commodifying moment itself. The club owner
clearly wishes to profit from the dance craze, as he had by a previous
introduction of rap into his club. Yet the profits for the evening sup-
port a cause relevant to this particular group of dancers—AIDS relief.
Nor are the sponsors of the event neutral spokespeople for whiteness.
The club owner is Asian American, and his marketing of black music
might be read as an act of ethnic solidarity. Equally marginal are the
authenticating "judges." Fran Lebowitz, antihomophobic humorist
and countercultural relativist, praises vogueing as "institutionalized
showing off," without indicating whether the institutionalization is
underwritten by the black community that invents the dance or the
white establishment that markets it. Geoffrey Holder, the actor/pro-
ducer most famous for restaging *The Wizard of Oz* for black culture as
The Wiz, stands as an exemplar of minority commercialization and
appropriation (and perhaps sexual ambiguity). And the final judge,

praising the dancers' energy and "theatricality," is the first lady of Broadway dance—Gwen Verdon.

Livingston's disinterest in exploring the ambiguity of such a panel of judges symbolizes the more general failure of the languages of difference to unleash the power implicit in dominant culture's need to coopt minorities. As scarcely feminine, barely black, and not quite gay, such panelists can only represent assimilation, compromise, and whiteness. But the success of these entertainers need not invalidate their cultural specificity, nor obscure the concessions dominant culture has to make to embrace such non-traditional figures as its own. It is in the establishment's interest to believe the melting pot burns away differences. It is in minorities' best interest to realize that mixing makes them simultaneously one and the other. In the television commercial that made both drink and actor famous, did Seven-Up coopt Geoffrey Holder or Holder deconstruct the Un-Cola? We choose to read it as we choose. When Gwen Verdon admires vogueing as an exciting and theatrical dance, we need not hear her authenticating adjectives as universalizing standards. Verdon before the voguers, like Lola before Joe, may once again ignore the devil's narrative to celebrate difference as the unstated "whatever" of desire.

Notes

Notes to Introduction

1 Joan W. Scott, "The Evidence of Experience," *Critical Inquiry* 17 (Summer 1991): 778. For more general treatments of identity politics, see Homi Bhabha, ed., *The Real Me: Post-Modernism and the Question of Identity*, ICA Documents 6 (London: Institute of Contemporary Arts, 1987); Jonathan Rutherford, ed., *Identity: Community, Culture, Difference* (London: Lawrence & Wishart, 1990).

2 For a review of the debate between essentialist and constructionist formulations, see Diana Fuss, *Essentially Speaking: Feminism, Nature and Difference* (New York: Routledge, 1989); Edward Stein, ed., *Forms of Desire: Sexual Orientation and the Social Constructionist Controversy* (New York: Routledge, 1992).

3 Stephen Heath was an early advocate for a reconsideration of essentialism. See "Difference," *Screen* vol. 19, no. 3 (Autumn 1978): 51-112, rpt. in *The Sexual Subject: A* Screen *Reader in Sexuality*, ed. Screen, (New York: Routledge, 1992), pp. 47-106. Gayatri Chakravorty Spivak has proposed a similar concept of "strategic essentialism"; see her "Criticism, Feminism, and the Institution" (1984) and "Strategy, Identity, Writing" (1986), both rpt. in *The Post-Colonial Critic: Interviews, Strategies, Dialogues*, ed. Sarah Harasym (New York: Routledge, 1990), pp. 1-16, 36-49, and her "In A Word" *differences* vol. 1 no. 2 (Summer 1989): 124-56. For an overview of the concept, see Diana Fuss, *Essentially Speaking*, pp. 1-21. For powerful revisions, see Teresa de Lauretis, "The Essence of the Triangle or, Taking the Risk of Essentialism Seriously: Feminist Theory in Italy, the U.S., and Britain," *differences* vol. 1, no. 2 (Summer 1989): 3-37; and Amanda Anderson, "Cryptonormativism and Double Gestures: The Politics of Post-Structuralism," *Cultural Critique* 21 (Spring 1992): 63-95. For neo-essentialist accounts of racial identity, see Kobena Mercer, "Skin Head Sex Thing: Racial Difference and the Homoerotic Imaginary," in *How Do I Look?: Queer Film and Video*, ed. Bad Object-Choices (Seattle: Bay Press, 1991), pp. 178-82, 195-206; and Valerie Smith, "'Circling the Subject': History and Narrative in Beloved," in *Toni Morrison: Critical Perspectives Past and Present*, ed. Henry Louis Gates, Jr. and K. A. Appiah (New York: Amistad, 1993), pp. 342-55. Henry Louis Gates, Jr., juxtaposes the two approaches in the deconstructive preface "Writing 'Race' and the Difference It Makes," and in the neo-essentialist afterword "Talkin' That

Talk" to his *"Race," Writing, Difference*, ed., Henry Louis Gates, Jr., (Chicago: University of Chicago Press, 1986), pp. 1-20, 402-409.

Notes to Chapter 1

1 *A Streetcar Named Desire*, scene xi; in *The Theatre of Tennessee Williams* (New York: New Directions, 1990), I, 418.

2 On the relation of homosexual subjects to the intersecting dichotomies of visible/invisible and public/private, see D. A. Miller's explication of "open secrets," in *The Novel and the Police* (Berkeley: University of California Press, 1988), pp. 192-220. For an attempt to re-evaluate silence positively as a culturally specific phenomenon, see King-Kok Cheung, *Articulate Silences: Hisaye Yamamoto, Maxine Hong Kingston, Joy Kogawa* (Ithaca: Cornell University Press, 1993).

3 Susan Sontag, "Notes on 'Camp,'" collected in *Against Interpretation and Other Essays* (New York: Farrar Straus & Giroux, Inc., 1966), pp. 275-78, 286-87. For a modern reinterpretation, which politicizes Sontag's evaluation but does not challenge its parameters, see Andrew Ross, *No Respect: Intellectuals and Popular Culture* (New York: Routledge, 1989), pp. 135-70.

4 The most extended reading of camp as part of gay culture is Esther Newton, *Mother Camp: Female Impersonators in America*, 2nd ed. (Chicago: University of Chicago Press, 1979). For camp and the critique of Sontag, see pp. 104-111. For equally negative evaluations of Sontag, see D. A. Miller, "Sontag's Urbanity," *October* 49 (Summer 1989): 91-101; David Bergman, *Gaiety Transfigured: Gay Self-Representation in American Literature* (Madison: University of Wisconsin Press, 1991), pp. 103-21; Marcie Frank, "The Critic as Performance Artist: Susan Sontag's Writing and Gay Cultures," *Camp Grounds: Style and Homosexuality*, ed. David Bergman (Amherst: University of Massachusetts Press, 1993), pp. 173-84. For more general analyses of camp, see Jack Babuscio, "Camp and the Gay Sensibility," *Gays and Film*, revised edition, ed. Richard Dyer (New York: New York Zoetrope, 1984), pp. 40-57; Robert F. Kiernan, *Frivolity Unbound: Six Masters of the Camp Novel* (New York: Continuum, 1990); David Bergman, ed., *Camp Grounds*; Moe Meyer, ed., *The Politics and Poetics of Camp* (New York: Routledge, 1994).

5 Edward Albee, *Who's Afraid of Virginia Woolf?* (New York: Atheneum, 1983), p. 3. In the abridged exchange that follows, I have removed George's interjections and Martha's repetitions. Subsequent references cite this edition parenthetically in the text.

6 For overviews which reprint the offending passages, see Michael Bronski, *Culture Clash: The Making of Gay Sensibility* (Boston: South End Press, 1984), pp. 124-27; John M. Clum, *Acting Gay: Male Homosexuality in Modern Drama* (New York: Columbia University Press, 1992), pp. 174-93.

7 Particularly useful overviews of the phenomenon are in the editorial introductions to Bergman, *Camp Grounds* and Meyer, *The Politics and Poetics of Camp*. For camp's relation to the gay sensibility, Bronski, *Culture Clash*, pp.

56-79. Bronski mentions many of my examples, though our emphases and evaluations often differ.

8 Ronald Firbank, *Five Novels* (New York: New Directions, 1981), pp. 317, 55; Ronald Firbank, *Three More Novels* (New York: New Directions, 1986), p. 356.

9 Cited on the back of the paperback edition of Firbank, the Auden quotation is not referenced in the standard accounts of Auden or Firbank. Auden's more general fondness for Firbank, whom he associates with Lewis Carroll and Edward Lear, is well documented.

10 "Introduction" to Firbank, *Three More Novels*, p. x.

11 The intersection of class and sexuality is central to much gay scholarship, especially the work of historians Alan Bray and John D'Emilio. For a recent theoretical account of the overlap, see Thomas A. King, "Performing 'Akimbo': Queer Pride and Epistemological Prejudice," *The Politics and Poetics of Camp*, ed. Meyer, pp. 23-50.

12 On sexuality in Coward's plays, see Alan Sinfield, "Private Lives/Public Theater: Noël Coward and the Politics of Homosexual Representation," *Representations* 36 (Fall 1991): 43-63. Sinfield not only places Coward within a broader historical and class context, but in so doing reveals the limitations of reading Cowards's sexual reticence as simple hypocrisy.

13 H. H. Munro, *The Penguin Complete Saki* (New York: Penguin Books, 1982), pp. 7, 107, 12. Subsequent references cite this edition parenthetically in the text.

14 Carl Van Vechten, *Nigger Heaven* (New York: Alfred A. Knopf, 1926), p. 3. Subsequent references cite this edition parenthetically in the text.

15 *Little Me: The Intimate Memoirs of that Great Star of Stage, Screen and Television Belle Poitrine as told to Patrick Dennis with photographs by Cris Alexander* (New York: E. P. Dutton and Company Inc., 1961), pp. 154, 152, 166. Subsequent references cite this edition parenthetically in the text. The history of the term "gay" is a highly contested one. For a general overview, see John Boswell, *Christianity and Social Toleration: Gay People in Western Europe from the Beginning of the Christian Era to the Fourteenth Century* (Chicago: University of Chicago Press, 1980), pp. 41-59. Boswell suggests that one of the earliest popular uses of the term was in *Bringing Up Baby* (1939), when Cary Grant explains his appearance in a woman's robe as "going gay." Alan Sinfield makes a similar observation about Noël Coward's use of "gay" in *Design for Living*; "Private Lives/Public Theater," pp. 56-57. My point, like my text, is much simpler. Unlike earlier coded references by Grant or Coward, which admit of a range of interpretations, Dennis's joke depends on the reader's understanding the sexual meaning of the term, even though his character Belle does not.

16 After reviewing the passages I wished to discuss, the Dennis estate without explanation refused me permission to quote the text directly. In this paragraph, I paraphrase Patrick Dennis, *Auntie Mame: an Irreverent*

Escapade in Biography (New York : Vanguard Press, Inc., 1955), pp. 24-25.
Subsequent references cite this edition parenthetically in the text. For the
stage version, see Jerome Lawrence and Robert E. Lee, *Auntie Mame* (New
York: Vanguard Press, 1957).

17 On the general problem of exoticization, see Edward W. Said, *Orientalism*
 (New York: Pantheon Books, 1978). For the ways in which the colonized
 internalize these categories as "autoethnography," see Mary Louise Pratt,
 Imperial Eyes: Travel Writing and Transculturation (New York: Routledge,
 1992). Anthony Appiah wittily critiques the process as "the Naipaul fallacy"
 in "Strictures on Structures: The Prospects for a Structuralist Poetics of
 African Fiction," in *Black Literature and Literary Theory*, ed. Henry Louis
 Gates, Jr. (New York: Methuen, 1984), pp. 127-50. For a survey of how this
 strategy is used by post-war American ethnic writers, see my "Society and
 Identity," in *The Columbia History of the American Novel*, ed. Emory Elliott
 (New York: Columbia University Press, 1991), pp. 485-509.

18 Truman Capote, *Breakfast At Tiffany's: A Short Novel and Three Stories* (New
 York: Signet, 1958), pp. 35-36. Holly's reference to the obscure character
 actress Maria Ouspenskaya in particular marks her origins in gay camp; such
 a reference is no more realistic from a hillbilly teenager than is a Bette Davis
 imitation from a faculty wife. It is interesting for the linguistic similarity that
 I would establish that the paperback edition of the novel quotes on the back
 cover *Time* magazine's comparison of Holly and Auntie Mame.

19 Truman Capote, *Breakfast At Tiffany's*, pp. 22-23. For a similarly troublesome
 treatment of lesbianism, resulting from Holly's unwillingness to confront
 Rusty's homosexuality, see pp. 50-51.

20 Truman Capote, *Answered Prayers: The Unfinished Novel* (New York: New
 American Library, 1988), p. 146.

21 Nora Ephron, *Heartburn* (New York: Pocket Books, 1983), p. 100.
 Subsequent quotations will cite this edition parenthetically in the text.

22 The "burden of representation" is a repeated theme in Mercer's analyses. See,
 for example, Kobena Mercer, "Black Art and the Burden of Representation,"
 Third Text 10 (Spring 1990): 61-78; Isaac Julien and Kobena Mercer,
 "Introduction—De Margin and De Centre," in *The Last 'Special' Issue on
 Race?*, ed. Isaac Julien and Kobena Mercer, *Screen* vol. 29, no. 4 (Autumn
 1988): 2-10.

23 The relation of women to camp is, of course, hotly debated. For a sophisti-
 cated review of the traditional arguments for the misogyny of camp, see
 Carole-Anne Tyler, "Boys Will Be Girls: The Politics of Gay Drag," in *Inside
 / Out: Lesbian Theories, Gay Theories*, ed. Diana Fuss (New York: Routledge,
 1991), pp. 32-70. For more appreciative accounts of female camp—especial-
 ly in terms of the lesbian theater of Holly Hughes, the WOW Cafe, and the
 Split Britches Company—see Sue-Ellen Case, "From Split Subject to Split
 Britches," *Feminine Focus: The New Women Playwrights*, ed. Enoch Brater
 (New York: Oxford University Press, 1989), pp. 126-49; Kate Davy, "From
 Lady Dick to Ladylike: The Work of Holly Hughes," Lynda Hart, "Identity
 and Seduction: Lesbians in the Mainstream," and Vivian M. Patraka, "Split

Britches in *Split Britches*: Performing History, Vaudeville, and the Everyday," all in *Acting Out: Feminist Performances*, ed. Lynda Hart and Peggy Phelan (Ann Arbor; University of Michigan Press, 1993), pp. 55-84, 119-37, 215-24; Cynthia Morrill, "Revamping the Gay Sensibility: Queen Camp and *dyke noir*," and Kate Davy, "Fe/Male Impersonation: The Discourse of Camp," both in *The Politics and Poetics of Camp*, pp. 110-29, 130-48; Pamela Robertson, "'The Kinda Comedy that Imitates Me': Mae West's Identification with the Feminist Camp," and Patricia Juliana Smith, "'You Don't Have to Say You Love Me': The Camp Masquerades of Dusty Springfield," both in *Camp Grounds*, pp. 156-72, 185-205. On Jane Cottis, see B. Ruby Rich, "New Queer Cinema," *Sight and Sound* vol. 2, no. 5 (September 1992): 30-36. On Midi Onodera, see Judith Mayne, *The Woman at the Keyhole: Feminism and Women's Cinema* (Bloomington: Indiana University Press, 1990), pp. 225-27; and her "A Parallax View of Lesbian Authorship," *Inside/Out*, pp. 173-84.

24 Gilles Deleuze, "What is a Minor Literature," in *Kafka: Toward a Minor Literature* (Minneapolis: University of Minnesota Press, 1986), pp. 16-27; Homi Bhabha, "Of Mimicry and Man: The Ambivalence of Colonial Discourse," *October* 28 (Spring 1984): 125-33; Bhabha, "Sly Civility," *October* 34 (Fall 1985): 71-80; Paul Willis, with Simon Jones, Joyce Canaan and Geoff Hurd, *Common Culture: Symbolic Work at Play in the Everyday Cultures of the Young* (San Francisco: Westview Press, 1990), pp. 1-29. See also Stuart Hall, "Encoding/Decoding," in *Culture, Media, Language*, ed. Stuart Hall (Birmingham: Centre for Contemporary Cultural Studies, 1980), pp. 128-38. On minority "damage," see Abdul R. JanMohamed and David Lloyd, "Introduction," in *The Nature and Context of Minority Discourse*, ed. JanMohamed and Lloyd (New York: Oxford University Press, 1990), pp. 1-16.

Notes to Chapter 2

1 John Lahr, *Prick Up Your Ears: The Biography of Joe Orton* (1978; rpt. New York: Limelight, 1986), p. 3.

2 The only published primary source for Orton's life is John Lahr, ed., *The Orton Diaries, including the correspondence of Edna Welthorpe and others* (New York: Harper & Row, Publishers, 1986). For a brilliant critique of popular readings of Orton, with special emphasis on the limitations of Lahr's biography and edition of the diaries, see Simon Shepherd, *Because We're Queers: The Life and Crimes of Kenneth Halliwell and Joe Orton* (London: Gay Men's Press, 1989). Although everywhere in Shepherd's debt, for brevity's sake I have only cited the most obvious of those debts in the notes. For a skeptical account of Lahr's use of a "diary" intended for publication to access Orton's "private" thoughts, see, in addition to Shepherd, Randall S. Nakayama, "Domesticating Mr. Orton," *Theatre Journal* 43 (1993): 185-95.

3 Quoted in *The Orton Diaries*, pp. 115n. For Lahr's discussion of Orton's intention to leave Halliwell, see *Prick Up Your Ears*, pp. 27-35. On the manipulativeness of Lahr's footnotes, see Shepherd, *Because We're Queers*, pp. 152-57.

4 Quoted in Lahr, *Prick Up Your Ears*, p. 30.

5 Upon the Lord Chamberlain's insistence, Rattigan had only a decade before removed references to homosexuality in *Separate Tables*. On Rattigan as establishment homosexual—the kind of playwright Orton was trying not to be—see Alan Sinfield, *Literature, Politics and Culture in Post-War Britain* (Berkeley: University of California, 1989), pp. 60-85.

6 *The Orton Diaries*, pp. 80, 219. Early in Olivier's career, his persona as smoldering matinee idol required him to appear as rampantly heterosexual; since his death, his bisexuality has become more openly discussed.

7 *The Orton Diaries*, pp. 131, 139.

8 *The Orton Diaries*, pp. 248, 249.

9 The phrase is again Willes's, quoted in *The Orton Diaries*, p. 131n.

10 Willes and Rattigan as quoted in Lahr, *Prick Up Your Ears*, pp. 30, 23-24.

11 Letter to Lahr, quoted in *The Orton Diaries*, p. 90n.

12 See Shepherd, *Because We're Queers*; Jonathan Dollimore, *Sexual Dissidence: Augustine to Wilde, Freud to Foucault* (New York: Oxford University Press, 1991), pp. 315-18; Alan Sinfield, "Who Was Afraid of Joe Orton?" in *Sexual Sameness: Textual Differences in Lesbian and Gay Writing*, ed., Joseph Bristow (New York: Routledge, 1992), pp. 170-86; John M. Clum, *Acting Gay: Male Homosexuality in Modern Drama* (New York: Columbia University Press, 1992), pp. 117-33; Nakayama, "Domesticating Mr. Orton." Although critics disagree on the degree of Orton's complicity in his domestication, all regret Lahr's interpretations.

13 Bennett, *Prick Up Your Ears, the Screenplay* (Boston: Faber & Faber, 1987), p. ix. Although not self-identified as gay, Bennett has shown particular tact and sympathy treating gay men—and has allowed his own homosexuality to be inferred.

14 For the traditional account of gay bathroom culture in America, see Laud Humphreys, *Tearoom Trade: Impersonal Sex in Public Places*, enlarged edition (New York: Aldine Publishing, 1975). For a powerful discussion of the moral implications of promiscuity after AIDS, see Douglas Crimp, "How to Have Promiscuity in an Epidemic," in *AIDS: Cultural Analysis/Cultural Activism*, ed. Douglas Crimp, *October* 43 (Winter 1987): 237-70.

15 Homosexuality was partially decriminalized in England by the Sexual Offences Act of 1967, signed into law in the final weeks of Orton's life. Halliwell and Orton clearly understood the relation between criminality and bathrooms. In Tangier, they were surprised when an English tourist retired to a bathroom to masturbate an Arab boy. Halliwell commented in bemusement, "Surely though . . . it isn't necessary to have boys in lavatories in this country." Orton wryly responded, "Perhaps some people being forced into the lavatories in England get to associate sexual pleasure with the smell of piss" (*The Orton Diaries*, p. 210). For a more general discussion of the history of legalization in England, see Jeffrey Weeks, *Coming Out: Homosexual Politics in Britain, from the Nineteenth Century to the Present* (1977; rpt.

London: Quartet Books, 1979), esp. pp. 168-82.

16 An interesting contrast to Frears's political naiveté is found in the films of Rainer Werner Fassbinder. Not only does Fassbinder's final work *Querelle* (1982) offer a less voyeurist, more erotic account of gay sexual activity; his films frequently focus on problems among class, race, and sexuality, especially through his cinematic use of his real-life lover, the Moroccan actor El Hedi Ben Salem. The very sexual tourism Frears celebrates is criticized by Fassbinder in *Fox and His Friends* (1975), where Salem plays an African hired to service Fassbinder's Fox, a working-class homosexual being taught the privileges of the German tourist by his upper-middle-class boy friend. On Fassbinder, race, and (homo)sexual spectatorship, see Judith Mayne, "Fassbinder and Spectatorship," *New German Critique* 12 (1977): 61-74; Kaja Silverman, *Male Subjectivity at the Margins* (New York: Routledge, 1992), pp. 125-56, 214-96; B. Ruby Rich, "When Difference Is (More Than) Skin Deep," in *Queer Looks: Perspectives on Lesbian and Gay Film and Video*, ed. Martha Gever, Pratibha Parmar, and John Greyson (New York: Routledge, 1993), pp. 423-25.

17 John Lahr, ed., *The Complete Plays* (New York: Grove Press, 1977), pp. 155, 274. Subsequent references to the plays will cite this edition parenthetically in the text.

18 For general theoretical treatment of the relation between sexual identity and fiction, see Sharon O'Brien, "'The Thing Not Named': Willa Cather as a Lesbian Writer," reprinted in Estelle B. Freedman, Barbara C. Gelpi, Susan L. Johnson, Kathleen M. Weston, ed., *The Lesbian Issue: Essays from SIGNS* (Chicago: University of Chicago Press, 1985), pp. 67-90; Judith Butler, *Bodies That Matter: On the Discursive Limits of 'Sex'* (New York: Routledge, 1993), pp. 143-66.

19 Lahr's definition in *Prick Up Your Ears*, p. 5. See also his introduction to *The Complete Plays*, p. 11. For a more extended consideration, see Maurice Charney, *Joe Orton*, Grove Press Modern Dramatists (New York: Grove Press, 1984), pp. 123-33. For the fullest discussion of the social implications of Orton's language, see Simon Shepherd, "Edna's Last Stand, Or Joe Orton's Dialectic of Entertainment," *Renaissance and Modern Studies* 22 (1978): 87-110. Lahr's definition emphasizes Orton's macabre effects, which are less frequent than he implies and largely restricted to *Loot*. For the argument that even these effects, especially the dismemberments, are ultimately sexual in origin, see C. W. E. Bigsby, *Joe Orton* (New York: Methuen, 1982), pp. 31, 45.

20 Feminist critics regularly see gender identity in terms of empowerment, a source of talent as well as of anxiety. See, for example, Carolyn G. Heilbrun, *Writing a Woman's Life* (New York: Ballantine, 1989), pp. 96-97; Sharon O'Brien's account of Cather's reconciliation with her sexual identity in *Willa Cather: The Emerging Voice* (New York: Oxford University Press, 1987). A comparable emphasis is less common in gay scholarship. Even so tactful a biographer as Richard Ellmann divides Oscar Wilde's artistic abilities from his sexuality. In formulations such as his sympathetic appraisal that "homosexuality fired his mind," Ellmann unintentionally suggests that homosexuality existed apart from Wilde's mind, that the mind was not itself homosex-

ual. See Richard Ellmann, *Oscar Wilde* (New York: Alfred A. Knopf, 1988), pp. 281. For an experimental, more aggressively gay reading of Wilde's life, see Gary Schmidgall, *The Stranger Wilde: Interpreting Oscar* (New York: Dutton, 1994). A bizarre (virtually homophobic) version of the identity debate is currently being played out in terms of the relation between Foucault's promiscuity and his seropositivity.

21 Joe Orton, *Head to Toe* (1971; rpt. London: Minerva, 1990), p. 35. For the complete sequence, see pp. 28-36.

22 The function of masculinity as a stereotype is a matter of considerable debate in the gay community. For a classic defense of masculinity, see John Rechy, *The Sexual Outlaw: a Documentary* (1977; rpt. New York: Dell Publishing, 1978). For a representative critique, see Leo Bersani, "Is the Rectum a Grave?" in *AIDS: Cultural Analysis/Cultural Activism*, pp. 197-222. For my own account of masculinity, see Irit Rogoff and David Van Leer, "Afterthoughts . . . : A Dossier on Masculinity," *Theory and Society* 23 (1993): 739-62.

Notes to Chapter 3

1 This essay focuses on two of Sedgwick's books: *Between Men: English Literature and Male Homosocial Desire* (New York: Columbia University Press, 1985), cited as *BM*; and *Epistemology of the Closet* (Berkeley: University of California Press, 1990), cited as *EC*. Among Sedgwick's other significant works are: "A Poem Is Being Written," *Representations* 17 (Winter 1987): 110-43; "Privilege of Unknowing," *Gender*, vol. 2, no. 1 (Spring 1988): 102-24; "Across Gender, Across Sexuality: Willa Cather and Others," *South Atlantic Quarterly*, vol. 88, no. 1 (Winter 1989): 53-72; *Tendencies* (Durham: Duke University Press, 1993).

2 Henry James, "The Beast in the Jungle," *The Complete Tales of Henry James*, ed. Leon Edel, 12 vols. (London: Rupert Hart-Davis, 1962-64), XI, 359, 401.

3 See Ruth Bernard Yeazell, "Introduction," in *Sex, Politics, and Science in the Nineteenth-Century Novel: Selected Papers from the English Institute, 1983-84*, ed. Yeazell, n.s. no. 10 (Baltimore: Johns Hopkins University Press, 1986), p. xi. Sedgwick's "Beast" first appeared in this anthology; a revised version was reprinted as the fourth chapter of *Epistemology of the Closet*.

4 Michel Foucault, *The History of Sexuality, Volume I: An Introduction* (New York: Vintage Books, 1978), p. 17.

5 The literature on the notorious ambiguity of the word "sodomy" is extensive. For historical overviews, see Jeffrey Weeks, *Coming Out: Homosexual Politics in Britain, from the Nineteenth Century to the Present* (1977; rpt London: Quartet Books, 1979), pp. 11-14; Salvatore J. Licata and Robert P. Petersen, eds., *The Gay Past: A Collection of Historical Essays* (1981; rpt. New York: Harrington Park Press, 1985); and Kent Gerard and Gert Hekma, eds., *The Pursuit of Sodomy: Male Homosexuality in Renaissance and Enlightenment Europe* (1988, rpt. New York: Harrington Park Press, 1989). For a theoretical account,

see Jonathan Goldberg, *Sodometries: Renaissance Texts, Modern Sexualities* (Stanford: Stanford University, 1992), esp. pp. 1-26.

6 My critique of ethnographic positioning is derived from James Clifford, *The Predicament of Culture: Twentieth-Century Ethnography, Literature, and Art* (Ithaca: Cornell University Press, 1988), esp. pp. 1-113. For the concept of participant observation, see Clifford, p. 34.

7 Mikhail Bakhtin, "Discourse in the Novel" (1934-35); in Bakhtin, *The Dialogic Imagination*, ed. Michael Holquist (Austin: University of Texas Press, 1981), p. 293. The passage is used by editor Henry Louis Gates, Jr. as one of the epigraphs to his ground-breaking anthology *"Race," Writing, and Difference* (Chicago: University of Chicago Press, 1986), p. 1. Clifford himself quotes the paragraph in *The Predicament of Culture*, pp. 41-42.

8 See Freud's study of Dr. Schreber, "Psychoanalytic Notes Upon an Autobiographical Account of a Case of Paranoia (Dementia Paranoides)"; in Philip Rieff, ed., *Three Case Histories* (New York: Macmillan, 1963), esp. pp. 162-68. For a more detailed (and balanced) account, see Freud's *Three Essays on the Theory of Sexuality*, trans. and newly ed. James Strachey (New York: Basic Books, Inc., 1962), pp. 2-14. The adequacy of Freud's approach to homosexuality is hotly debated. For a homosexual critique (itself both within the context of feminism and favorable to Sedgwick's work), see Craig Owens, "Outlaws: Gay Men in Feminism," *Men in Feminism*, ed. Alice Jardine and Paul Smith (New York: Methuen, 1987), pp. 219-32. For more favorable readings, see Henry Abelove, "Freud, Male Homosexuality, and the Americans," *Dissent* 33 (1986): 59-69; Arnold I. Davidson, "How to Do the History of Psychoanalysis: A Reading of Freud's *Three Essays on the Theory of Sexuality*, *Critical Inquiry* 13 (1987): 252-77; and Douglas Crimp, "Mourning and Militancy," in *Out There: Marginalization and Contemporary Cultures*, ed. Russell Ferguson, et al. (1990), pp. 233-245. Sedgwick discusses Schreber in *BM*, pp. 20, 91-92.

9 For an historical overview of the relation between psychoanalysis and homosexuality, see Kenneth Lewes, *The Psychoanalytic Theory of Male Homosexuality* (New York: New American Library, 1988), esp. pp. 140-72. For a critique of the relation between paranoia and homosexuality in traditional psychoanalytic discourse, see Richard C. Freidman, M. D., *Male Homosexuality: A Contemporary Psychoanalytic Perspective* (New Haven: Yale University Press, 1988), pp. 164-79. For an account of the depathologization of homosexuality, see Ronald Bayer, *Homosexuality and American Psychiatry: The Politics of Diagnosis* (Princeton: Princeton University Press, 1987).

10 See Homi Bhabha, "Sly Civility," *October* 34 (Fall 1985): 78-79.

11 W. E. Burghardt Du Bois, *The Souls of Black Folk* (New York: New American Library, 1969), pp. 44-45, 49, 46-47.

12 *Narrative of the Life of Frederick Douglass, An American Slave, Written by Himself* (Garden City, N.Y.: Anchor Press/Doubleday, 1973), p. 14. For a comparable analysis of the cultural significance of spirituals, see Du Bois, pp. 264-77.

13 Henry Louis Gates, Jr., *Figures in Black: Words, Signs, and the "Racial" Self* (New York: Oxford University Press, 1987), pp. 96-97. For a discussion of the white reader's relation to the *Narrative*'s epistemological paradoxes, see my "Reading Slavery: The Anxiety of Ethnicity in Douglass's *Narrative*," in *Frederick Douglass: New Literary and Historical Essays*, ed. Eric J. Sundquist (New York: Cambridge University Press, 1990), pp. 118-40.

14 For a poststructuralist critique of confession and its notion of motivation, see Michel Foucault, *The History of Sexuality Volume I: An Introduction*, pp. 58-67; Paul De Man, *Allegories of Reading: Figural Language in Rousseau, Nietzsche, Rilke, and Proust* (New Haven: Yale University Press, 1979), pp. 278-301.

15 On the linguistic status of performatives, see J. L. Austin, *How To Do Things With Words*, eds., J. O. Urmson and Marina Sbisa (Cambridge: Harvard University Press, 1975). For the performative dimension of gender, see Judith Butler, *Gender Trouble: Feminism and the Subversion of Identity* (New York: Routledge, 1990), esp. pp. 128-41. Although Butler's sense of gender as performance is more wide-ranging than my limited grammatical observation, the two notions are compatible. Sedgwick aligns herself with Butler's notion of performance, but not with Austin's, in "Queer Performativity: Henry James's *The Art of the Novel*," *GLQ* 1 (1993): 2-4.

16 Butler, *Gender Trouble*, p. 13.

Notes to Chapter 4

1 This tradition has been reviewed in Martin Bauml Duberman, Martha Vicinus, and George Chauncey, Jr., eds., *Hidden From History: Reclaiming the Gay and Lesbian Past* (New York: New American Library, 1989), whose introduction (pp. 1-13) offers a summary similar to my own.

2 For an early critique of this static image, see John D'Emilio, "Capitalism and Gay Identity," in *Powers of Desire: The Politics of Sexuality*, ed., Ann Snitow, Christine Stansell, and Sharon Thompson (New York: Monthly Review Press, 1983), pp. 100-113. For a good summary of the conflict as it plays itself out in gay scholarship, see David M. Halperin, *One Hundred Years of Homosexuality and other essays on Greek love* (New York: Routledge, 1990), pp. 41-53; Halperin's statement casts itself very indirectly as a critique of Boswell's position.

3 For general overviews of recent work in literary theory, see Elaine Showalter, ed., *Speaking of Gender* (New York: Routledge, 1989); and Joseph A. Boone and Michael Cadden, eds., *Engendering Men: The Question of Male Feminist Criticism* (New York: Routledge, 1990).

4 Eve Kosofsky Sedgwick, "Tide and Trust," *Critical Inquiry* 15 (1989): 755n; Wayne Koestenbaum, *Double Talk: The Erotics of Male Literary Collaboration* (New York: Routledge, 1989), p. 177; Ed Cohen, *Journal of the History of Sexuality* vol. 1, no. 1 (July 1990): 164-67.

5 Douglas Crimp, "AIDS: Cultural Analysis/Cultural Activism," *AIDS:*

Cultural Analysis/Cultural Activism, ed. Douglas Crimp, *October* 43 (Winter 1987): 3. Similar formulations can be found in most AIDS theory, including the first (and best) of all the representational studies: Simon Watney, *Policing Desire: Pornography, AIDS and the Media* (Minneapolis: University of Minnesota Press, 1987).

6 Paula A. Treichler, "AIDS, Gender, and Biomedical Discourse: Current Contests for Meaning," in *AIDS: The Burdens of History*, ed. Elizabeth Fee and Daniel M. Fox (Berkeley: University of California Press, 1987), pp. 222, 208. Similar limitations inform the otherwise illuminating discussion of gay male "promiscuity" in Steven Seidman, "Transfiguring Sexual Identity: AIDS and the Contemporary Construction of Homosexuality," *Social Text* 19/20 (Fall 1988): 187-205.

7 See P. F. Strawson, *The Bounds of Sense: An Essay on Kant's* Critique of Pure Reason (London: Methuen & Co., 1966), esp. pp. 97-112. This argument is related to Strawson's more general position in his own *Individuals: An Essay in Descriptive Metaphysics* (1959; rpt. Garden City: Doubleday, 1963), pp. 81-113. See also Richard Rorty, "Strawson's Objectivity Argument," *Review of Metaphysics* 24 (1970): 230-34, from whose formulations my examples derive.

8 It is important to realize at least that certain diseases, like tuberculosis, have in America largely been contained through such a defensive treatment of symptoms. For a related critique of the false positivism of biomedical discourse (particularly as propounded by Susan Sontag), see Allan M. Brandt, *No Magic Bullet: A Social History of Venereal Disease in the United States Since 1880*, expanded edition (New York: Oxford University Press, 1987). For preliminary attempts to uncover some of the assumptions of biomedical discourse, see Paula A. Treichler, "How to Have Theory in an Epidemic: The Evolution of AIDS Treatment Activism," *Technoculture*, ed. Constance Penley and Andrew Ross (Minneapolis: University of Minnesota Press, 1991), pp. 57-106; Donna Haraway, "The Biopolitics of Postmodern Bodies: Determination of Self in Immune System Discourse," *differences* vol. 1, no. 1 (Winter 1989): 3-43.

9 Renée Sabatier, et al., *Blaming Others: Prejudice, Race, and Worldwide AIDS* (Philadelphia: New Society Publishers, 1988), p. 7. See also Panos Dossier, *AIDS and the Third World* (Philadelphia: New Society Publishers, 1989); and for more theoretical considerations of the problems of representation in African AIDS, Paula A. Treichler, "AIDS and HIV Infection in the Third World: A First World Chronicle," in *Remaking History*, ed. Barbara Kruger and Phil Mariani, Dia Art Foundation Discussions in Contemporary Culture no. 4. (Seattle: Bay Press, 1989), pp. 31-86; Simon Watney's two articles, "AIDS, Language and the Third World," in *Taking Liberties: AIDS and Cultural Politics*, ed. Erica Carter and Simon Watney (London: Serpent's Tail, 1989), pp. 183-92; and "Missionary Positions: AIDS, 'Africa,' And Race," *differences* vol. 1, no. 1 (Winter 1989): 83-100; Susan Sontag, *AIDS and Its Metaphors* (New York: Farrar, Straus and Giroux, 1989), pp. 60-71; and in response D. A. Miller, "Sontag's Urbanity," *October* 49 (Summer 1989): 91-101.

10 Cartoons reprinted from *Decision*, a publication of the New York City

Department of Health. For a comparable problematization of the relation of Latino culture to the concept of "homosexuality," see Ana Maria Alonso and Maria Teresa Koreck, "Silences: 'Hispanics,' AIDS, and Sexual Practices," *differences* vol. 1, no. 1 (Winter 1989): 101-24.

11 For a sensationalized account of Foucault's bathhouse activity, see James Miller, *The Passion of Michel Foucault* (New York: Simon & Schuster, 1993). For more balanced considerations of the place of AIDS within the Foucauldian concept of "sexuality," see the essays by Judith Butler, Douglas Crimp and Jeffrey Weeks in Domna Stanton, ed., *Discourses of Sexuality: From Aristotle to AIDS* (Ann Arbor: University of Michigan Press, 1992), pp. 344-411.

12 Leo Bersani, "Is the Rectum a Grave?" in *AIDS: Cultural Analysis / Cultural Activism*, ed. Douglas Crimp, *October* 43 (Winter 1987): 199.

13 Lee Edelman, "The Plague of Discourse: Politics, Literary Theory, and AIDS," in *Displacing Homophobia*, ed. Ronald R. Butters, John M. Clum, and Michael Moon, *South Atlantic Quarterly* vol. 88, no. 1 (Winter 1989): 316.

Notes to Chapter 5

1 Marjorie Garber, *Vested Interests: Cross-Dressing and Cultural Anxiety* (New York: Routledge, 1992), p. 16.

2 Gloria Anzaldúa, *Borderlands: The New Mestiza = La Frontera* (San Francisco: Spinsters/Aunt Lute, 1987), pp. 77, 79, 73. Much recent Chicano/a theory has made similar claims for the transgressive character of borders. See, for example, Renato Rosaldo, *Culture and Truth: The Remaking of Social Analysis* (Boston: Beacon Press, 1989), pp. 196-217; Héctor Calderón and José David Saldívar, ed., *Criticism in the Borderlands: Studies in Chicano Literature, Culture, and Ideology* (Durham: Duke University Press, 1991).

3 Although Crenshaw's work presents intersectionality as a black feminist critique of a one-dimensional focus on gender or race, there are, as she implies, as many intersectionalities as there are differences. For her formal critique of legal theory, see Kimberlé Crenshaw, "Demarginalizing the Intersection of Race and Sex: A Black Feminist Critique of Antidiscrimination Doctrine, Feminist Theory and Antiracist Politics," *The University of Chicago Legal Forum* 1989: 139-67; for her popular reading of how such theory informs cultural criticism, see Crenshaw, "Beyond Racism and Misogyny: Black Feminism and 2 Live Crew," *Boston Review* vol. 16, no. 6 (December 1991): 6, 30-33.

4 George Abbott, [Richard Bissell,] and Douglass Wallop, *Damn Yankees*, music and lyrics by Richard Adler and Jerry Ross (New York: Random House, 1956), pp. 91-92.

5 The recent literature on these issues is enormous. The classic statement on masquerade is Joan Riviere, "Womanliness as a Masquerade" (1929). For modern reformulations, see Stephen Heath, "Joan Riviere and the

Masquerade," in *Formations of Fantasy*, ed. Victor Burgin, James Donald, Cora Kaplan (London: Methuen, 1986), pp. 45-61; Mary Ann Doane, *Femmes Fatales: Feminism, Film Theory, Psychoanalysis* (New York: Routledge, 1991), pp. 17-32. For theoretical readings of performance and drag, see the work of Judith Butler, especially *Gender Trouble: Feminism and the Subversion of Identity* (New York: Routledge, 1990), "Imitation and Gender Subordination," *Inside/Out: Lesbian Theories, Gay Theories*, ed. Diana Fuss (New York: Routledge, 1991), pp. 13-31. See also the essays in Sue-Ellen Case, ed., *Performing Feminisms: Feminist Critical Theory and Theatre* (Baltimore: Johns Hopkins University Press, 1990).

6 There is a wealth of scholarship in ethno-musicology on the influence of Afro-Caribbean music on popular music in the United States. For a general overview, see John Storm Roberts, *The Latin Tinge: The Impact of Latin American Music on the United States* (New York: Oxford University Press, 1979).

7 Monroe's performance lies at the center of debate on gender performativity and the female gaze. See especially Maureen Turim, "Gentlemen Consume Blondes," and Lucie Arbuthnot and Gail Seneca, "Pre-Text and Text in *Gentlemen Prefer Blondes*," in Patricia Erens, ed., *Issues in Feminist Film Criticism* (Bloomington: Indiana University Press, 1990), pp. 101-11, 112-25. Insufficient critical attention, however, has been paid to Jane Russell's imitation of that performance.

8 For the fullest exploration of this duplicity, see Richard Meyer, "Rock Hudson's Body," in Fuss, ed., *Inside/Out*, pp. 258-88. For more general treatments of male homosexuality and spectatorship, see Richard Dyer, "Don't Look Now: The Male Pin Up" *Screen* vol. 23, nos. 3-4 (Sept/Oct 1982): 61-73; Steve Neale, "Masculinity as Spectacle: Reflections on Men and Mainstream Cinema," *Screen* vol. 24, no. 6 (Nov/Dec 1983): 2-16; D. A. Miller, "Anal *Rope*," in *Inside/Out*, pp. 118-41. The scholarship on lesbian spectatorship is voluminous. Most begins with Laura Mulvey's psychoanalytic reading of the male (heterosexual) gaze in "Visual Pleasure and Narrative Cinema" (1975); rpt. in Mulvey, *Visual and Other Pleasures* (Bloomington: Indiana University Press, 1989), pp. 14-26. For important statements which review previous arguments, see Teresa de Lauretis, "Sexual Indifference and Lesbian Representation," in Case, ed., *Performing Feminisms*, pp. 17-39, de Lauretis, "Film and the Visible," in *How Do I Look?: Queer Film and Video*, ed. Bad Object-Choices (Seattle: Bay Press, 1991), pp. 223-84; Patricia White, "Female Spectator, Lesbian Specter: *The Haunting*," in *Inside/Out*, pp. 142-72.

9 Deborah E. McDowell, "Introduction" to her edition of Larsen's two novels *Quicksand and Passing* (New Brunswick: Rutgers University Press, 1986), pp. xxiii-xxxv; Judith Butler, *Bodies That Matter: On the Discursive Limits of 'Sex'* (New York: Routledge, 1993), p. 174. See also Cheryl A. Wall, "Passing For What? Aspects of Identity in Nella Larsen's Novel," *Black American Literature Forum* vol. 20, no. 1/2 (Spring/Summer 1986): 97-111; Thadious M. Davis, *Nella Larsen, Novelist of the Harlem Renaissance: A Woman's Life Unveiled* (Baton Rouge: Louisiana State University Press, 1994). Subsequent references to Larsen's novel cite McDowell's edition parenthetically in the text.

10 For an overview of the relation between class and gender within passing nar-
 ratives, see Valerie Smith, "Reading the Intersection of Race and Gender in
 Narratives of Passing," *Diacritics* vol. 24, no. 2-3 (Summer-Fall 1994): 43-57.

11 For the use of the re-identifiability argument to deconstruct the concept of
 race (and especially of racial history), see Anthony Appiah, "The
 Uncompleted Argument: Du Bois and the Illusion of Race," in *"Race,"
 Writing, and Difference*, ed., Henry Louis Gates, Jr. (Chicago: University of
 Chicago Press, 1986), pp. 21-37. I review the problem in terms of Emerson,
 and its philosophical pre-history in seventeenth- and eighteenth-century
 debates about memory, in *Emerson's Epistemology: The Argument of the Essays*
 (New York: Cambridge University Press, 1986), pp. 168-70, 268-69.

12 The first position is enunciated for a general readership by Arthur C. Danto
 in "Playing with the Edge: The Photographic Achievement of Robert
 Mapplethorpe," in *Mapplethorpe*, ed. Mark Holborn and Dimitri Levas
 (New York: Random House, 1992), pp. 311-39. For a more theoretically
 sophisticated account, see Paul Morrison, "Coffee Table Sex: Robert
 Mapplethorpe and the Sadomasochism of Everyday Life," *Genders* 11 (Fall
 1991): 17-36. The second position is fully explored in Kobena Mercer's
 numerous meditations on Mapplethorpe. For an emphasis on
 Mapplethorpe's racism, see Kobena Mercer and Isaac Julien, "Race, Sexual
 Politics and Black Masculinity: A Dossier," in *Male Order: Unwrapping
 Masculinity*, ed. Rowena Chapman and Jonathan Rutherford (London:
 Lawrence and Wishart, 1988), pp. 97-164. For a later revision of this read-
 ing in the direction of ambivalence, see Kobena Mercer, "Skin Head Sex
 Thing: Racial Difference and the Homoerotic Imaginary," in Bad Object-
 Choices, eds., *How Do I Look?*, pp. 169-222.

13 For Mercer's argument that minorities must resist the postmodern trope of
 the death of the artist, see "Skin Head Sex Thing," *How Do I Look?*, pp. 178-
 82, 195-206.

14 Many of the key documents in the debate are reprinted in Richard Bolton,
 ed., *Culture Wars: Documents from the Recent Controversies in the Arts* (New
 York: New Press, 1992). The limits of the popular debates about "The
 Perfect Moment" are most fully exposed in Judith Butler, "The Force of
 Fantasy: Feminism, Mapplethorpe, and Discursive Excess," *differences* vol. 2,
 no. 2 (Summer 1990): 105-125.

15 The most powerful negative reading is bell hooks, *Black Looks: Race and
 Representation* (Boston: South End Press, 1992), pp. 145-56; the best
 defense, Judith Butler, "Gender is Burning: Questions of Appropriation and
 Subversion," in *Bodies That Matter: On the Discursive Limits of "Sex,"* pp. 121-
 40.

16 Marjorie Garber exposes culture's failure to treat cross-dressing itself, and its
 tendency instead to read it as a symptom of something else. See *Vested
 Interests: Cross-Dressing and Cultural Anxiety*, esp. pp. 267-303.

17 J. Hector St. John de Crèvecoeur, *Letters From an American Farmer* (1782;
 rpt. New York: Penguin Books, 1986), pp. 69-70.

INDEX